A Brief History of
VASHON ISLAND

A Brief History of

VASHON ISLAND

Bruce Haulman

THE
History
PRESS

Published by The History Press
Charleston, SC
www.historypress.net

Cover images: Lower front image courtesy of Terry Donnelly. Point Robinson Lighthouse image by Joe Mabel, Creative Commons.

First published 2016

Manufactured in the United States

ISBN 978.1.62619.169.3

Library of Congress Control Number: 2015958240

Notice: The information in this book is true and complete to the best of our knowledge. It is offered without guarantee on the part of the author or The History Press. The author and The History Press disclaim all liability in connection with the use of this book.

CONTENTS

PREFACE

This is a brief interpretive history of Vashon Island. It cannot touch on every event and every person on the island, but it does look at the larger patterns that form the story of the island and identifies those events and people who helped shape the island's history. This is the second in a trilogy about Vashon history. The first, *Vashon Island: Images of America* (2011), sought to tell the history of Vashon through photographs. *A Brief History of Vashon Island* looks at the broad sweep of forces and events that shaped Vashon. It is my attempt to tell the story of Vashon Island in a way that helps makes sense of who we are and how we became what we are today. The third will explore the exceptional individuals and personalities whose stories capture the full sweep of the human experience on Vashon.

Vashon Island exists as an "imagined community." The concept of being an islander is a concept based on a collective existence and location that people share, despite the fact that they will never all know one another. Vashon Islanders describe themselves as distinct, and it is this story of self-identification that creates the island's history. These stories unite a diverse, often contentious, collection of people around a vision of what they share as islanders. What aids this process of self-identification and gives it clearly defined boundaries is the island itself. Cut off from the mainland by the waters of Puget Sound, our island's shoreline both embraces and entraps, helping to shape our experiences as islanders.

The core story of Vashon Island starts with its eight sx̌ʷəbabš Native American villages linked to Puyallup River native communities. In the

nineteenth century, the island changed into a collection of separate settler communities linked only by water, gradually expanding over 150 years into a unified island community able to collectively oppose a ferry monopoly, a bridge and a massive strip mine. How this series of "imagined communities" arose, thrived and changed, and how our ever-shifting conceptions of Vashon Island developed, is the focus of *A Brief History of Vashon Island*.

ACKNOWLEDGEMENTS

The faculty members of Vashon College's "Vashon 101" course have given me insights and critical perspectives that have help focus and hone this work. Tom DeVries, Kevin Freeman, Alice Larson, Joe Meeker and Bianca Perla have all provided collegial support, and Glenda Pearson helped build an impressive bibliography. Ann Irish, Karen Dale, Craig Ellery and Benno Bonkowski provided invaluable comments and criticisms in our exchange of manuscripts and ideas. Chris Austin helped organize the photographs and captions. The volunteers at the Vashon-Maury Island Heritage Museum all helped me see the island through a variety of different perspectives. Cyrus Anderson, Mary Jo Barrentine, Steven Benowitz, Jessica DeWire, Jean Findlay, Reed Fitzpatrick, Chris Gaynor, Rayna Holtz, Mike Kirk, Miyoko Matsuda, Kathy Sider and Laurie Tucker have all provided inestimable help. Jim Sherman and Brian Brenno, who developed the Facebook site "Old Vashon Pictures and Stories," have provided access to many current and former islanders and their stories and photographs. Royce Wall has provided valuable assistance in building the website vashonhistory. com. Peter Rinearson's work on the history of Seattle has helped me see Vashon in a better context. Michael Monetelone and Peter Ray have been experienced colleagues as we have collected stories and oral histories of the island, and along with Rick Wallace and Susan McCabe, they have helped encourage my work on the Voice of Vashon *Then and Now* historical series. Leslie Brown, Natalie Martin and Annali Fogt, as editors of the *Vashon-Maury Island Beachcomber*, have been strong supporters of the ongoing "Time

ACKNOWLEDGEMENTS

& Again" series of historical articles. Megan Laddusaw and Ryan Finn, at The History Press, were patient and perceptive editors. This book also benefitted from the friendship and collaboration of photographer Terry Donnelly—his patient listening in long conversations as I developed ideas while aboard *Vashona*, his work co-producing the "Time & Again" series and his photographs that enhance this work all helped make this work stronger. Finally, this book would not have been possible without the loving support and ongoing faith in this project by my family and especially by my wife, Pamela Sue Haulman, to whom this work is dedicated.

INTRODUCTION

This book is an assessment of the island at the beginning of the twenty-first century and an interpretation of how the island came to be the community and landscape we find today. This history is very different from Oliver van Olinda's *History of Vashon-Maury Island*, first published in 1935, which western historian William Cronon characterized as an "antiquarian" history.[1] This book, as an interpretive history, seeks to tease out the important from the unimportant, searching for the deeper meanings in the island's past.

This history of Vashon is part of the larger history of the American westward movement. It is a history filled with success and failure, heroism and villainy, virtue and vice, nobility and shoddiness. It is a real human history rather than a mythic version of the past. It reflects the important roles of women, men, minorities and the land and its ecosystems. Vashon's history is a multicultural, cosmopolitan history that reflects the presence of a diverse population. It is a history of changes in the land and of how, as resources were used and often depleted, humans changed the land and, in return, were changed by the land they had transformed. This work attempts to create a useable past—not an idealized illusion of what the past has been.[2]

Vashon sits in the middle of Puget Sound between Seattle and Tacoma, in waters framed by the snowcapped peaks of the Cascades to the east, Mount Rainier in the southeast and the Olympics to the west. Its land mass—approximately thirty-four square miles, fourteen miles long and four miles wide—is roughly two-thirds the size of Manhattan Island, but with less than 1 percent of its population. With numerous coves, beaches and

bluffs, no place on the island is more than two miles from the water. The surrounding shore shifts from low sandy beaches to steep cobble, towering cliffs of Vashon till (the compressed detritus of the Vashon Glacier) and muddy deltas where island streams empty into Puget Sound. The highland plateaus that dominate the island are thinly soiled (originally covered with forest) and pocketed with a few marshes, bogs and ponds. More fertile lowlands are found on the Burton Peninsula, at Monument at the head of Quartermaster Harbor, in the large central Paradise Valley and in Cove/Colvos. This rich collection of shellfish beaches, evergreen forests and rich lowlands is what drew native people, and later early Euro-Asian-American settlers, to the island.

Humans came to Vashon in three distinct waves. The first waves of nomadic hunters arrived in about 11000 to 12500 BCE (Before Current Era), shortly after the Vashon Glacier retreated and exposed what today we call Vashon. This first wave probably did not settle on the island, but evidence of early tools and points found in middens and on beaches indicates their possible presence. These early nomadic hunters seemed to have peaked and subsided in the region by about 8000 BCE because of the loss of the native North American megafauna (e.g., mammoths, mastodons and ground sloths) they hunted. The second wave developed into the Coast Salish culture that thrived in the environs of the Salish Sea for millennia, including the sx̌ʷəbabš of Vashon. The third wave was the Euro-Asian-Americans who swept into the Puget Sound in the mid-1800s and brought settlers to Vashon in the 1860s. Each wave of human migration wrought changes in the island's flora, fauna, and natural environment. And as each wave of immigrants established itself, the people shaped the island as much as the island helped shape them.[3]

The history of Vashon has had few climactic moments and few heroes. This is not a history of individual accomplishments. Rather, it is a history of groups attempting to find their place in the world, to find a living, and in so doing profoundly and significantly changing the island and its resources. The Vashon Island we know at the beginning of the twenty-first century is the result of millennia of Native American habitation, followed more recently by 150 years of Euro-Asian-American impact on a landscape already altered by human intervention.[4]

Groups have not always grasped the consequences of their impact on the land that is Vashon. Each group found initial success but then confronted changes that alter their world, prodding the emergence of a new group armed with new strategies. The sx̌ʷəbabš lived close to the land and thrived

on the marine resources of the island for millennia, but that very lifestyle offered multiple points of entry to the diseases brought by the new European arrivals. Pioneer farmers achieved early successes in their domination of the island landscape but undermined their success with unsustainable farming practices. Loggers, brick makers and shipbuilders brought successful industries to the island, enterprises that later failed because of lack of capital or exhaustion of the natural resource on which the industry depended. In the last half of the twentieth century, Vashon's latest residents—urban tourists, suburban commuters, escapists and retirees—have come to the island seeking relief from urban sprawl to find a rural natural environment that conforms conveniently with their image of bucolic living. Patricia Limerick called this the "Daniel Boone Paradox"—by opening trails into the trans-Appalachian West to escape what he saw as overcrowding, Daniel Boone ironically provided directions and routes for settlers, who crowded him farther and farther west as they arrived. Those coming to Vashon at the beginning of the twenty-first century come seeking their own image of a rural lifestyle only to see it gradually destroyed by their own large numbers and new homes.[5]

This history of Vashon is organized into eight distinct sections to help the reader understand significant turning points in Vashon's history. Each section is defined by a set of circumstances and events that set the stage for the next section in the ongoing island saga. At each of these points, Vashon could have become something different, but because of certain decisions made—often subconsciously and often unknown at the time—a new course was set and the island became what we know today.

What will emerge in the future and how future historians will characterize Vashon is difficult to see from today's vantage point. But change will come to Vashon, and those alterations will funnel through the enduring patterns that have molded past change—just as the abundant rainfall of the island is channeled into its familiar gullies and streams. I feel sure that by the end of this century, Vashon will be as different to us as the island of today is different from the island of the 1880s or 1920s or 1960s. And yet, in the future, I am sure that Vashon will still possess a clear identity.

VASHON LANDSCAPES

Geology, Geography and Place

Islands are as much imagined as real, and live in the mind's eye with as much raw power as they live in the world of tides and wind.[1]

—*David Guterson*

Landscapes are what we call the relationship between the natural environment and human society. The landscape we call Vashon Island is both a physical reality of land and water and a social construct created by the people living here. These three elements—water, land and human imaginings—have shaped Vashon from the beginning.[2]

Vashon Island is a place defined by water. Water both frozen and liquid shaped the island, and water has set its boundaries. Water has also shaped Vashon's human activity—by its presence or absence, by its action on the ground beneath our feet and by its oft-dampening effect on the lives and moods of those who choose to live in its wet maritime climate.

Vashon Island is also a place defined by land that determines, by its topography, soils and niche ecosystem, what can exist here. The sx̌ʷəbabš native people who first inhabited the island depended on the land for sustenance and for materials for their houses and canoes. The "Big Four" extractive resources—farming, fishing, logging and mining—drove the island's early settler economy. And now the land provides a rural/suburban extension of the growing Pugetopolis.

Finally, Vashon Island is a place defined by the people who live here and by those who do not. Islanders have always held two opposing orientations:

one focuses inward toward the land and the resources that land provides, while the other focuses outward to the water, its rich marine resources and the world beyond the watery moat. This structure of opposed orientations typifies a strikingly constant island mindset: looking inward for self-definition yet also looking outward for validation that these definitions are indeed real.

And so Vashon's landscape becomes our reality through the images of it we have created, the physical realities of the land and the waters that run over, through and around it.

MAPPING THE ISLAND

The earliest imaging of Vashon came in the maps, charts and namesakes left by its earliest explorers, and such maps are still being made today. These images reveal as much about the mapmakers as the island they portray.

The very first known map of Vashon is Captain George Vancouver's chart of 1792 for the British Royal Navy. Visualizing the island as one entity, he captured the general outline of the island but distorted its shape by elongating and narrowing it and gave no details of the interior. Lieutenant Charles Wilkes and the American Exploring Expedition drew the next known map in 1842. The Wilkes map has more detail—it separates Vashon and Maury Islands and gives us soundings of the surrounding waters. But while more accurate than Vancouver's, it still leaves the interior as unknown space. The first mapping of the island's interior came with the 1857 U.S. government survey map drawn by William H. Carlton and T.H. Berry. The Carlton and Berry map allowed the island to be claimed by American settlers, and it provides the basis for today's property maps.

The 1905 chart of Vashon drawn by the U.S. Coast and Geodetic Survey is very accurate and became the basis for all future charts. The Metsker Map Company began producing property maps of the island in the early 1900s. They show patterns of landholding already emerging: the shoreline developed early in relatively small lots, while the inland areas of the island remained in larger agricultural or logging blocks.

The State of Washington did an aerial photographic survey of the entire state during each decade between 1937 and 1957, and in the late 1950s, the United States launched a series of photo satellites. Today, Google Map photographs give us an up-to-date, bird's-eye view of the island online. Together these images provide an amazingly accurate representation of the

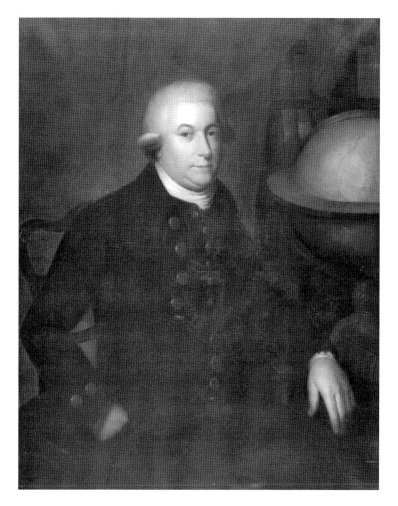

George Vancouver (1757–1798) commanded the *Discovery* on his expedition
to America's Northwest coast. He explored Puget Sound in 1792, naming
seventy-five landmarks for colleagues and friends. On May 28, 1792,
Vancouver named Vashon's Island for Captain James Vashon. *Borough Council
of Kings Lynn and West Norfolk.*

island. When these aerial images are viewed chronologically, you can easily
see dramatic changes in island land use over these eighty-plus years.

Geologic maps developed by the U.S. Geologic Service, the State of
Washington and the University of Washington help us to understand the
geologic structure of the island and the underlying fault structure that
periodically jolts the island. Derek Booth of the USGS and UW developed
the *Geologic Map of Vashon and Maury Islands, King County, Washington* in 1991.

Finally, a series of maps made by individuals and organizations reveals what they believe is important to know. Maps by Adkinson, Buerge, Fitzpatrick, Sohl and Speidel portray these individuals' unique perspectives, as do the maps created by the Vashon Business Association, the *Vashon-Maury Island Beachcomber*, the Vashon-Maury Island Chamber of Commerce and the Vashon-Maury Island Park District, as well as the Washington Automobile Club, the United States Department of the Interior and King County.

NAMING ISLAND PLACES

The power to name implies the power to control. The names we append to this island reveal more about the preconceptions we bring to it than the actualities of what the island is.

The island's first residents, the native sx̌ʷəbabš, had no single name for what we call Vashon, although they did give names to their village sites and to hunting and gathering sites. This lack of name for an entity Europeans saw so clearly as needing one perhaps reflects the sx̌ʷəbabš worldview: the island was "home" and needed no other name.[3]

For the Europeans of the Vancouver expedition, naming was how they took ownership for their country and honored themselves, compatriots or friends. When George Vancouver coined "Vashon's Island" in honor of his naval colleague, he did more than just name the island—the act of naming brought with it a set of European assumptions. Vancouver assumed that the land was not owned and thus needed both name and owner. He assumed that the new name would identify the island from that day forward. And he assumed that others, by accepting the name he gave, would also accept the island's ownership as British. Roughly fifty years later, Charles Wilkes and the American Exploring Expedition visited the same island and, perceiving not one island but two, named the as-yet-unnamed eastern landmass Maury Island after Lieutenant William Maury, the cartographer on the voyage.

As Euro-American settlers flowed into the Puget Sound region, particularly after the arrival of the railroad at Tacoma in 1887, places on the island were quickly named to reflect the predilections of the newcomers. Vermontville, Burton, Lisabeula, Reddings Beach, Chautauqua—the list goes on, each reflecting a past or a hoped-for future.

GEOLOGY

We construct our knowledge of the physical realities of Vashon Island through the sciences of geology, physical geography, meteorology, climatology and biology, all of which help us to understand the processes that shape and change the island.

The geologic history of Vashon as an island is a recent part in the long and complex history of the modern Puget Sound Basin. Over the past 100 million years, the land that was to become Puget Sound was created in a series of collisions between the North American Plate and various other plates that created the Cascades Mountains to the east and the Olympic Mountains to the west.

During the past 2 million years, the Cascades continued to expand in a series of volcanic events that formed the major volcanic peaks that define this range, and the Olympics to the west continued to uplift. Together, these two mountain ranges define the Puget Trough, which funneled the advancing ice sheet between them as the global climate cooled. During these 2 million years, numerous advances and retreats of ice took place, but it is the last, the Fraser Glaciation, that is of most interest to the history of Vashon Island.

The Vashon stade, or ice sheet lobe, of the Frasier Glacier developed about twenty thousand years ago, and in its slow movement southward from Canada, it sculpted the Puget Sound landmass. At its greatest extent, about fourteen thousand years ago, the Vashon lobe, named by Bailey Willis in 1898 after deposits he observed on Vashon, extended just south of Olympia. The ice was about three thousand feet thick over the island, and although this extension lasted only about one thousand years, its movement over the region shaped this bump we call Vashon Island.

As the glacier advanced, it left massive deposits of debris in the form of what Willis labeled Vashon Till, a heavily compressed layer of gravelly, silty sand with scattered cobbles and boulders. As the ice melted, several meltwater lakes formed and deposited sands known as the Esperance Sands. In other spots, the pressure of the ice compressed a layer of silts and organics into what's known as the Lawton Clays. The interplay of these three layers—Lawton Clay, Esperance Sand and Vashon Till—create many of the landslide, septic and groundwater problems we confront today. Landslides occur as the Esperance Sands become supersaturated with water and slide along the relatively impermeable Lawton Clay. Septic tanks fail and fields stay soaked as the relatively dense Vashon Till refuses to allow water to percolate through it. And as Vashon Till and Lawton Clay keep surface

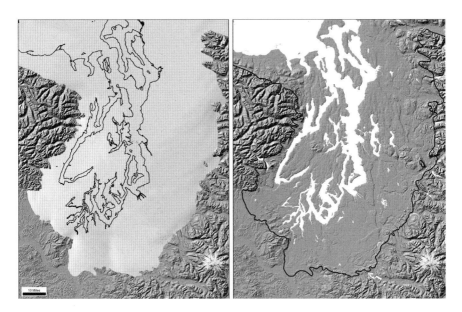

The most recent glaciation, sixteen thousand years ago, was the Puget Lobe of the Vashon Glacier, which created the Vashon Island we know today. *Harvey Greenberg.*

water from reaching deeper groundwater aquifers fast enough to keep up with our rate of withdrawal, the scarcity of water sometimes becomes a public issue.

Earthquakes rattle and shake the island regularly and are a part of life on Vashon. The slow subduction of the Juan de Fuca Plate under the North American Plate (about three centimeters per year) creates an area of seismic and volcanic activity, with Vashon at its center. Small earthquakes hit the region regularly but usually cause little damage. Major earthquakes (magnitude 6.5 or greater on the Richter Scale) rock the region every few decades, such as those in 1949, 1965 and 2001 that each caused significant damage on Vashon, although no lives were lost. Massive earthquakes of magnitude 8.0 to 9.0 or more occur in the Pacific Northwest, on average, every five hundred years, although this interval appears to be irregular, as short as one hundred years or as long as one thousand years. Evidence from the Washington coast suggests that a massive megathrust earthquake occurred about three hundred years ago, causing coastal subsidence by six to nine feet and significant flooding. The massive block landslide along the west shore of Outer Quartermaster Harbor where Lost Lake is found may be associated with this event. The region can expect another massive earthquake with substantial land movement and possible flooding in the

future. How this future earthquake will affect Vashon is difficult to project, but as the island continues to develop, and as more buildings are built in sensitive areas and close to steep slopes, the level of damage from a massive megathrust earthquake will likely be substantial.

WEATHER

In contrast, Vashon Island's climate has been relatively stable for the past four thousand years, allowing communities of plants and animals, both terrestrial and marine, to develop and flourish. This climate stability has also allowed humans to occupy the island and forge successful communities based on the resources that this stable, temperate marine climate provides.

While the climate has remained relatively stable, day-to-day weather on the island varies widely across its landmass, through the seasons and even hour to hour. Four factors dominate the climate and weather in Puget Sound: the Pacific Ocean pumps warm moist air into the region; the oscillating Aleutian Low and North Pacific High propel winds from the southwest in the winter and from the north in the summer; the Cascade and Olympic Mountains divert weather's passage, creating rain shadows and convergence zones; and the El Niño Southern Oscillation causes periodic irregularities in the general pattern. The result of all these is rain and lots of it. As island author Betty MacDonald proclaimed, "It rained and rained and rained and rained. It drizzled—misted—drooled—spat—poured—and just plain rained."[4]

While it does rain, and often, Vashon Island shares the Puget Sound's typical pattern of warm wet winters and cool dry summers. But if we examine what meteorologists call ultralocal weather, we will find that a same day's weather may be felt very differently depending on where on the island you are.

For instance, on a typical warm, dry summer day (the mean high temperature in July is 75.2°F), the prevailing north wind creates very different conditions in different parts of the island. North-facing beaches receive cool winds blowing directly off the water, which can make jackets and sweaters a necessity on hot summer days. At the same time, south-facing beaches sit comfortably in wind shadows and can have temperatures 10°F to 15°F warmer than a north-facing beach just a few miles away. The reverse is true in the cool, wet marine winter: typical weather systems coming from the southwest don't affect the north-facing, wind-shadowed parts of the island as hard as the south-facing areas. An exception is when winter high pressure

builds—the weather clears, and cold, frigid air from the Fraser Valley sweeps down the Sound to blast the north-facing parts of the island, while the south-facing areas remain wind shadowed and warmer.

The pattern of prevailing winds also helps set the island's rain pattern. The highest levels of precipitation are found on the northwest corner of Vashon Island and the lowest on the southeast corner of Maury Island. This pattern comes from the way the Olympic Mountains obstruct the winter's southwest, moisture-carrying winds, forcing rising air to condense and drop more rain (orographic precipitation) on the west side of the Sound, just as the Cascades force rising air to drop more rain to the east of the Sound. The northwest tip of Vashon just catches the edge of this precipitation line and thus has slightly more rain than the southeast tip of Maury Island.

Ultralocal winds are another phenomenon of island weather that distinguish different areas of the island. The Tacoma Convergence is a familiar wind pattern to those living on the southern end of the island. The summer north winds often never fill in completely, and while the island north of Dockton may experience light north winds, from Dockton south the water is flat and without a riffle of breeze. The opposite is often true for narrow Colvos Passage and for the channel between Burton Peninsula and Maury Island, where, when the rest of the island finds itself windless, these narrow passages channel the air and create local winds—much appreciated by sailors becalmed by the Tacoma Convergence.

Although Vashon Island may experience diverse ultralocal weather, and the island may be separated from the mainland, we are nonetheless connected to the region by the seasonal weather patterns that dominate our lives.

FLORA AND FAUNA

Because islands are limited in area and isolated from the mainland, they tend to have unique patterns of species distribution. Vashon, while following the general pattern of the Puget Sound region, does have its own patterns of species distribution and has developed distinct plant and animal communities.

As the climate has warmed and cooled over the millennia, the island's rich profusion of plants has changed dramatically. Although the record of plant life is difficult to reconstruct with any certainty, we do know that as the Vashon ice sheet covered and cooled the region, grasses, pine and spruce dominated—very similar to the glaciate areas found today in Alaska. As the

glacier began to retreat and temperatures warmed around 14000 BCE, the spruce thrived, pines did even more and alders first appeared—probably something like the modern cool, dry Alaskan tundra. Around 12000 BCE, the climate warmed to a cool and moist environment, and lodgepole pines, spruce and hemlock dominated the plant world. Around 10000 BCE, when the temperature was warmer and drier than today, grasses and spruce were in decline, pines and alders peaked and Douglas fir and western red cedar began to appear. By about 4000 BCE, the current climate was established, and the distribution of plants we know today was well established.

As plants appeared after the retreat of the Vashon ice, so did the animals that depended on the world of plants and the predator species that depended on the plant eaters. The fossil record is very thin and few have been found on Vashon, yet we can assume that animals migrated through ice-free corridors into the Puget Trough. In the early centuries after the glaciers retreated, Pleistocene megafauna—bison, caribou, woolly mammoth and mastodon—roamed throughout the Puget Trough. About 10000 BCE, these big mammals went through a rapid extinction phase—nearly 43 percent disappeared. The reason is not clear, and paleoecologists offer two competing explanations. One explanation, termed "coevolutionary disequilbrium," focuses on a climate change that disrupted these tightly co-evolved communities and led to mass extinctions. The second explanation, termed the "Pleistocene overkill," argues that newly arriving humans, with their big-game hunting skills and adaptability, decimated these animals as their own numbers increased. Either way, the Pleistocene megafauna of the post-glacial period disappeared very rapidly.[5]

There is little evidence in the fossil record of modern animals like deer, bears, squirrels, foxes, rodents and birds, yet we can assume that these species returned as the glacier retreated or else appeared in biological niches left open by the megafauna extinctions. We do know from archaeological digs in middens around Puget Sound and on Vashon that that these animals were utilized by the Coastal Salish, who established themselves in the area around 6000 BCE.

A similar pattern occurred with marine organisms. As the climate cooled, those species associated with southeastern Alaska flourished in Puget Sound. As the climate warmed and the ice retreated, a large meltwater lake called Lake Russell formed at the foot of the retreating glacier, allowing a variety of freshwater organism to flourish. As the ice sheet retreated north of the Straits of Juan de Fuca, salt water reached the Puget Trough and allowed the marine species we know today to colonize an emerging Puget Sound.

As modern conditions stabilized, a wide variety of marine plants, shelled mollusks and fish gradually established themselves, followed by the marine animals that feed on them.

Just as geologic and geographic forces shaped the physical nature of Vashon, so did these same forces help shape the humans who came to live here. With the ice sheet gone, sea levels stabilized and a temperate climate established, humans began to use and then inhabit the island: nomadic hunters, the Coast Salish sx̌ʷəbabš native people, Euro- and Asian-Americans and, most recently, a more diverse group of Americans. Each of these groups brought change to the island, and these changes are the focus of this history.

THE SX̌ʷƏBABŠ

First People of Vashon Island

Near the present town of Burton on Vashon Island, a woman went to a spring and dipped up water with a clam shell into her wooden bucket. Looking down into the water, she saw the face of a man wearing a war bonnet. She thought, "I must say something." She pretended to cough and pass wind, then said—
"tsikake'dtcid EX pohoab LOXedidId
I always pass wind, whatever I do."
The man up in the tree laughed. He was a scout for the enemy. The woman returned and told to the people in the house the story of what had happened out there. They said, "You must be encouraging a man (of our own)." They did not believe her. She said, "I am going." She left and took two children, a boy and a girl. The people of that place were all killed except the woman and the two children, who had gone far away. After a while the children grew up. There were no other people near. The woman said, "I pronounce you man and wife." They became the ancestors of a tribe of people. The name of that place is tcitcixa'l, *which means war bonnet.*[1]

T his ancient legend says a lot about Vashon Island and attitudes that have characterized islanders since humans first came to live here. The island is an exceptional place, both magical and earthy, a place of origin stories and the place where passing wind can save you. The people of this origin story are the sx̌ʷəbabš (pronounced "schwa ba sh," although there is not an exact English phonetic parallel), who settled on Vashon and were a predecessor band of the current Puyallup tribe. The sx̌ʷəbabš in the Txʷəlšucid or Twulushootseed

language of the Puyallup People are also known as the S'Homamish in the later Chinook Jargon trade language used in the Medicine Creek Treaty and as the Swiftwater People by early anthropologists. There is controversy whether the sx̌ʷəbabš/Swiftwater name applies to both the Vashon and Gig Harbor/Wollochet Bay groups, but for now, the Puyallup tribe prefers to use the name sx̌ʷəbabš for the native people of Vashon.

This story, told in their winter houses during the long rainy season, became one of the ways the sx̌ʷəbabš distinguished themselves from other Salish villages and recognized the special nature of the place they called home. When we compare this story with the stories we tell ourselves about the first white settlers, about strawberry crops and ferries, about fights over bridges or gravel mines, we get some idea of the distance that separates our own culture from the culture of the sx̌ʷəbabš. Yet at the core, these are all stories about who we are as islanders.[2]

HUMANS FIRST ARRIVE ON VASHON ISLAND

As the Cordilleran Ice Sheet that covered much of North America retreated about fourteen thousand years ago, humans began to move into North America. In the Puget Sound region, the first known human inhabitation came at about this same time. Paleoecologists argue that these hunters used their big-game hunting skills on the abundant mastodons, giant sloths and mammoths to generate a rapid increase in their human population but, at the same time, caused an overkill and extinction of those species.

The discovery of the Kennewick Man's remains along the Columbia River in eastern Washington supports the idea that nomadic hunters roamed through the Pacific Northwest as early as twelve thousand years ago, perhaps even earlier. Clovis points unearthed near East Wenatchee date back to 10000 to 12000 BCE, and the Mastodon Site at Sequim dates to about 8000 BCE. Vashon lies in a direct line between these two sites. Our first evidence of humans on the island comes from points and other stone artifacts dating somewhere from 6000 and 9000 BCE.[3]

The shift from nomadic hunters to the settled Coast Salish culture that pervaded Puget Sound when Europeans arrived is shrouded in mystery. The first nomadic hunters were either replaced by or evolved into a river-based Marpole culture (named after the Marpole archaeological site in the Fraser Valley of British Columbia). This Marpole culture was primarily a hunting

culture, located along the major rivers in the Puget Sound region but living in established villages. Changes evident in its artifacts—tools made with local stone, bone or antler—reveals its culture shifting, around 5,000 years ago, from hunting game to fishing and gathering. About 3,500 years ago, a Coast Salish culture emerged that focused more on marine resources; it grew to dominate the region by about 1,500 years ago. The archaeological record is disappointingly thin because of the perishable materials these cultures used and a series of sea level changes that shifted the coastline, but Wayne Suttles argued persuasively that the Coast Salish culture dates back at least 3,000 to 6,000 years.[4]

As this Coast Salish culture slowly emerged, the precursor bands of the current Puyallup tribe developed and called themselves the People of the Puyallup. They developed in different but related bands at the mouth of the Puyallup River, along the upper Puyallup River, at Gig Harbor and Wollochet Bay and on Vashon Island. These groups each clustered at a number of village sites that were closely linked by rituals and marriage. The sx̌ʷəbabš flourished on Vashon for thousands of years, with substantial village sites on the island. They used the marine resources of the island and also made significant modifications to the upland ecosystems.[5]

We don't know much about the sx̌ʷəbabš of Vashon. What is known is fragmentary and in a variety of sources. But we do know quite a bit about Coast Salish culture. By extrapolating from the general culture and adding what is in the record, we can create a sense of what life was like on the island before European contact.

THE SX̌ʷƏBABŠ OF VASHON ISLAND

The pre-contact native population of Vashon is unknown, but I estimate it to have been about 650. A number of censuses and contemporary reports help to create this estimate. A Hudson's Bay census in 1838–39 counted the population of the "Shone-mah-mish" at 315: 100 males, 89 females, 56 boys, 69 girls and 1 slave, with ten guns and twenty-eight canoes. This census was taken after the first waves of disease had swept through the Puget Sound and killed an estimated one-third to one-half of the native population. If the island's natives were decimated to the same degree, then one can extrapolate that before European contact, the island population could have been as high as 630. E.A. Staling, the Indian agent for Puget Sound, estimated in

his 1852 *Annual Report to the Commissioner of Indian Affairs* that the population on Vashon's Island stood at 40. George Gibbs, the Indian agent in 1854, estimated the population at 33. These estimates come after at least three more waves of diseases, with a similar one-third to one-half mortality rate for each wave, which puts the pre-disease population at about 640.

Another estimate, based on Richard White's technique, builds on an average family size of 6 to 8 persons and an average of five family compartments per house. Applying White's technique to the eight identified village sites on Vashon and nineteen or more houses of various sizes, we arrive at a population conservatively between 570 and 760. This figure fits nicely with the 630 figure based on the 1838–39 census of 315 and Taylor's estimate of a 50 percent disease mortality rate, as well as on Stalling's and Gibb's estimates after three more epidemics. Thus, I believe we can confidently estimate the pre-contact, pre-disease sx̌ʷəbabš population of Vashon at about 650 individuals.[6]

Sx̌ʷəbabš Villages on the Island

There were eight major permanent village sites and numerous temporary gathering sites on Vashon. The permanent villages were all located on the southern part of the island, and all but one were on Quartermaster Harbor: Burton, Quartermaster, Assembly Point, Shawnee, Kingsbury, Tahlequah, Manzanita and possibly Judd Creek. There were temporary gathering sites at Jensen Point, Newport, Ellisport and Peter Point.

Burton and Quartermaster seem to have been the two most substantial sites, and both are desirable given their southern exposure, their usable beaches, their freshwater springs and their easy access to the food resources on the harbor's beaches and on the island's plateau.

Thomas Talbot Waterman, an anthropologist at the University of Washington who mapped place names in the Puget Sound region around 1920, believed that the Burton village near what is today known as Governor's Row was "the principle settlement in ancient times." The sx̌ʷəbabš name *kʷilut* means "across; over there" and is possibly a reference to the myth about the attack of the Snakes that Ballard collected in the 1920s. The story goes that a sx̌ʷəbabš man, married to a Snake woman, killed one of the leaders of the Snake People and then fled back to Vashon to avoid punishment. In response, warriors of the Snake People came

"across, over there" to attack and destroy a sx̌ʷəbabš village in revenge. Lucy Gerand, a sx̌ʷəbabš woman born here in the 1840s, reported that there were six houses dug into the ground, each about forty by forty-five feet in size. This is the same site where Harlan Smith, the first archaeologist to dig on the island in 1899, found a shell midden a quarter of a mile long and three feet thick. All this evidence lends weight to the argument that this was Vashon's major village site.

The site at Quartermaster/Portage is more difficult to locate but was probably in between the foot of Monument Road and Portage (interestingly, it was also the site of one of the first farming settlements on the island). According to Lucy Gerand, this village was called stəx̌ʷugʷit and had seven houses—several large ones about forty-five by fifty feet and some smaller ones about thirty by thirty-five feet. She said that seven families lived at this site, and she associated this group with houses at Gig Harbor, so they may have lived at both places or been closely related. In 1899, Harlan Smith found middens that extended all "along the shore of the northern side of the bay." While there may have been house sites spread along the north side of Inner Harbor, it seems most likely that the primary house site was east of what is now Monument.[7]

The village site at Shawnee, at the mouth of Fisher (Shawnee) Creek, was called ʔalʔalʔal, which means "old houses." Also near ʔalʔalʔal was the spring known as "noble's water," possibly referring to residence of an important Salish family. Andrews, in *Fisher Creek Watershed Stories: As Told by Its Neighbors*, identified this site as A lal El ("old houses") and the spring as Siaoa-I-qo ("chief's water"). The general recognition of this site as "old houses" implies that this may have been one of the first permanent settlements on the island but was replaced as the primary village site by qʷuqʷuƛəc at Burton for unknown reasons.[8]

Four other significant villages were at Kingsbury, Tahlequah, Judd Creek and Manzanita, and an ancient pit house village was at Assembly Point. Bul'bulac at Kingsbury means "bubbling up" and refers to the spring and two houses at this location. Qʷuʔal at the southern tip of Vashon, probably at Tahlequah, had an unknown number of houses. Waterman gave the designation xwob-a'-bc ("swift water dweller") to those dwelling on the Narrows between Point Defiance and Vashon Island and thus to this Tahlequah site. Marjorie Stanley also identified this place and called it Squawpabsh, or "the place between." In 1937, a cairn burial site was unearthed at the site; there was a report of a ceremonial house at the site, and the village is in the oral history of the Puyallup tribe. The village at the south entrance to Judd Creek was called sdəgʷalat, which means "enclosed,"

referring to the innermost part of the Inner Harbor. This information comes from references in Arthur C. Ballard's work but seems credible. QebqebaXad was at the entrance to Quartermaster Harbor at Manzanita. According to Lucy Gerand, a two-hundred- by sixty-foot fort or large house was constructed there, along with four fifty- by thirty-five-foot houses hosting some five to seven families. Waterman identified this site as QebqEba-had, which means "sheltered at both ends," and Manzanita is indeed a flat area

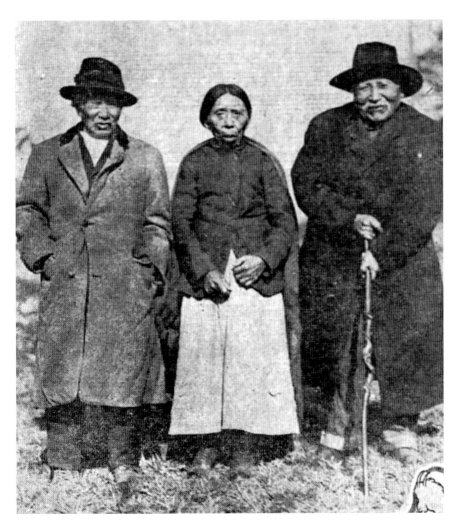

In 1927, a land claims tribunal heard testimony from Lucy Gerand (center), a sx̌ʷəbabš elder, about villages on the island. Lucy (1836–1929) was buried in Vashon Cemetery, but her grave remained unmarked until 2008, when a monument was finally erected. *Vashon-Maury Island Heritage Association.*

along the beach with high cliffs closing it off at both ends. David Beurge and Marian Smith also identified this site. Smith identified it as a "fortification built by a single man and populated by him through wives from neighboring groups." She believed him to be a "Skagit wanderer" who was in constant danger from the Duwamish in retaliation for some actions against them. When the founder became old, the village moved to Gig Harbor shortly before the Medicine Creek Treaty in 1854. The ancient village site at Assembly Point was called qʷuqʷuƛəc, which means "madrones" and consisted of pit houses that Lucy Gerand recalled seeing as a child.[9]

Other sites were at Jensen Point, Newport, Inner Harbor Burton, Dockton, Ellisport and Peter Point. The site at Jensen Point where Tom and Lucy Gerand lived was called qʷə qʷqʷs ("white promontory") because "it was littered with broken white shells." The Newport site, along the Inner Harbor north of Burton and south of Judd Creek, was apparently used for gathering and processing shellfish—Harlan Smith found substantial shell middens up to four feet high that contained many oysters and burned shells. Waterman identified this site as AchwE-tLos ("to face first one way, then the other"), suggesting its situation between two village sites. The Inner Harbor site at Burton, near where the marina is now located, was called Deqo-ya and was a feast site with a large potlatch house. Harlan Smith found its midden to be "slightly over 1.5 meters high…made up of about equal quantities of shell and soil, with a little ash." The sites at tbXhʷI (Dockton), dəxʷqʷuʔali (Ellisport) and kʷuʔti(I) (Peter Point) are less well documented and were probably gathering sites for shellfish and, in the case of Ellisport and Peter Point, also for cattails and reeds used in weaving mats.[10]

Sx̌ʷəbabš Lifeways: Balance and Beliefs

The estimated 650 sx̌ʷəbabš who permanently lived on Vashon had a well-defined lifestyle and had a significant impact on the ecosystem. In what is now Washington State, about two dozen languages were spoken at the time of European contact. The native people living on Vashon spoke what is now known as Txʷəlšucid or Twulushootseed, the language of the Puyallup People, a Salish language related to many others in the region. Like all North American native languages, Txʷəlšucid was not a written language until linguists began transcribing it into phonetic script. It is written with forty-one letters, including several representing sounds not found in English.

A BRIEF HISTORY OF VASHON-MAURY ISLAND

Txʷəlšucid is being documented by linguists and the Puyallup tribe. It continues to find voice on Vashon in the monument to native people at McMurray Middle School, which reads:

> gwe?eslaxedx cel ki ?aciltalbix tudi?a? ?al ti?a? swawtixted
> *(In honor of those who went before us, the Native People of Vashon-Maury Island)*

Traditional Ecological Knowledge (TEK) is the term that modern ecologists and native peoples use to denote cultural knowledge of the environment and traditional use of a region's abundant resources. The sx̌ʷəbabš on Vashon depended on the resources of Puget Sound: the sea with its abundant fish, mammal, bird and shellfish foods, plus ease of transport by canoe; and the land with its timber, fiber, fresh water and foods from plants and animals. Knowledge of how to use these resources was passed from generation to generation and was so deeply embedded within a culture that this knowledge came to define the culture. Traditional Ecological Knowledge was expressed in the daily life of the sx̌ʷəbabš people and of the entire Coast Salish culture.

Our modern sensibility leads us to see these First People living in harmony with their environment, achieving a self-sustaining balance perpetuated for thousands of years. Could Coast Salish culture have sustained itself indefinitely? We do know that this Coast Salish culture, here for three thousand to six thousand years, "had not decimated the forests, had not fished out the nearby waters." We also know that while this culture did affect the ecological systems of the region, natural events like volcanoes, post-glacial climate changes and natural fires caused much more ecological change than the First People ever did.

In the Puget Sound region, an ecological equilibrium developed between the sparsely populated shorelines and the abundant natural world around the people, a balance that lasted for millennia. There is no clearly defined environmental ethic in the ethnologies of the Coast Salish because, as Arthur Kruckeberg suggests, there was no need for such an ethic to be developed and articulated. The abundance of the ecosystem itself, and the light human footprint on it, made an environmental ethic unnecessary. For instance, there is evidence around Quartermaster Harbor of smaller shell middens that saw periodic use and abandonment, which would have given those shellfish beds time to regenerate. The cultural modification of the upland ecosystems to ensure harvestable berries and roots and to maintain open hunting areas did not overturn the ecological balance but instead only

modified it. In contrast, the ecological practices of the European loggers, farmers and fishers who replaced the Coast Salish destroyed that ecological balance, eventually replacing it with a new ecological system intended to be subservient to human needs.

Could the Salish cultural system have continued? We will never know. What interrupted this ecological equilibrium was the new cultural system that came with the Europeans—a cultural system based on exploiting natural resources and an emerging industrial technology. It changed the balance lived by the native people within a single century.[11]

THE SX̌ʷƏBABŠ YEAR: HUNTING, GATHERING, FARMING AND PROCESSING

The concept of tribes is largely a European construct, designed to ease dealings with aboriginal inhabitants and to fit European concepts of political organization. The reality was that the Coast Salish lived in "many autonomous but interrelated villages." Puget Sound Indians were a single yet exceptionally fragmented and diverse people. They shared a common Coast Salish culture, but "most Puget Sound villages had multiple affiliations, multiple loyalties, and multiple ways to identify themselves to other people." The reason for this was kinship. Puget Sound groups intermarried frequently, so most villages contained members from many other villages, which created a wide range of options for villages to exchange resources. The most important exchange was access to a variety of hunting, gathering and fishing sites that came with marriage. This flexibility and resource sharing "worked at cross purposes with U.S. Government efforts to sort them into a manageable number of tribes, assign them to a few reservations, and administer their affairs on a tribe-by-tribe basis."[12]

The daily life of the sx̌ʷəbabš was dominated by the weather and the need to gather food for the long, wet winter. Everyone did the work, but men and women had clearly defined roles and certain individuals had skills that were passed down through families. Since most houses contained extended family groups and most villages had strong kinship bonds, house groups and sometimes whole villages often worked together to gather, hunt, prepare and store food and goods. During the summer months, small groups would often go to a family or traditional hunting or gathering site and return well supplied. The usual routine was to leave the winter houses in early May to

collect shellfish, gather berries and hunt in June and July and then, in late August, begin fishing—perhaps the most important of these activities. The names given to the weather cycles hint at how the sx̌ʷəbabš spent their time during each part of the year and how each part of the year influenced their daily lives.[13]

Artifacts from the sites that Harlan Smith excavated in 1899 give insights into the daily life of the sx̌ʷəbabš. The most common items in the middens investigated by Smith were shells from clams, mussels, oysters and other shellfish. Interestingly, "in none of the shell-heaps on or near Quartermaster Harbor did we find any points or fish knives rubbed out of slate." A number of points and implements were uncovered in other sites. At Newport he discovered a "small point chipped from agate…which closely resembles the famous 'bird-points' from the Columbia Valley." West of Portage he found "several small scrapers…bone points, one barb, and one barbed harpoon-point [that] resemble points found in the Thompson River region and the Lower Fraser Valley." From other sites he collected "specimens showing chipping…characteristic of the materials used…in the Yakima Valley." One was argillite, which is found only on the northern British Columbia coast and the Queen Charlotte Islands. He also found a "fragment of the handle of a digging-stick made of antler," "a fragment of a hammer or pestle made of stone," "sixteen wedges made of elk-antler," "fifteen flat fragments of sandstone, thought to have been used as whetstones" and "three awls, and a stone war club." An interesting discovery was a "flat boat-shaped slate tablet…[which] seems to be foreign to the general type of artifacts of the Northwest coast…[I]t closely resembles the perforated slate tablets or gougets of the eastern United States, and…may have come from the east."[14]

These artifacts tell us a lot about how the sx̌ʷəbabš lived. Marine resources were the backbone of Salish culture, and many of the artifacts were used to dig or catch these marine resources. The antler wedges were commonly used to split planks from cedar logs for use in houses or for felling cedars to carve canoes. Other large trees were also felled on occasion for a variety of uses. The points were used for hunting birds, deer and other mammals. Scrapers were used to prepare skins for use, and awls were used to create holes in materials that were then sewn or attached with cords made from cedar bark or cedar withes. The discovery of artifacts made from materials originating in the Yakima Valley and the Queen Charlotte Islands indicate a fairly extensive trade network along the coast and into the interior. But perhaps Smith's most interesting discovery was the remains of food animals he uncovered along the north shore of the Inner Harbor. He unearthed

the "[b]ones of food animals, including those of Steller's sea-lion, the deer, birds, and fish, antlers, and a tooth of the killer whale." These discoveries help to support the contention that the sx̌ᵂəbabš used the complete resources of the island, not just those of the shoreline. They also show the wide range of food resources available to, and used by, the sx̌ᵂəbabš.[15]

Harvesting the Sea

The salmon, fish, shellfish and other creatures in the marine ecosystem were the most important food resources used by the sx̌ᵂəbabš. Salmon was the most important, but because Vashon only has salmon streams and no large rivers, the sx̌ᵂəbabš used other marine resources as well. Judd Creek and Fisher (Shawnee) Creek on Quartermaster Harbor both had substantial salmon runs, as did Ellis Creek and Shinglemill Creek. Nets, hooks, traps or weirs and spears caught salmon, and once caught, they were eaten or smoked for storage. The traditional method of cooking was to skewer the fish, spread it open with sticks and then stand it beside or sometimes over a fire. For smoking fish, small smokehouses were often built. Salmon eggs were sometimes used as bait on hooks to catch trout. Flounder (or skates), rock cod, true cod, smelt and herring were also important fish taken by the sx̌ᵂəbabš. Shellfish provided another staple of the sx̌ᵂəbabš diet: clams, oysters, mussels, barnacles and crab were all gathered and used.

Sea mammals were hunted, particularly seals and sea lions. Seal oil was sometimes used as a condiment. Sea mammals were hunted using long harpoons with removable points attached to ropes, which allowed the hunter to pursue the harpooned animal from within a canoe.[16]

In 1838, the sx̌ᵂəbabš on Vashon had twenty-eight canoes for a population of 190 adults and a total population of 315. This 7:1 ratio doesn't come close to equaling the 1.5 cars per person on the island in the early twenty-first century, but the canoe served the sx̌ᵂəbabš much the way the automobile serves us. For a culture very oriented toward the water, the cedar canoe provided useful access to Puget Sound's marine resources, as well as easy transport around the Sound, primarily to relations and to gathering sites on the Puyallup River, around Gig Harbor and the Hudson's Bay Company trading post at Nisqually House (later Fort Nisqually).

The sx̌ᵂəbabš, like other Salish cultures, used three types of canoes: the shallow shovel-nose canoe for the sheltered waters and streams of

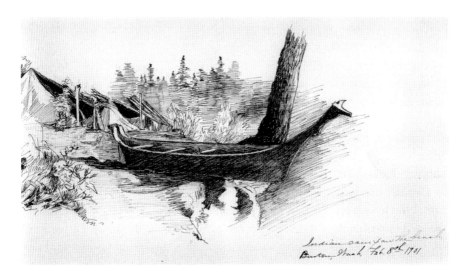

Tacoma artist Abby Williams Hill recorded this scene in her diary on January 23, 1901: "There are Indians camping down the beach. Three families. They have a large space enclosed with mats and sheets, and from it little tents for sleeping." *University of Puget Sound.*

Quartermaster Harbor, the seagoing Westcoast canoe for open travel on Puget Sound and the versatile Puget Sound canoe for general purposes. By far the most common canoe for the sx̌ʷəbabš was the Puget Sound canoe—twelve to thirty feet in length, relatively narrow with a rounded bottom and both bow and stern projections, an evenly curved shear, a conspicuous broad band along the gunwales and a fine entry and run. It was an easily driven and smoothly tracking craft, lighter in weight than the Westcoast canoe and much more seaworthy than the shovel-nose canoe.

These canoes were carved from cedar logs that were tapered at the ends, shaped and then hollowed. The hollowing process used plugs to determine the proper thickness of the hull as the interior wood was removed. The exterior of the canoe was usually completed before the hollowing process, and then the interior wood was removed with chisel, adze, and wedges. Songs and rituals to ensure a successful canoe accompanied each step of this process. After carving was done, the most dramatic and problematic part of the process occurred: the spreading of the final form. The canoe was filled with a few inches of water and lined with mats, and then heated rocks were dropped in to create steam. The steam saturated the sides of the canoe so they became flexible enough to open to a desired width, creating the gently curving shear and graceful flaring sides of an elegant canoe.[17]

HARVESTING THE LAND

The sx̌ʷəbabš also used a variety of animals and birds for food. Deer were probably the most important of the meat animals used by the sx̌ʷəbabš, but beavers, groundhogs and the occasional bear supplemented their diet. The native Puget Sound elk was hunted on Vashon, and wedges of elk bone were prominent in the middens. Birds were an important resource both for meat and for eggs. Nets hung between trees or long poles were often used to capture ducks; Van Olinda, Waterman and Gerand all describe duck hunting at Portage using this type net. One of the names for Portage is Sdou-gwa-luth, "the trap is full," which designates the isthmus as an important hunting place. The sx̌ʷəbabš also used arrows to hunt birds, as the Jusup Expedition's finds of "bird points" suggest. Eagles, gulls and hawks were not eaten.[18]

The sx̌ʷəbabš also used the island's upland area for hunting, gathering, the pasturing of horses and food gardens. The best evidence of sx̌ʷəbabš cultivation of the island's upland areas comes from the Carlton and Berry 1857 survey. Because of their detailed records, "we are able to know what Vashon was like in considerable detail before it was settled by the pioneers and before logging and farming transformed the landscape." The island was heavily forested as we would expect, yet there was evidence of massive burning, with more than half of the sections on Vashon showing evidence of large fires. Although many were undoubtedly set naturally by lightning strikes, others were probably set by the sx̌ʷəbabš to keep the understory down and let sunlight reach the plants they used for food. This form of land husbandry would not be one that Europeans would recognize as farming, but indeed it *was* farming: these upland areas were food gardens cultivated by the sx̌ʷəbabš, no matter how unrecognizable they were to whites.

The sx̌ʷəbabš did alter their home landscape, but in a way that did not overturn its ecological balance. When the food plants that dominated the understory of the upland areas are identified, it seems clear that these plants did not become a major food source because they dominated the upland areas, but rather they became dominant because the sx̌ʷəbabš created good conditions for them. Carlton and Berry found that the most common plants were "salal, huckleberry, and briers, probably blackberries." These were important food sources for Native Americans throughout the Puget Sound region, and "they were probably also important for the sx̌ʷəbabš."[19]

Other food plants identified by Carlton and Berry included sword fern, bracken fern, hazelnuts, nettles and skunk cabbage. These plants provided greens and much-needed carbohydrates for a diet that was rich in protein but

short on carbohydrates. The young fiddle heads of the sword fern provided greens for the sx̌ʷəbabš in early spring, and the bracken root—its rhizome roasted, ground into flour and baked into a bread—was one of their most important sources of carbohydrates. In addition, the presence of Garry oaks on the Burton Peninsula—the oldest about 350 to 400 years old—suggests that they cultivated acorns as a foodstuff; Garry oaks, which are native to the prairies south of Puget Sound, are found only north of that range, where they were planted by Indians as a food source. It is possible that this tree came here through natural dispersion, but more likely it was planted and cultivated by the sx̌ʷəbabš to be handily near their main village. The acorns could easily be collected, soaked to remove the bitter tannins, ground and used as flour. Additional food plants used by the sx̌ʷəbabš, although not identified by Carlton and Berry, were root plants like the camas, the tiger lily, the cattail and several wild potatoes, such as the wappato and the small SxaasEm.[20]

Vashon indeed was no virgin landscape but rather a "landscape that displayed marks of considerable human activity and long human residence." Carlton and Berry found patches of open land that they identified as swales—large grassy areas, perhaps created through intentional burning, that were used for "gardens" or hunting areas. Keeping such areas open took repeated and controlled burning to keep out unwanted plants and let grasses establish and dominate. Carlton and Berry identified two swales in Cedarhurst running north–south, two small grassy swales and one large ten-acre swale near the present-day airport and a fifty-acre swale west of the high school in the upper reaches of Paradise Valley.[21]

In 1824, John Work, a clerk with the North West Company who accompanied James McMillan's exploration of the route between the Columbia and the Fraser Rivers, noted "signs that Indians were pasturing horses on Vashon." The idea of the sx̌ʷəbabš using horses has never been considered before, but their use does make sense: transporting foodstuffs from the interior of the island to villages would have been much easier with horses, and the sx̌ʷəbabš certainly would have seen horses used by groups with close ties with the horse culture of the Yakimas. Getting horses to the island presents a difficulty but not an insurmountable one; well-documented sightings of deer and other animals swimming the half-mile that separates the island from the mainland suggests that swimming horses across could have been done. And the open swales could easily have served as pasture, as well as gardens and hunting parks.[22]

HOUSING

The houses that stretched from Magnolia to the Burton Peninsula, and from Judd Creek to Portage, each formed a single winter village group of related families on the Outer and Inner Harbor. Lucy Gerand's family lineage provides evidence for this. The sx̌ʷəbabš were typical of Puget Sound Indians in that they intermarried with Indians from all over the Sound. Lucy married Tom Gerand, who lived on Quartermaster Harbor near Burton. Her father, SilE'q3ub, was from Victoria, and her mother, SdElu''lista, was from the Black River near modern Renton/Tukwilla. Lucy's grandfather is identified as Ts3E'bulukud, the headman at Quartermaster Harbor, and her grandmother SxEbtso1'tsa was from Protection Island. Since Lucy was born before the Medicine Creek Treaty and the subsequent internment of Puget Sound Indians and dispersal to reservations, Lucy's heritage from a number of Puget Sound groups was probably fairly typical of pre-contact native people. Lucy's family lineage suggests a pattern of intermarriage that could bring advantages, the primary of which was gaining access to inherited gathering rights. For the sx̌ʷəbabš, access to fishing rights on the major salmon rivers, with their larger runs, was a primary concern, given the island's lack of rivers. Thus, if the salmon runs on Vashon were delayed or smaller than usual, strong family ties to villages at Puyallup and Gig Harbor, as well as to other villages around the sound, ensured access to the region's primary protein source, salmon.[23]

The Salish "shed type" houses, or longhouses, were an ideal adaptation to the needs of the Puget Sound Salish. Houses were constructed using vertical poles supporting the walls, topped by horizontal poles and lashed in place with cedar withe ropes that could support roof beams. The front wall was typically ten to eighteen feet high and forty feet long, with a roof that gently sloped to the eight- to ten-foot-high rear wall. The walls were covered with cedar boards made by splitting cedar with elk horn wedges. Cedar boards were laid across the roof beams and weighed down by stones. Openings in the roof corresponded with fire pits in the floor below. Inside, the large house was divided into partitions for each of the five to six interrelated families who lived there. Each interior had a bed platform surrounding a central dirt floor with its fire pit. Mats made from cattails or other grasses were hung on the walls to insulate and deflect drafts.[24]

Usually built near the water in a single row parallel to the shore, these houses performed a variety of functions for the Salish residents. The longhouse was not merely a dwelling; it was a food processing and storage

plant, workshop, recreation center, temple, theater and fortress. As Wayne Suttles concluded, the shed roof house was the "product of evolution, on the coast, from some proto-typical Northwest Coast plank house…[to serve] the social, economic, and ceremonial purposes [of Coast Salish culture]."[25]

These substantial winter houses were supplemented by temporary summer houses with a frame of poles tied together and covered with mats. These mats and poles, easily transported by canoe, were used year after year. The fire was outside the house, and a loose mat served as a door.

Both these house styles—the permanent winter plank house and the temporary summer mat house, could be easily dismantled and moved. They served the needs of the sx̌ʷəbabš and worked well in the temperate maritime climate of the Puget Sound.

CONCLUSION

The sx̌ʷəbabš established some of the enduring patterns that have characterized Vashon throughout its history. The sx̌ʷəbabš saw themselves as an exceptional people, distinct from other Puyallup groups and yet tied to the other Puyallups and other groups throughout the Puget Sound Basin by a complex web of marriages, affiliations, rituals, shared resources and mutual defense—just as today's island residents see themselves as distinct yet are tied to families, jobs, organizations, shopping and entertainment in the surrounding Pugetopolis. The sx̌ʷəbabš also clearly defined themselves as "the people" of Vashon, and newcomers, although often welcomed, were long seen as new—just as today's islanders take pride in being islanders and while welcoming newcomers also are often slow to warm to and fully accept new residents. Changing weather cycles over the millenia the sx̌ʷəbabš lived on Vashon made them familiar with boom and bust cycles, a pattern that continues to be felt by islanders to this day. And like islanders after them, the sx̌ʷəbabš were dependent on resources off the island for their well-being if not outright survival, with access to hunting, fishing and gathering places off island a significant part of their yearly cycle. Off-islander groups also used the resources of the island and, in so doing, established another island pattern: Vashon as a place whose resources could be exploited for off-island use.

At the end of the eighteenth century, sx̌ʷəbabš culture was at its peak, existing in an ecological equilibrium with the resources available that allowed

them, for millennia, to be a successful, thriving people. This was all about to change. In 1792, George Vancouver sailed into Puget Sound and named Vashon's Island, and a new era began for the sx̌ʷəbabš. In less than one hundred years, a third wave of human migration pushed the sx̌ʷəbabš from Vashon, disrupted their culture and dispersed individuals near and far. By 1890, a new and thriving Euro-American culture had established itself on the island, happy to settle in with little mind or regard for the sx̌ʷəbabš who had preceded them. But the sx̌ʷəbabš did not disappear.

CONTACT AND DISPERSAL

1792–1893

As always in history actions had consequences the actors did not contemplate.[1]
—Alexandra Harmon

CONTACT

The Coast Salish concept of "capsizing" (sp'alac') described the change that replaced the ancient world, where humans and animals existed in interchangeable forms, with the natural world the Salish lived in day to day. For a canoe culture, the concept of capsizing represents a fundamental loss of stability.

In 1792, the world of the Puget Sound Salish, and of the sx̌ʷəbabš of Vashon Island, would be capsized and changed forever. First contact with Europeans was made that year when George Vancouver sailed into Puget Sound seeking the Northwest Passage. But long before Vancouver sailed into the Sound, the Coast Salish were aware of the newcomers. Trade goods from earlier contacts on the coast had certainly made their way into Puget Sound, as had stories about the Europeans. Through their close connections between the upper river groups in the Puget Sound and groups east of the Cascades, the Salish would also have heard stories about the overland contact well east of them. Furthermore, the European diseases had already found their way to the region—Archibald Menzies, traveling with Vancouver in 1792, noted evidence of smallpox among the Puget Sound natives.[2]

DISEASE

As Richard White noted, "Disease forms a gloomy…backdrop for all early contact between the races." On Puget Sound between 1780 and 1840, the population declined an estimated 50 percent as people succumbed to European diseases. The sx̌ʷəbabš on Vashon were not isolated from the waves of disease that affected the entire region.[3]

The list of epidemics that swept through the Puget Sound is long and painful. The first major wave of disease began on the Columbia River with a smallpox outbreak in the early 1770s. Menzies's evidence of smallpox infection on Puget Sound in 1792 was probably the result of this outbreak spreading to Puget Sound. The list of epidemics that struck Puget Sound during this era is astonishing: 1810, smallpox; 1824–25, smallpox; 1830, "intermittent fever" (either influenza or malaria); 1836, smallpox; 1837–38, influenza; 1843, measles; 1848, measles; 1853, smallpox; 1862, smallpox; and 1888, whooping cough and measles. Each of these waves of disease brought death with it.

Underlying the ravages of these epidemics was the silent and generally unmentioned epidemic of venereal disease. Because nineteenth-century sensibilities barred open discussion of venereal disease, the incident rate is not clear, but "[b]y the 1850s venereal diseases were the prime killers of Indians." The silent and slow development of these diseases until their last stages made them even more difficult to identify and associate with any particular encounter. As Richard White concluded, "Perhaps the most significant effect of the new diseases was that it seems to have imbued the Puget Sound Indians with the peculiar fatalism that colored much of their future dealings with the whites. They came to consider themselves a dying people even before they were a conquered people." The social structure was badly shattered, and the loss of skills and knowledge significantly reduced the ability and capability of the survivors to meet the challenge of the invasion of Euro-Americans.[4]

The very things that made sx̌ʷəbabš culture successful on Vashon were the things that made European diseases so successful spreading through native populations. The houses, the mobility provided by canoes, the daily routine as the seasons changed, the way food was collected and stored, the social organization of villages and their shaman's healing practices all worked to increase the severity of these waves of epidemics. The large cedar houses became death traps; the common shared interiors became the breeding grounds and transmission sites for a host of diseases. As the people moved among their hunting, gathering and fishing sites, the mobility and intimacy

of canoe transport provided easy means for diseases to travel from spot to spot and transmit through contact. Food became infected from baskets made of fibers wetted in diseased mouths. The proximity of houses within a village, and the communal living arrangements of multigenerational houses, provided optimum conditions for the spread of diseases. The shaman's inability to combat the diseases with traditional uses of power increased the cultural collapse that followed the waves of epidemics. The lifeway and cultural practices of the sx̌ʷəbabš, developed over generations and admirably adapted to their environment, were well suited to the spread of European diseases for which the sx̌ʷəbabš had no protection.[5]

FIRST CONTACT: THE BRITISH

George Vancouver sailed the *Discovery* into Puget Sound in 1792 and initiated first contact with the sx̌ʷəbabš people of Vashon. On May 28, 1792, he named Vashon's Island, "the most extensive island we had yet met with," after his friend and former commander Captain (later Admiral) James Vashon. What Vancouver's expedition saw was a "wilderness only because they defined it that way."[6]

However, after Vancouver's initial exploration and mapping of Puget Sound, little European contact was made with the sx̌ʷəbabš until the early part of the nineteenth century, although European trade goods certainly spread through Puget Sound. The Hudson's Bay Company's exploring expedition in 1828 had contact with the sx̌ʷəbabš, as noted in John Work's journal. The company, unlike American fur traders, traditionally developed trade relationships by working closely with native groups, attempting to accommodate their cultures as much as possible. Company officials and Indians developed trade relations by a mutual process of trial and error that helped define each group to the other and that led to mutually beneficial results. The sx̌ʷəbabš from Vashon participated in this process, trading with the company's post at Nisqually. When the Hudson's Bay Company established Nisqually House (later Fort Nisqually) in 1833, Frederick Tolmie, chief factor at Nisqually, noted that "people streamed in from all corners of the region. On many days the waterfront bustled with activity so benign that [he] compared it to a county fair." Vashon was also a convenient stopping place between Fort Langley and Fort Nisqually, and Portage and Point Richardson were well-used stopping places.[7]

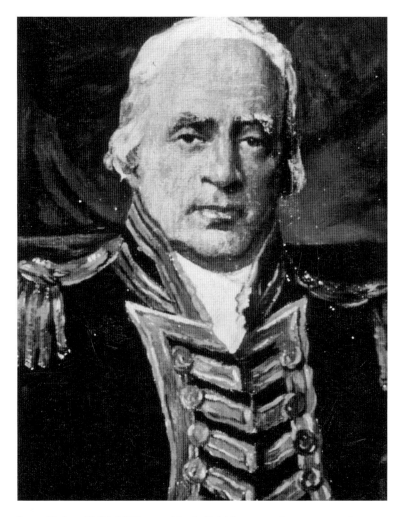

James Vashon (1742–1827) served in the British navy and was promoted to admiral in 1821. In retirement, he lived in his native Shropshire, where he died at age eighty-five and was buried in the village of Ludlow. Vashon never saw the island that bears his name. *Vashon-Maury Island Heritage Association.*

When Nisqually House set up trading, it altered the sx̌ʷəbabš relationship with the natural world by placing a commercial value on fur. The new commercial relationships merged with the Salish's existing trading patterns. However, the trade in beaver and otter pelts was never particularly significant in the Puget Sound, and little evidence of beaver or otter remains have been found in the middens on Vashon. Only about one thousand hides were traded at Nisqually House in 1836, and when

the trading station shifted its focus to agriculture, the fur trade in Puget Sound virtually disappeared.

Richard White's concept of the "middle ground," that place between two cultures where a new set of cultural definitions developed in a mutualistic way, best characterizes this period of relations between whites and natives:

> *On the middle ground, diverse peoples adjust their differences through what amount to a process of creative, and often expedient, misunderstandings. People try to persuade others who are different from themselves by appealing to what they perceive to be the values and practices of these others. They often misinterpret and distort both the values and practices of those they deal with, but from those misunderstandings arise new meanings and through them new practices—the shared meanings and practices of the middle ground.*

Both sides had incentives to make the relationship work, and neither side felt confident enough to try to dominate the other. Alexandra Harmon characterized this as a "symbiotic relationship" that worked to the mutual benefit of both. There were, however, significant differences in the way Euro-Americans and Indians approached trade. Nineteenth-century European capitalists tended to think of trade as an exchange of equivalents, and they entered into relations with the Indians with this paradigm upmost in their minds.[8]

For Puget Sound Indians, trade "both created and symbolized immediate social relations. Although acquiring valued items was one object of trade, the items acquired were proof of, and the means to, personal relationships, and relationships were the true indication of a person's worth." For Coast Salish culture, prestige did not come from the "accumulation and possession of property, but from the demonstrated ability to acquire prized items and from ritual redistribution of the items." For instance, the potlatch in which goods were given away as a sign of the giver's wealth was an important cultural ritual for maintaining the hierarchical social structure but was at odds with the Euro-American concept of trade. By seeing animals and other resources as objects to be defined by monetary values, Europeans breached the cultural traditions and sacred concepts that defined Coast Salish culture and set the stage for the next series of blows.[9]

SECOND CONTACT: THE AMERICANS

The period of mutualistic and peaceful trade ended when the Americans took control of the Puget Sound. The whole American mindset was different from that of the British. For Americans, the point of holding Puget Sound was not to trade with the local Indians but rather to displace them with American settlers who would transform the land. During the 1840s, America was gripped by an expansionist doctrine, often termed Manifest Destiny, that preached American dominance of the continent from "sea to shining sea," promising the benefits of civilization to the "savage West." The different approach taken by Americans marked the end of Coast Salish culture as it had existed for millennia, subjugating it until the 1970s Indian rights movement reinvigorated Salish culture in the region. During the decade of the 1850s, the Puget Sound Salish, among them the sx̌ʷəbabš of Vashon, had to abandon the "middle ground" they had occupied under the Hudson's Bay Company and make "stark choices between assimilation and otherness."[10]

In 1841, Lieutenant Charles Wilkes and the United States Exploring Expedition sailed into Puget Sound and initiated the second era of Euro-American contact with the sx̌ʷəbabš of Vashon. The Independence Day celebration at Fort Nisqually that year, attended by Wilkes and his expedition decked out in their finest and firing volleys of cannons, is representative of the new attitude Americans brought to the Sound. In his oration to the gathered whites and Indians, Dr. John Richmond, a Protestant missionary, declared, "The time will come…when these hills and valleys will have become peopled by our free and enterprising countrymen." How well the Indian listeners understood this is not clear, but throughout the years of conflict that followed, Puget Sound Indians continued to "declare the land was theirs." The "myth-quoted" words of Chief Seattle about the Indians as a dying race being replaced by whites fit well into the Americans' view of the world and their place in it. Unfortunately, the words attributed to Seattle had little relationship to the realities of the Salish's view of the world and their place in it.[11]

Wilkes, from a patrician New York family, was a slight man with brown hair, a ruddy complexion and an "abrupt manner" created by his intense, hyperactive nature. Forty years old and a renowned surveyor but having had limited sea duty (although he had cruised the Mediterranean and Pacific), Wilkes was the center of controversy for the expedition from the very beginning. With a reputation for "punish first and enquire afterwards,"

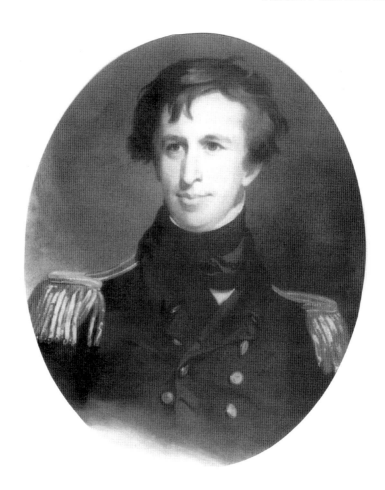

In 1841, Charles Wilkes and the United States Exploring Expedition established American claim to the territory and named the major points on Vashon for his quartermasters Beals, Heyer, Robinson, Piner, Neill, Dalco and Sandford; Wilkes named the major harbor Quartermaster for them all. He named Colvos Passage for midshipman Colvocoresses. *U.S. Naval Academy Museum.*

his manner typified the new American era in the Puget Sound and for Americans' early relations with the sx̌ʷəbabš.[12]

Wilkes's chief contribution to Vashon was to name the major points of the island after his quartermasters—Beals, Heyer, Robinson, Piner, Neill and Sandford—and dub the harbor in the island's center after them all. He also charted the sound, drew the most accurate and complete map up to that time and recognized Maury as a separate island, naming it after Lieutenant William Maury, the expedition's astronomer and hydrographer. (Maury's

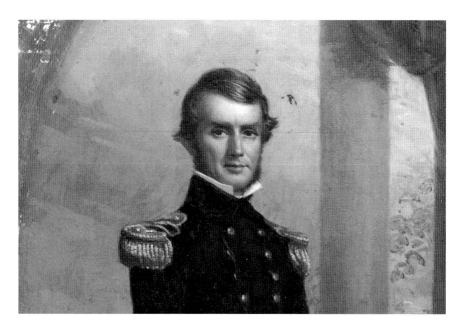

Maury Island was recognized as a separate island by Wilkes, who named it after Lieutenant William Maury, the expedition's astronomer. A Virginian, Maury was commissioned in the Confederate States navy when the Civil War began and commanded the raider *Georgia* and the ironclad *South Carolina* during the war. *U.S. Naval Academy Museum.*

U.S. naval career ended with the Civil War, when he resigned his U.S. commission and joined the Confederate navy, where he rose to command of the Confederate raider CSS *Georgia*.) In addition, the Wilkes Expedition provided excellent descriptions of the island, noting that it was "composed of rough masses of rocks, and is well covered with timber." Joseph Perry Sandford, for whom Point Sandford is named, noted that "[m]any deer were seen on this Isle likewise a large black bear."[13]

Lieutenant Colvocoresses, whose name was shortened to Colvos by his companions and after whom Colvos Passage is named, saw rather more here than timber one fine spring evening, penning perhaps the earliest example of someone waxing poetic on the island's beauties. He described the evening of May 10, 1841, when the expedition anchored at the South End of Vashon: "At sunset we came to under the western shore to wait for daylight. It was a rich treat to behold the sublime prospect around us through all its transitions of sunshine, purple hues, mellow twilight, and every shade, until there was nothing else to see but the dark loom of Mts Rainer and Olympus, uplifting themselves against the clear and starry skies of this region."[14]

George T. Sinclair, one of the acting masters in the expedition and after whom Sinclair Inlet in South Puget Sound was named, noted the expedition's contact with the sx̌ʷəbabš. He wrote in his journal that "[t]here is a deep indentation in the south Pt of Vashon but the whole is filled up by a mud flat & I presume a small stream comes in there. There is much shoal water off the SW Pt of this Island & several Rocks above water off the SE Pt where there is a stockade & several of the winter residences of the Natives which are built of timbers…. There were more natives here than I have seen any where else on the coast. They…appeared very friendly. They were very anxious that I should land."[15]

In June 1846, the United States, following a negotiated settlement with Great Britain, assumed control of land north of the Columbia River to the 48th parallel. Initially, not much changed in the Puget Sound region. Early American settlers still depended on the Hudson's Bay Company for goods, and there were relatively few Americans—fewer than ten families. A measles epidemic in 1848 led Indians to become suspicious of white doctors, who seemed able to cure whites but not Indians. A similar suspicion at the Waiilatpu Mission in southeast Washington Territory led to what has been called the Whitman Incident. The killing of the Whitmans and the subsequent Cayuse War; the Donation Land Act (1850), the precursor to the Homestead Act and which encouraged the migration of Americans to the Puget Sound; and the appointment of Isaac Stevens as governor for the Washington Territory meant that a new phase in Indian-white relations was about to begin.[16]

Treaty, War and Internment

As Americans began to arrive in the Puget Sound in larger numbers, tensions between whites and natives increased. Yet it is important to remember that both groups remained deeply divided over how best to move into the future. Counter to the Manifest Destiny vision of settlers and pioneers as self-reliant individuals, there's plenty of evidence that many American settlers around Puget Sound desperately wanted the government to help them. They wanted the government to assume responsibility for relations with the Indians, and they wanted the government to compensate Indians for the land the settlers occupied. This should not be surprising, given the mutuality that defined relationships between Indians and whites during the early stages of this era

of second contact. Whites needed Indians for food and transportation and as guides; and Indians sought the trade goods whites provided.[17]

Into this complex set of new relationships stepped Isaac Stevens, who brought with him a set of attitudes about Indians and an agenda to raise his political capital by quickly concluding treaties with the territory's Indians. Stevens was a veteran of the Mexican-American War who had graduated first in his class at West Point; he combined the roles of governor, Indian agent and chief of the railroad survey when he arrived in Washington Territory. Stevens's attitude toward the Indians is represented by his chief Indian agent, E.A. Starling (and interestingly, echoed nearly one hundred years later by Van Olinda in his history of Vashon): "They are excessively indolent and selfish, having no gratitude or affection beyond themselves.… They are thievish and will steal nearly anything." Stevens quickly set up a series of meetings with the Puget Sound Indians and later with the eastern Washington Indians. His meeting with the sx̌ʷəbabš from Vashon took place as part of the Medicine Creek meetings in December 1854. Lucy Gerand, who was then about twelve years old, vividly recalled the meeting for her 1927 deposition, remembering that the Indians thought "the Government was giving them free gifts of some goods…[but] they didn't understand it was for land."[18]

The treaty concluded at the Medicine Creek meeting defined Vashon, and thus the sx̌ʷəbabš, as part of the Medicine Creek Indians. The territory covered by the treaty ran from Three Tree Point on the mainland east of Ellisport to the Cascade summit and then circled south and westerly through Centralia, turning north at the Satsop river and running to Point Southworth. "Thence around the foot of Vashon's Island, easterly and southeasterly, to the place of beginning."

The Medicine Creek Treaty was a deeply flawed document, and these flaws profoundly affected the sx̌ʷəbabš as well as the rest of the Medicine Creek Indians. The treaty listed ten "tribes" that included the sx̌ʷəbabš, the rest of the Puyallup groups, the Nisqually groups and the Squaxon groups. What the treaty defined as "tribes" is an American/European construct that does not really reflect the complex set of autonomous, interrelated groups that lived in separate villages. This designation of "tribes" really indicates Stevens's inability to understand the nature of the village structure and his failure, like other whites, to perceive the real differences between the prairie, river and saltwater Indians.[19]

From the Americans' perspective, the Medicine Creek Treaty was a progressive treaty, modeled on the treaties recently concluded with the

Omaha, Otto and Missouri tribes. The treaty created reservations and guaranteed the Indians the right to graze horses. In words that would return 120 years later in the Boldt Decision, the treaty declared that "[t]he right of taking fish, at all usual and accustomed grounds and stations, is further secured to said Indians in common with all citizens of the Territory, and of erecting temporary houses for the purpose of curing, together with the privilege of hunting, gathering roots and berries." In addition, Indians were given twenty years of payments, ranging from $3,200 in the first year to $1,000 in the last year, for a total of $32,500. Finally, Indians were promised an "agricultural and industrial school" and "a physician." In return the Indians "hereby cede, relinquish and convey to the United States, all their right, title, and interest in, and to the lands and country occupied by them." Additionally, the Indians acknowledged dependence on the U.S. government, agreed not to be hostile and agreed "not to trade at Vancouver's Island, or elsewhere outside the dominions of the United States."[20]

From the Indians' perspective, the Medicine Creek Treaty took their land and culture away from them. And almost immediately, the treaty was in trouble. Problems stemmed primarily from the use of Chinook Jargon (a vocabulary of some five hundred words) to negotiate a set of very complex issues. Also, the forgery of some of the Indian signatures on the treaty by M.T. Simmons, Stevens's representative and an original settler on the sound, added to the Indians' distrust of the agreement. Added to this was the fact that the reservation sites were not acceptable to the Indians and that Stevens expropriated funds allocated to put the Medicine Creek Treaty into effect for use in his campaign among the Yakimas. Additional insult was added when, in 1855, the Washington territorial legislature outlawed marriage to Indians. Taken together, these problems soon became insurmountable.[21]

As unrest over the Medicine Creek Treaty increased, Governor Stevens ordered the Eastern Puget Sound Indians gathered into relocation centers. One of the seven relocation sites was "Vashon's Island," and although little is known about the sx̌ʷəbabš during this time, undoubtedly the sx̌ʷəbabš, along with most of the Puyallups and the upper river T'kaw-kwa-mis, were gathered here. Since Gig Harbor and Port Orchard were also relocation sites, very likely the Suquamish and the Skokomish were gathered at those spots. The Medicine Creek "tribes" were then interned at Fox Island. This First Internment (the Second Internment was of the Japanese during World War II) began in December 1855 and was a grim experience for the sx̌ʷəbabš. Exposed to the Puget Sound winter without shelter and without their traditional stores of dried food, the interned Indians faced a steady

physical and cultural deterioration. By May 1856, more than one-third of the population had become sick. The Indian agent assigned to Fox Island reported 80 deaths among the 729 Indians between May and September 1856 (no record of the December 1855–May 1856 casualties exists). These additional deaths, added to the already severe losses from disease over the past twenty years, led to further cultural breakdown, as the Indians often blamed the tamaneous, or medicine men, for these losses.[22]

At the beginning of the Puget Sound War, in January 1856, Nisqually chief Leschi visited Fox Island. He and his band held the island for two days, while the American forces from Fort Steilacoom engaged in a disastrous series of inept attempts to retake the island. At one point, they rushed to Fox Island in a schooner but were unable to land because they had forgotten to bring a dingy to get themselves to shore. The whole affair, with its few bloody but limited exchanges, was, as Richard White so succinctly concluded, "very nearly a war with more histories than battles, more reminiscences than casualties." Settlers seized on the Indian war "as a symbol of their destiny and the destiny of indigenous people in the Northwest." The problem was that no one could agree on what the symbol meant, and even today there are disputes about the real significance of the Puget Sound War. This stems from the white population's sense that they were not fighting the Puget Sound Indians alone but rather a whole history of Indian savagery and mistrust. For the sx̌ʷəbabš, the war had a devastating effect because they were removed, many of their longhouses were burned or destroyed and they were never allowed to freely return to their home. Following the war's end, the population in the internment centers actually increased, as Indians who were not interned fled to Fox Island to avoid the rash of murders and assaults by whites angered at the war.[23]

THE Sx̌ʷəBABŠ, 1855–1890

Following the war, the Indian population continued to decline. Census figures, particularly for Indians and other minority groups, are notoriously inaccurate; yet they are all we have to identify population trends, and they do give us a sense of a declining Indian population. In 1857, there were 1,500 Medicine Creek Indians. By 1858, this figure had dropped to 1,357, to 1,353 by 1860 and to 828 by 1870. A small increase in 1878 raised the population to 985 and again to 1,040 by 1880. Still, between 1857 and 1880, the

Medicine Creek tribes lost more than 30 percent of their population. Given this severe drop in population and the American mindset of assimilation, we can easily understand the popular white view of the Indians as a dying race, soon to be no more.

But the sx̌ʷəbabš and other Puget Sound natives had no intention of fading away. By adopting white clothes, white tools and white weapons, the Indians began to become a part of the white culture that engulfed them. The sx̌ʷəbabš's relationship with the natural world was engulfed by white culture as well. The Salish dog, which was bred for its hair to make blankets, disappeared as trade blankets replaced the need for them. Guns and steel hooks shifted the traditional hunting and fishing methods of the sx̌ʷəbabš. The potato became a significant part of the Salish diet, as did livestock like pigs and cows, dramatically altering the sx̌ʷəbabš use of the uplands on Vashon as gardens. The livestock rooted out the bracken so carefully cultivated by the sx̌ʷəbabš, and as white farmers began to clear land, the prairies or swales were among the most desirable parcels.

During the 1860s and 1870s, Indians and white immigrants "met and mixed on terms that were constantly in process of definition." The relations were fluid, and Indians retained a degree of independence that disappeared rapidly in the 1880s and 1890s. Indian labor was an important part of the growing resource economies in the two decades after the Indian war. Most Indians covered by the treaty did not move to reservations until the 1870s. This was because of the rather haphazard involvement of the government in Indian affairs during and right after the Civil War. During the Civil War, the government had few dollars to spend on a remote group of Indians on the fringe of the nation while the country was fighting for its existence. Ten years after the treaty, in 1864, the government did open the Puyallup School.[24]

After the Civil War and its immediate aftermath, the struggle for "national unification," rapid economic expansion, the development of transcontinental railroads and the flood of immigrants that resulted "drastically altered the context of relations between Indians and non-Indians around Puget Sound." During the 1870s and 1880s, new pressures were put on the Puget Sound Indians to accept whites' conditions. Indian manpower became an important part of the growing resource economies of logging, brick making, fishing and farming, a process that in its demands for workplace cooperation and submission must have pressured employed natives to accommodate to, if not take on, white patterns of behavior.[25]

During much of the 1870s, Indians stayed away from the reservation because they were poorly organized, the agents were disillusioned and they

lacked financial support from the other Washington. But the reformist zeal that characterized the post–Civil War Reconstruction had its impact on Indian policy. A series of reforms in the 1870s and 1880s, capped by the passage of the Dawes Act (the General Allotment Act of 1887), began to push Indians onto reservations. In 1874, only 74 of the 184 families belonging to the Puyallup Reservation selected land allotments, but by 1877, this number had jumped to 150. The primary intent of the Dawes Act of 1887 was to break reservations into individual allotments and thus encourage Indians to assimilate into white culture. Since the policy included the stipulation that unclaimed land would be sold on the open market (presumably to white settlers), "[t]he Indians feared the dissolution of the Reservation and thought taking allotments was better than losing the whole thing." This shift in policy, plus the growth of white settlement on Vashon, put pressure on the remaining sx̌ʷəbabš to move to the reservation at Tacoma to access what land they could.[26]

In reality, the main impact of the Dawes Act was to significantly reduce the size of the reservation, as Indians sold or were cheated out of their allotments. By the 1880s, the rapid growth of Tacoma, the arrival of the railroads and the growth of agriculture made life on the Puyallup Reservation and for the sx̌ʷəbabš increasingly difficult, as pressure grew on them to sell reservation land and as their traditional lifestyle came into conflict with the new arrivals' concepts of property and proper ways to live. The white population in Washington soared from 5,000 in 1860 to 25,000 by 1880 and quadrupled to 100,000 by 1890. While in 1860 half of the state's residents were native, by 1890 whites outnumbered Indians 20:1. This was true for Vashon as well. In 1860, there were no whites living on Vashon, although the first land claim was filed in 1863 and timbers were logged on the island as early as 1852. Census data shows the white population grew dramatically, from 347 in 1885 with 11 Indians (a 31.5:1 ratio) to 926 in 1892 with no Indians counted because Indians were not citizens.[27]

But old habits die hard. The reservations had inadequate food, the land was not farmable and the families were too densely clustered, so reservation Indians continued to visit the island to hunt and fish at their accustomed sites; some eventually sold their allocations and moved back to their island home. Because the Dawes Act made those Indians accepting allotments citizens, those who accepted allocation and then later sold them were Indians in name and culture only. They were "no longer Indians for most legal purposes." Tom and Lucy Gerand, John and Lucy Williams and Mary Bridges fell into this category. Their old culture shattered, these Indians "remained loyal to

a place, refusing to disappear and entered a strange limbo. They were no longer a people as they had once been, but neither were they the dark white men the Indian Department had hoped for them to become." These Indians developed a group of "diverse strategies for surviving in a white-dominated world." The Gerands survived by digging clams and selling them to whites. The Bridges and Thomas families worked in the mills and brickyards. They worked odd jobs. They worked as caretakers and bartered work for crops and fish. They did what was necessary to survive and still remain at the place they called home.[28]

CONCLUSION

The sx̌ʷəbabš began to be forced onto the Puyallup Reservation at Tacoma during the 1870s and 1880s. As American settlers flooded into the Puget Sound, and as the Dawes Act (the General Allotment Act of 1887) attempted to break up reservations into individual allotments, the sx̌ʷəbabš, along with the other groups assigned to the Puyallup Reservation, began to make individual decisions whether to accept allocations or stay where they were. During this process, the distinctiveness of the sx̌ʷəbabš as a separate group began to disappear within the federally recognized Puyallup tribe. The remaining sx̌ʷəbabš either moved off the island or became involved in the white island economy, laboring as wageworkers in the principle industries of lumber, fishing and agriculture. Beginning in the 1920s but not finding significant success until the 1970s, the Puyallup tribe, along with other Puget Sound Indians, used the federal court system to seek claims against the treaties signed in the 1850s. By the end of the twentieth century, Indians had begun to reassert a presence on Vashon by establishing tideland rights for shellfish, by connecting with archaeological digs on the island and by individuals from a variety of Pacific Northwest and other tribal groups establishing homes as part of the suburbanization of the island.

Between 1856, the end of the Puget Sound Indian War, and 1893, when depression swept America and the Puget Sound, the sx̌ʷəbabš were pushed aside, new economic and cultural systems were established on the island, new settlements replaced the sx̌ʷəbabš villages and the basic pattern for the development of Vashon was set.

FIRST EURO-AMERICAN SETTLEMENT

1865–1893

The pioneer days are surely behind us. The past ten years have brought a host of settlers; we have a post office here at Quartermaster and another at Vashon up near the center of the island; a daily boat to Tacoma and the Iola is making regular stops every other day on the east side and alternate days on the west side; we have several miles of wagon roads and many of the farmers have teams and wagons and therefore several buckboards.[1]

–John Smith, 1891

Between 1865 and 1893, the Pacific Northwest was transformed by a wave of Euro-American immigration. The railroads arrived, settlers flooded into the region, Washington became a state and resource-based economies and industries were established as the major cities of Seattle and Tacoma experienced explosive growth.

Vashon, lying between these two metropolitan centers and easily tied to them by the "water link" of Puget Sound steamers, experienced similar growth. Within these thirty years, the new settlers replaced the sx̌ʷəbabš and their way of life, establishing Euro-American patterns of community settlement, society, transportation, business and discrimination that has influenced the island ever since.[2]

ISLAND SETTLEMENT

Once the Civil War ended, white settlement resumed, and the government began to pay attention to the needs of this expanding region. Government surveys allowed settlers to claim and own land on Vashon. The 1857 Carlton and Berry survey mapped the island into townships and sections. It is easy to underestimate the significance of the surveys because we take them for granted, but this "governmental activism" was essential to the successful settlement of the island.[3]

The arrival of the Northern Pacific Railroad in Tacoma in 1873 and the Great Northern in Seattle in 1888 opened the Pacific Northwest. By the 1880s, the rigorous six-month trip to the region had been replaced by a three- to four-day train ride from the Midwest. Such easy transport brought a tremendous influx of settlers to the region. By the mid-1880s, almost all of Vashon had been claimed. Access to salt water and the protected shores of Quartermaster Harbor drew most early settlement toward the south and made Tacoma the primary city.

The attitude of many of these early settlers is perhaps best captured by Oliver van Olinda's description of his 1891 arrival on Vashon. He landed via the steamer *Iola* at Langill's Landing on Colvos Passage and walked up to Center. Later, he recorded his reaction: "I came from the great prairies of Nebraska and, as I walked up to Center in the gathering dusk of a mid-August evening, giant fir trees towering three hundred feet above me on either side of the trail in an almost impenetrable wall and flanked by great banks of ferns, the beauty of the scene was overshadowed by the thought that such environment simply must harbor hoards of bears and catamounts. I marveled at the folly of man, in thinking he could ever convert such material into a farm, a garden, or even a home. It was truly a stupendous task to contemplate."[4]

Like Van Olinda, we tend to romanticize the success of these early settlers in terms of rugged individualism and their struggle to conquer the land. The reality is somewhat different: the early settlers were dependent on a host of outside forces for their success. Federal government surveys and the Homestead Act allowed settlers to find land at very low cost, but the initial capital outlay needed was high. In an economy that was land rich and cash poor, Salmon Sherman's work as a blacksmith in Tacoma, plus his Civil War pension, provided essential cash, while the market for Mathew Bridges's timber made his success possible.

But despite the enormous support for settlement from outside forces, the success of the first settlers should not be underestimated. They did succeed,

and they did remain. Matthew Bridges, the first permanent settler, came from Maine to log but was not considered a "real" settler by early historians because he committed three "sins": he married an Indian, Mary, a sx̌ʷəbabš native; he was not a Civil War veteran; and he was an itinerant logger instead of a landed farmer. The Sherman party is a good example of "chain migration," where individuals who knew one another or were connected migrated together or followed one another. Eliza and Salmon Sherman arrived in November 1877 with Eliza's parents, Daniel and Phoeby Price, as well as her sister, Alice, and Alice's husband, John Gilman. They were joined a year later by Franklin and Cloussia Miner. This extended family became the first farmers on Vashon. In contrast, many did not succeed—Matilda Jane Carman, Jedediah Paige, Tom Redding and others failed and left the island. These individuals have been largely dropped from the narrative. Yet their stories, too, are as significant as the success stories, as all these stories reveal the repeating patterns of island life.[5]

ISLAND SOCIETY

Demographics

Early census data is problematic. Yet however flawed it may be, it is all we have. As Washington applied for statehood, territorial censuses were taken in 1885, 1887, 1889 and 1892. The population grew rapidly from 347 counted in 1885 to 926 in 1892. During these years, Vashon, like most of the rest of the West, was a male society, with relatively few women. Farmers predominated on the island. Seattle's and Tacoma's demand for bricks led to increasing numbers of brick workers, and the number of laborers and service employees increased. Logging continued to be important, as did fishing.

The place of origin of these early residents also gives another very interesting insight into the early settlement and development of Vashon. What becomes clear is that cluster immigration—immigrants coming from the same area—played an important part in the early settlement of Vashon as the island became an enclave for Union Civil War veterans. Significantly, settlers from the South made up less than 3 percent of the population, while more than 55 percent of the population came from the former Union states. The other significant aspect of this data is the relatively small number of

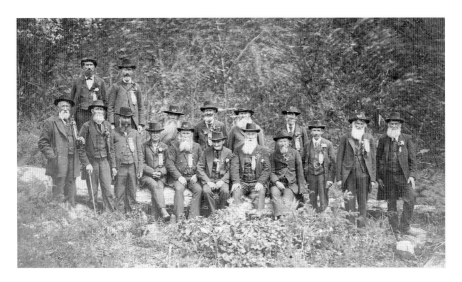

These Civil War Union veterans were the charter members of the H.G. Sickles Post No. 57, Grand Army of the Republic. They helped define Vashon as an enclave for Union Civil War veterans. *Vashon-Maury Island Heritage Association.*

Asian immigrants. The anti-Chinese riots in Seattle and Tacoma in 1885 helped account for this low number, as did the slow opening of Japanese immigration into the United States.

Social

By 1893, the social structure of Vashon had become established. Most islanders identified not with the island as a whole but with their local community, with its churches, clubs, schools, stores, post offices, docks, places of employment, homes and summer cabins. The basic pattern for the next several decades was set.

Churches were established early and provided a gathering place for social and ethnic groups. Most were established and had buildings in place by 1893, and all had strong congregations and professional ministers by the mid-1890s. The Methodist Church was the first, formed in 1884, followed quickly by churches near Vashon for Baptists, Lutherans, Roman Catholics and Presbyterians. Other congregations established in Burton, Dockton, Cove and Lisabeula.

By 1893, a number of social organizations had helped create the active and interdependent social structure that has characterized the island ever

since. In 1888, the Independent Order of Grand Templars, a fraternal organization, bought land and built a large meeting hall at Ellisport. That same year, a chapter of the Woman's Christian Temperance Union was established to work against the use of alcohol. In 1890, the H.G. Sickles Post No. 57, Grand Army of the Republic, organized, with sixteen Civil War Union veterans as charter members. In the fall of 1890, a women's branch was organized as the H.G. Sickles Corps No. 37, Women's Relief Corps; later, a Sons of Veterans, General Wadsworth Camp No. 29, was formed.

The year 1892 was a significant one for Vashon organizations. In June, the Vashon Horticultural Society began, the very first such organization in the state. That July, the Vashon Cornet Band first tuned up with fourteen members, beginning a long history of musical organizations on the island. Also that year, Dr. W.T. Lovering built a house and office just south of Vashon, becoming the first physician on the island. And to cap off this significant year, E.E. and O.S. van Olinda began publication of a monthly magazine, the *Island Home*—the first of a long line of news publications that continue today with the *Beachcomber* and the *VashonLoop*.

Discrimination has always been an unfortunate sub-theme in the history of the Pacific Northwest and Vashon. By 1893, a pattern of discrimination was already in place. When Washington became a territory, the new constitution excluded black residents from owning property and voting and prohibited marriage between whites and Indians. The First Internment of the sx̌ʷəbabš in 1855 was not the act of islanders but represented the beginnings of regional discriminatory practices that continued until the middle of the twentieth century and still have echoes on the island today.

Shortly after the 1885 anti-Chinese riots and expulsions in Seattle and Tacoma, a community of Chinese fishermen living on Maury Island's South End disappeared. Few records of Vashon's Chinese exist, but Oliver van Olinda, Howard Lynn and Art Chin referred to the event and identified the community as "Hong Kong." They all located the community on the west side of Maury Island just north of Manzanita, describing it as a "large and busy colony" with a "wharf extending over four hundred feet along the shore." "The principal occupation was fishing and fish-drying." They fished with boats they built themselves using large seine nets, bought fish from the Indians and shipped much of their catch to San Francisco.[6]

Schools

By 1890, Center, Vashon, Quartermaster, Columbia, Vermontville, Chautauqua and the West Side had formed school districts. The first school was built at Center in 1881, and by 1883, the island had fifty-one children in school, taught by Julia A. Judd. The first schools were rough cabins, but by 1887, a board-and-batten school building had been constructed at the site of Ober Park.[7]

Vashon College opened in 1892 when Miles Hatch invited professor A.C. Jones, associate president of the Methodist Episcopal College in Olympia, to the island. A meeting in April recruited community pledges of land and money. A site on Burton Hill was selected, and in September, the foundation was laid for a three-story building. The college founders, believing that "co-education and Christian instruction and example, free from all trace of sectarian lines, are important factors in modern education," opened the school without church affiliation. On October 25, 1892, the first term opened while construction proceeded, admitting seventy-eight students who paid a combined fee of $165.50 for tuition and forty weeks of room and board. The future for Vashon College looked bright indeed, as the college catalogue bragged: "There are no saloons, gambling houses, dance halls or other places of evil influence within eight miles of Vashon College." So began nearly twenty years of higher education on Vashon.[8]

Island Economics

During this settlement era, Vashon developed the fundamental economy of resource extraction that historian Carlos Schwantes termed the "Big Four"—agriculture, logging, fishing and mining. Adding to the island's economic structure were the shipyards and dry dock at Dockton, summer tourism that began with the Chautauqua Assembly at Ellisport and the growing retail center at Vashon. Each of these sectors was subject to boom and bust cycles. Together, these seven sectors defined the island economy well into the twentieth century.

Of these early economies, agriculture was the most significant. By the early 1890s, more than half the working population was in agriculture. Early attempts at ranching were made, like Alex McLeod's failed 1875 sheep farm with its one thousand imported sheep. Others developed orchards, such as Reverend John A. Banfield, who, according to the

Tacoma News in 1883, planted four hundred trees and a variety of berries. By 1890, greenhouses began to produce vegetables for the burgeoning markets of Seattle and Tacoma.

Logging was the first significant business on the island. As early as 1852, the crews of the schooner *Leonsea* were cutting and loading spars at Inner Quartermaster Harbor. The first permanent settler on the island, Matthew Bridges, made a claim in 1880 and logged at Cove, later Paradise Cove and finally Clam Cove in the 1920s. By the 1870s, the logging camp of James T. Phinney, north of what would become Vashon Landing, employed twelve to twenty men and twelve oxen to cut timber for the Seattle market. Warren J. Gordon established the first sawmill on the island near Center. In 1888, W.L. Lively ran his shingle mill at the entrance to Nettle Creek, which locals soon nicknamed Shinglemill Creek. In 1889, A.D. Kingsbury began an extensive logging operation and constructed a dock at Kingsbury Beach. This logging company later became Metzker Lumber, then Pankratz Lumber, and kept logging well into the twentieth century.

Fishing was another important early enterprise that, like logging, peaked in the early twentieth century before going into a slow decline. But subsistence fishing was also important to early settlers, as they, like the sx̌ʷəbabš, used

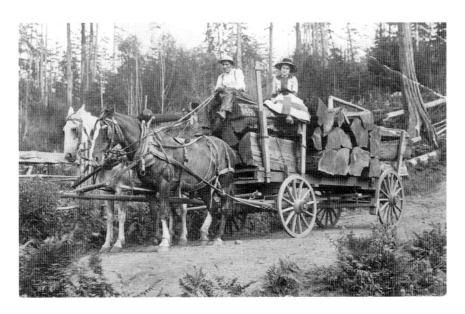

Shake mills were an important part of the logging industry on Vashon. Shake bolt wagons delivered cedar bolts to be split into shakes for roofs and siding. *Vashon-Maury Island Heritage Association.*

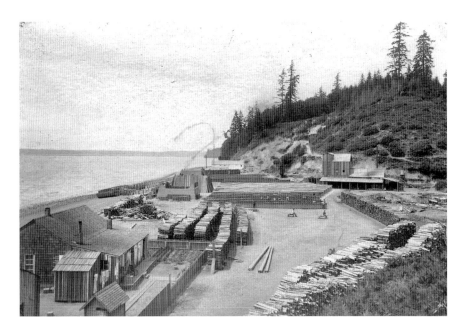

Easily accessible clay deposits along the shorelines made clay mining and brick making significant early industries. At one time, there were as many as ten to twelve brickyards, including the Fairwold Brickyard at Vashon Landing. *Vashon-Maury Island Heritage Association.*

fish as an important part of their diet. Early farmers also used the readily available salmon carcasses to fertilize their fields.

Today, it is difficult for us to visualize Vashon as an industrial center, but by 1893, the brickyards, lumber mills, dry dock and shipyards that set up on the shores of Quartermaster Harbor had made this an early center of industrial activity for south Puget Sound. Easily accessible clay deposits along the shore (a legacy of the Vashon Glacier), the ease of shipping bricks by barge and the ready markets of booming, fire-prone Seattle and Tacoma made clay mining and brick making a significant early industry. At one time, there were as many as ten brickyards operating on the island (five by 1885), employing more than two hundred men around Quartermaster Harbor. There were also two brickyards at Vashon Landing, one brickyard north of Aquarium and several brickyards on the west side. For a time, Vashon was one of the "brick capitols" of the Pacific Northwest.

The island's long engagement in shipbuilding and servicing began in 1888, when Reverend Dilworth had the first boat built on Vashon, the steamer *Halys* (from the Greek "fisher of men"); it was built just north of Vashon Landing. The Puget Sound Drydock Company was formed in 1891 to build a large

dry dock; that November, it was towed—not yet finished—from Tacoma to Dockton. At 102 feet wide by 325 feet long, the Dockton dry dock was the largest west of the Mississippi. Open for business in March 1892, by that June more than eighty employees worked at the yard. The dry dock stayed open even through the economic depression of 1893, and it hosted the repair of many vessels until it was sold and towed to Seattle in 1909.

Miles Hatch, the most important early entrepreneur on Vashon, financed the dry dock, the sawmill at Assembly Point, the town of Burton, Vashon College and the Burton Dock. He filed a homestead claim on Maury in 1884 and by 1892 owned much of the Burton Peninsula. He raised the first building at Burton (which he named after his birth place in Illinois) and created Mileta Ranch (Mileta was a contraction of the names Miles; Lewis, his son; and Tamar, his wife), where he initiated the dairy industry on Vashon. Hatch was elected to the Washington state legislature and began a long line of developers, entrepreneurs, businessmen and philanthropists who have made a distinctive and lasting impact on the development and growth of Vashon.

A tourist economy was established early on Vashon and is still important today. The island has always been a haven for city escapees. Mrs. Otto Case, who was fourteen during the Seattle Fire of 1889, recalled that her father "took us to Vashon island until conditions in Seattle became more settled." Many families came to Vashon for their summer break, building small cabins or tent platforms along the shore.[9]

The most important tourist development during this era was the emergence of the Chautauqua movement, which held the first Puget Sound Chautauqua Assembly at Dilworth Point in 1885. Named after Chautauqua, New York, where the movement began in 1874, the assembly was a summertime presentation of lectures, discussions and cultural activities in a resort atmosphere that lasted several days to a week. Advertisements promised that "families may escape the noxious vapors and the immoral influences of a crowded city and combine health, instruction and pleasure." After two years spent south of Alki Point, in 1888 the assembly returned to make a permanent camp in what would become Ellisport. Several islanders (McClintock Ellis, Fuller and Judd) donated an initial 115 acres; eventually, the site grew to 600 acres, with two miles of shoreline, a dock, a hotel, dozens of cottages and a 1,200-seat pavilion.[10]

On May 24, 1888, the Puget Sound Chautauqua Assembly platted Chautauqua Beach, the first town platted on the island, with roads named for American writers Bryant, Emerson, Lowell, Hawthorne and Irving; for

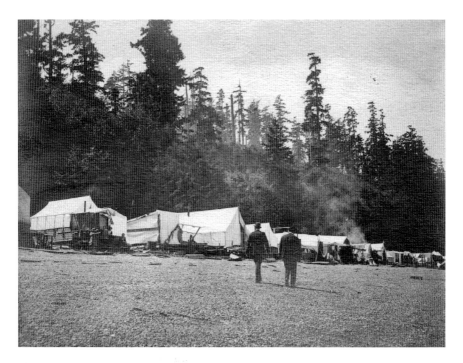

The Chautauqua movement held the first Puget Sound Chautauqua Assembly meeting at Dilworth Point in 1885. These tents along the beach were typical of the early Chautauqua meetings. In 1888, Chautauqua returned to Vashon, choosing the area that would become Ellisport for its assembly grounds. *Vashon-Maury Island Heritage Association.*

inspirational concepts like Olympus and Prospect; and for native trees such as Alder, Fir and Cedar. A post office was established that summer. By 1889, steamers were making regular stops at Chautauqua, and in 1892, a company within the Chautauqua Association raised $10,000 to build a new dock and hotel. In spite of all these efforts, the drawing power of Vashon's Chautauqua began to fade during the 1890s. By 1904, the "Traveling Chautauqua" run by national agents began to eclipse local assemblies. In 1909, the Vashon group found it necessary to reorganize, and in 1912, it renamed itself Ellisport after early settler and assembly activist J.E. Ellis. By the 1920s, most traces of the PSCA were gone. While the Chautauqua Assembly at Ellisport was the most dramatic of the early tourist developments on the island, other communities and resorts began to open. After a dip during the 1893 depression, tourism would reemerge and become an economic driver for the island.[11]

Retail businesses opened on the island early but in a scattered-about fashion; the town of Vashon didn't solidify as the island's major retail center until after the turn of the century. In 1884, the first store on Vashon was

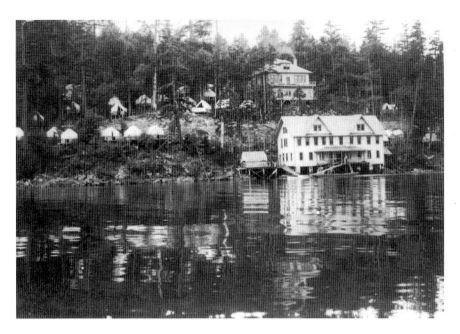

In 1888, the Puget Sound Chautauqua Assembly platted Chautauqua Beach. This was the first town platted on the island. Eventually, the site grew to six hundred acres, with two miles of shoreline, a dock, a hotel, dozens of cottages, a 1,200-seat amphitheater and a three-story pavilion at the water's edge. *Vashon-Maury Island Heritage Association.*

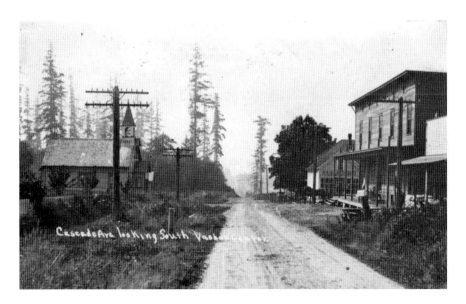

Center, pictured here in 1890, with these two stores, the first school and a church, was the largest inland community on the island. *Albert Therkelsen.*

built at Chautauqua; it was soon bought by Loren B. Anway and John E. McLean and moved to Center, where the building still stands. In 1890, the first store at what would be Vashon town was opened by F.W. Gorsuch. That same year, W.H. Clarke and Jason Wylie opened a store in Burton that held the new Quartermaster Post Office, with Wylie as postmaster. Once Miles Hatch built the Hatch Building in 1892, Burton became the commercial center of the island.

The depression of 1893, which began in June as a financial panic on the East Coast, brought a decade of rapid island growth to an end. The depression hit Puget Sound hard: fourteen Tacoma banks failed, and large numbers were unemployed. Agricultural prices dropped, depressing the island's prosperity. Despite these temporary setbacks, the patterns of settlement and industry were set, and within a decade, the island was again experiencing an economic boom.

Political

By 1893, Washington was a state, King County had governed the island for forty-one years and voting had been taking place for thirteen years. Even though part of King County, the island was largely ignored by county government, although in 1883 the county did authorize the construction of three major roads on the island that quickly established new patterns of development. Mail service also had an important early impact and aided development. Post offices opened at Vashon in 1883, Chautauqua and Maury in 1888, Burton in 1890 and Aquarium and Lisabeula in 1892; they became social and economic hubs for the isolated communities scattered around the island.

Another significant event for island politics was when Washington became the forty-second state in 1889 and John T. Blackburn became Vashon's first state legislator. A Cemetery District was established in 1888, lending a sense of permanence to settlement of Vashon and beginning a long tradition of local political jurisdictions to administer services. The federal government has always had a presence, beginning with the first survey. The federal land office administered land grants and homesteads, and several military preserves that were unused were ultimately opened to settlement. The Point Robinson Lighthouse and the Army Corps of Engineers' dock permit process instituted in 1890 kept the U.S. government involved.

Governments have always had problematic relationships with Vashon. Islanders are fiercely independent yet tend to vote as the rest of King County votes. And the island has always been dependent on outside sources for services and development incentives. Nothing highlights this dependence more than ferries.

Ferries

The island has always needed ferries, and ferries have driven island development. Ferry wars in this era set the pattern for subsequent ferry wars, and they are one of the striking continuities in Vashon's history. Early ferry service focused on runs on the East and West Passage and in Quartermaster Harbor. But ultimately, all of these gave way to ferry docks at the North and South Ends of the island.

The first island ferry was Salmon Sherman's *Old Black Joe*, a ship's boat purchased in 1878. "It was a sturdy craft built of oak and painted black, hence was given the name of *Old Black Joe*." Sherman rigged it as a schooner and put it in semi-regular service between Quartermaster and Tacoma. In 1883, Sherman retired *Old Black Joe* and purchased the *Swan*, a thirty-two-foot steam launch that ran a twice-a-week service to Tacoma from its home port of Burton. In 1890, Frank Bibbins, who had come to Vashon in 1884, began the first regular daily service to Quartermaster Harbor, making two daily trips with the forty-two-foot steamer *Sophia*. Bibbins served the harbor for eighteen years—with the *Sophia* from 1890 to 1899 and then with the *Norwood* until 1907.[12]

The first ferry war was fought between 1892 and 1895. It pitted Captain John Vanderhoef against Tom Redding, the son of Matilda Jane Carman. Vanderhoef, a "great, robust, ruddy complexioned fellow, with a luxuriant, though faded, red beard," came to Puget Sound in 1885 as a former tugboat skipper out of Chicago. In 1887, he became skipper of the *Iola*; by 1889, the *Iola* was making six round trips per week between Tacoma and Seattle, stopping at Vashon on Monday, Wednesday and Friday on the East Passage and on Tuesday, Thursday and Saturday on the West Passage.[13]

In 1889, Tom Redding bought the *Iola* from Captain Vanderhoef, who then purchased the 80-foot sternwheeler *Glide* and left the Vashon run. Tom Redding was very successful for three years, but in March 1892, Vanderhoef returned the *Glide* to the Vashon route. He operated six days per week and set his schedule so the *Glide* and Tom Redding's *Iola* were on opposite sides

of the island each day. Redding felt betrayed at Vanderhoef's return to the Vashon route, so he purchased the 104-foot sternwheeler *Mary F. Perley* and put it in direct competition with the *Glide* while continuing to operate the *Iola*. Tom Redding began to lose the competition when, on October 3, 1892, the *Perley* collided with the steamer *Flyer* off Alki Point in dense fog. The collision severed the stern-wheel off the *Perley*. The passengers were transferred to the *Glide*, which was nearby, and the *Flyer* towed the *Perley* into Seattle. By 1894, Redding was forced to lease the *Perley* to the Seattle and Tacoma Navigation Company for the freight run between Seattle, Everett and Tacoma. By this time, the creditors were closing in on the overextended Redding. In December 1895, the *Perley*, which Redding had purchased for $4,500 three years before, was sold at U.S. Marshall's auction for $985. Redding went into bankruptcy and was forced to sell the *Iola* in 1896. Redding and his mother, Matilda Jane Carman, were forced to sell off their Vashon property, and they moved off the island. Having "won" this first "ferry war," Vanderhoef continued to operate the *Glide* on the Vashon run until 1899, when he and his wife retired to Ollala on the Kitsap side of Colvos Passage.

CONCLUSION: END OF ERA

The depression of 1893 brought the settlement era to a close; the island's rapid growth temporarily reversed, and the island lost two-thirds of its population. Yet by 1893, all the patterns and themes of the Vashon's future story were clear: settlement in scattered communities along the shores, social organizations and class structures with some episodes of discrimination, resource extraction industries dominating the economy and an attitude of islander independence coexisting with dependence on outside government and ferry services.

The early island historian Oliver van Olinda, writing in the 1930s, captured the feeling of the significance of this time in island history: "It is my belief that more was accomplished on the island during this year of 1892…than has been done in any ten consecutive years before or since. It was the high spot in the march of progress for the islands.[14]

FOUNDING VASHON

1893–1920

[Vashon Island,] *situated as it is, halfway between Seattle and Tacoma, is in fact a residential suburb of both of them. The island vies with the mainland in supplying its share of poultry and eggs, strawberries and raspberries, and other small fruit. Vashon has no cities and no backwoods, but it is a rural community, quite prosperous, progressive, and attractive.*[1]

—Clarence Bagley, 1929

FOUNDING VASHON

Between 1893 and 1920, Vashon changed from a frontier into settled farm country. The island's population grew by nearly 800 percent, from 294 residents in 1900 to 2,337 in 1920. The few logging operations, homestead farms and waterfront villages grew into many proud, well-established communities. The island went through its boom and bust cycles; fought in three "ferry wars," as well as the nation's wars; and saw the arrival of automobiles, electricity and telephones. By 1920, the island we know today had emerged.[2]

This was an era of consolidation. The many communities, with their separate identities, soon gave way to Vashon town as the commercial center. The first school consolidation occurred in 1913, and within forty years, there would be one Vashon School District. The "Mosquito Fleet" shifted from more than thirty community steamer docks landing private-owned boats

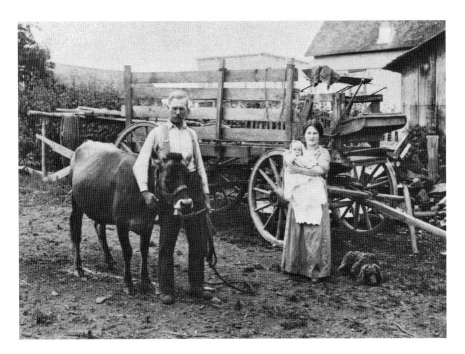

Otto and Hazel Therkelsen and baby Alfred on their farm at Center in 1915. *Albert Therkelsen.*

toward only two government-run docks that, by the late 1940s, served only public-owned automobile ferries.

During this period, Vashon built a stable agricultural society. The land frontier gave way to what Carlos Schwantes has termed the "Wageworkers Frontier," a "highly mobile work force made up largely of young men who often moved from one kind of work to another and who also moved seasonally." A wage economy took over the frontier exchange economy, and as wages became essential, conflicts between labor and management arose. Farming came to dominated the island as it grew to supply city larders with island berries, fruit, greenhouse crops, chickens and eggs.[3] The other resource economies—logging, fishing and brick making—all peaked and began to decline during this era.

Boosterism and new development came in waves, with proposals for an electric streetcar line, a canal at Portage and new plats at Harbor Heights, Vashon Heights and Glen Acres. Vashon College was founded in 1892 at Burton, prospering until a fire in 1910 led to its closure. The dry dock at Dockton flourished and then was moved to Seattle, but other shipyards continued to build and repair vessels. Electricity, automobiles,

telephones and roads began to connect communities. Vashon State Bank was formed. Tourist resorts and camps opened, each summer boosting the island's population and economy.

The latest group of immigrants, the Japanese, faced increasing discrimination as a series of state and national efforts worked to end Japanese immigration and limit their ownership of land—part of a larger shift in American culture in which the "nation of immigrants" began to close its doors. These actions directly affected the Vashon Japanese and helped foster an attitude that would comply with Japanese internment during World War II.

Although a few remained, the sx̌ʷəbabš virtually disappeared from the island. But they also began to fight back during this era in a series of court battles that, though the effort would take more than fifty years, would finally restore rights they had negotiated in the 1850s.

Re-Creation

As the settler generation began to pass on, islanders began to reconstruct their history through the Pioneer Society. This is a remembered history, a story of progress in which "savages" were displaced, a wilderness was conquered, a society was founded, the industrial and agricultural roots of wealth were created and the future was ensured.

The reality is somewhat different. The story was not all progress, it was not smooth and the future was not ensured. The real history was "far more concerned with re-creation than with creation. The goal of the transformation…was ultimately the restoration of the familiar world they had left behind." The new residents sought to create a world molded on familiar patterns they brought with them. The society they created, the farms they planted, the houses they built and the businesses they started looked like the society, farms, houses and businesses they left behind in the Midwest, the East Coast and Europe.[4]

ISLAND SOCIETY

Demographics

From 1893 to 1920, Vashon witnessed its largest growth in population ever—nearly 800 percent. Between 1892 (the 1890 census data was all lost in a fire) and 1900, the population actually decreased by 68 percent because of the impact of the 1893 depression.

Social

During this era, what would become known as Vashon's "Mason-Dixon Line" emerged. The line is a division between the north and south running roughly along Cemetery Road—a line found not just in in the island's soil differences and rainfall patterns but echoed in school district boundaries, census tract divisions and telephone exchanges. The Mason-Dixon Line was at the heart of Ira Case's fight to develop the South End. The rivalry and jokes of this north/south division continues today, although their intensity diminished as the island became more connected.

The interior of the island began developing when bicyclists, farmers hauling crops and car owners demanded better roads. The honor of owning the first automobile on the island belongs to L.C. Beall, who obtained a twelve-horsepower Franklin in 1907. Harold Steen had ordered an automobile first, but his delivery was delayed, and thus Beall's Franklin became the first automobile on the island. In 1915, the Good Roads Association invited the King County Council to come drive island roads to see firsthand the need for developing and improving them.

As America's national vision turned away from westward expansion and toward international influence, island citizens played their parts. William J. Stuckey of Dockton was the only islander to serve in the Spanish-American War. But World War I saw keen island interest: 125 young men left to serve, Victory Gardens proliferated, a Home Guard was organized, Liberty Loan drives raised $29,300 and returning veterans were celebrated at a ceremony at Burton High School in June 1919. The Martinolich shipyard won a contract from the Norwegian government to build three four-master cargo vessels, only one of which, the *Dockton*, was completed.

The island was hit hard by the 1919 influenza epidemic, which tended to be more deadly to young people than to the elderly. The labor unrest of the Seattle General Strike in 1919 affected the island when shipyard workers

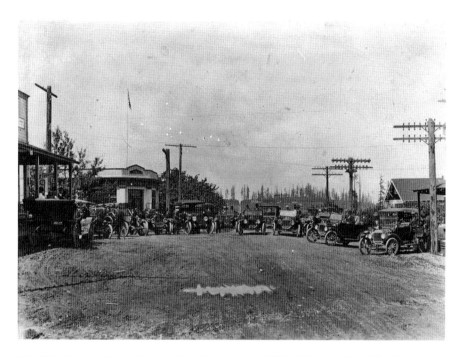

The King County Council staged this photograph in 1915 while on a Good Roads tour to examine the roads on Vashon. It arranged the cars for this photograph in Vashon's main intersection. *Vashon-Maury Island Heritage Association.*

went on strike to demand better wages and working conditions. This strike was a reflection of the "wage workers frontier" that Schwantes described.

A number of organizations founded at this time became the basis for future community groups and political organizations. Perhaps the most significant was the organization of the Camulos Club to support social and civic improvement. The year 1895 saw an athletic club organized at Lisabeula, and 1896 saw the organization of the Vashon Athletic Club, which began to support teams in a variety of sports. The International Order of Odd Fellows formed and built a lodge at Center, which later became the home of Vashon Allied Arts (VAA). In 1911, the Vashon Island Women's Club was organized at Burton. The Boy Scouts of America organized a troop in 1916, and the Island Rebekah Lodge No. 277 was formed. The Ellisport Women's Club organized in 1919.

While many of the island's churches were already established, during this period churches began to consolidate. In Vashon town, a new Methodist church in 1907 and, two years later, a new Presbyterian church were built. These two fine examples of early twentieth-century church architecture

still grace Vashon and provide a reminder of the continued importance of organized religion on this island.

There's nothing like a local newspaper to give readers a sense of belonging to a single community. Oliver van Olinda began publishing the *Vashon Island Press*, the island's first newspaper, between 1895 and 1897. In 1907, the *Vashon Island News* began publication, and in 1914, it was bought by Ira Case and moved to Burton to boost South End interests. Meanwhile, a rival paper, the *Vashon Island Record*, began its short run; in 1919, it merged with the *Vashon Island News* to become the *News-Record*, which moved back to Vashon and continued publication until 1958, when the publishers of the new *Vashon Beachcomber* (first issue March 7, 1957) bought out and retired the *News-Record*.

Vashon's minority population, which was primarily Japanese, grew slowly during this era. The disappearance of "Hong Kong" on Maury Island had little impact on the island, but the Japanese Exclusion Movement of the early twentieth century certainly affected the island's Japanese residents. In the 1907 "Gentlemen's Agreement" between the United States and Japan to limit immigration, the Japanese government stopped issuing passports except to wives, children and parents of those Japanese already in the United States. In 1913, bills were proposed in Olympia to prevent the hiring of white women by Japanese, to prevent leasing of land to Japanese, to prevent Japanese from marrying a white person and to prevent aliens of Japanese ancestry from owning land. While none of these passed, they presaged the 1921 Washington State Anti-Japanese Land Act, which prevented Japanese aliens from owning land; it was not repealed until 1968.[5]

Prior to 1908, Japanese men on the West Coast vastly outnumbered Japanese women, which led to the "picture bride" stage of immigration. Marriages were arranged by marriage brokers carrying photo albums of prospective brides. Most Japanese women who immigrated here between 1910 and 1920 came as "picture brides." Raised traditionally, they received a series of cultural shocks upon arrival: immigration procedures that included a medical exam, a new language, new clothing styles, new home, new roles and a stranger for a husband. Perhaps because they were raised to obey parents and husband—and knowing they were crucial to their new family's success—they quickly adjusted, working long hours in the fields or in business enterprises, as well as taking responsibility for running the home and taking care of the children.

The 1920 "Ladies Agreement" ended "picture bride" immigration, and legislation in 1921 and 1924 nearly halted Japanese immigration. The

Immigration Act of 1924 (the Johnson-Reed Act, which superseded the 1921 Emergency Quota Act) excluded anyone of "Mongolian descent." The exception was Filipino immigration; Filipinos carried U.S. passports as a result of American control of the Philippines after the Spanish-American War. This loophole was closed in 1932.

These national patterns were echoed on Vashon and in Japanese immigration to the island. About 90 percent of the Vashon Japanese were in agriculture, and because of the land laws, few owned land until they could purchase it in the names of their American born-children. The Mukai family is a good example of this pattern. B.D. and Sato move to Vashon in 1910, and their son, Masa, was born in 1911. When Sato died in 1915, B.D. married her sister, Kuni. Successful as a strawberry farmer, in 1924 B.D. started the Mukai Cold Processing Barreling Plant. At its height, the business employed four hundred to five hundred seasonal workers and packed two hundred tons of strawberries per season. This success allowed them to developed the Mukai House and Garden once they could purchase land in Masa's name. The Mukai house and garden represent a blending of two cultures: in B.D Mukai the Americanization of a Japanese immigrant who designed and built a traditional American suburban house, and in Kuni the expression of Japanese heritage in her design of the stroll garden. The Mukais found a way to balance their Japanese heritage and their newly adopted American home. They became successful and accepted members of the Vashon community. The island's Japanese came for the same reasons many came to Vashon: for opportunities, for cheap land and for the upward mobility they could not find back home. Their numbers were small—by 1920, there were only 95 Vashon Japanese out of a total population of 2,557—but they became an influential and integral part of the island community.

Schools

The first schools had been formed earlier, but between 1893 and 1920, the number of schools peaked, with thirteen separate school districts plus Vashon College. Consolidation began in 1913 when Burton and Southern Heights combined and began to move to a single island school district.

The first high school was opened in 1908 at Burton. In 1913, Vashon built a high school north of Vashon town, and Burton built a new high school at Judd Creek in 1913. These high schools would combine into one in 1930: Vashon Union High School.

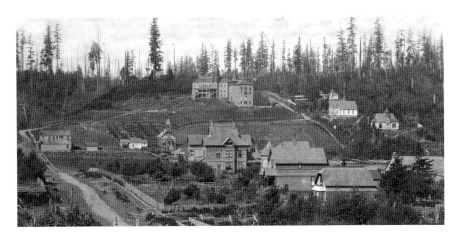

Vashon College opened in Burton in 1892. Old Main, Commercial Hall (1894) and the Armory (1901), then the largest drill hall in the state, formed the campus. In 1910, Old Main burned and was almost a total loss. The fire effectively ended Vashon College. *Vashon-Maury Island Heritage Association.*

When most private colleges were affiliated with churches, Vashon College was an interesting experiment in nondenominational education. The campus on Burton Hill had three major buildings, dominated by Old Main, built in 1893, a four-story building with forty-six rooms used as classrooms, offices, dining hall and student dorms. The three-story Commercial Building was added in 1894 with classrooms and housing for ninety young men; it expanded in 1898. The Armory, added in 1901, was the largest drill hall in the state. Vashon College grew rapidly and by the early 1900s had more than two hundred students. A disastrous fire in 1910 burned Old Main and damaged the Commercial Building. The college never recovered and soon closed.

ISLAND ECONOMICS

This era marked the height of the "Big Four" extractive resource activities (agriculture, fishing, logging and mining), the height of shipbuilding, the shift of tourism away from the Chautauqua toward summer residences and camps and the emergence of Vashon town as the dominant commercial center on the island.

Logging peaked between 1906 to 1916, when more than one-third of the island was intensively logged. Compared to the lush forests we have today,

photographs show an island without forests. A typical logging operation was that of Harold Steen. He operated a mill just north of Vashon town for seven years beginning in 1900 and then moved up what is now Cove Road, where he built a substantial Craftsman-style house, his mill and a small logging railroad. In 1923, he moved his operation to Ellisport and built another Craftsman home nearly identical to the one on Cove Road. (Both houses still stand as beautiful examples of the style.) Steen retired and sold the mill in 1932, but the mill continued to operate into the 1940s. Logging declined after 1920. It would take another sixty years for the forests to be reestablished, and it will take another three hundred years to regrow the "cathedral forests" that once blanketed Vashon.

The Puget Sound fishery reached its height in 1914. The salmon runs of Puget Sound and the bottom fish around the island and in Quartermaster Harbor gave good harvests to the fishermen of Dockton and Cove, and canning plants at Vashon Landing and Dockton opened to serve them. But those fisheries soon played out, forcing fishermen to follow the salmon runs north into southeast Alaska or turn to other work for their primary income. The canning plants soon closed, victims of the typical boom and bust cycles of extractive resource economies.

Mining for gravel and clay had also peaked by the turn of the century. With the end of the building boom after the 1893 depression, the Vashon brick factories quickly disappeared, and the remaining mines turned to extracting gravel. The scars of these mines can be seen along the road at High School Hill and Pohl Road and from the water at Vashon Landing, Robinswood Beach and Biloxi Road. The neighborhood of Gold Beach is in a reclaimed gravel pit, just north is a former gravel mine that is now the Maury Island Marine Park and just to the south is the former Glacier Mine that, after a long fight, became Maury Island Regional Park.

Of all the extractive resources tapped on the island, agriculture was the most important. As Tacoma and Seattle grew to dominance in the Pacific Northwest, Vashon was well placed to ship produce to their markets, and demand steadily increased. By the mid-1890s, greenhouses built by the Covey brothers, by E.M. Gordon and by Hilen Harrington were churning out produce, and in 1896, three more greenhouse operations opened by Griswold, Fuller and Nye brought the total to six. These greenhouses "supplied the near-by cities with the bulk of their tomatoes and cucumbers." During the 1895 summer, the *Skagit Chief*, a large stern-wheeler making daily runs to the east docks, picked up more than 400 crates of berries each day on average. The state agriculture report for that year recorded the following

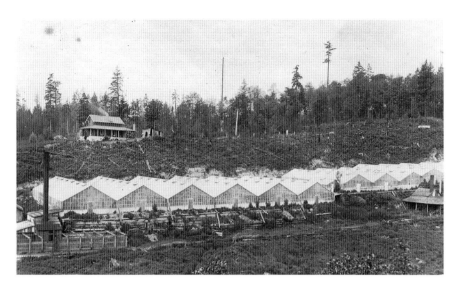

The Newcom Greenhouses at Ellisport supplied vegetables to the growing cities of Seattle and Tacoma. *Vashon-Maury Island Heritage Association.*

totals shipped: strawberries, 6,595 crates; raspberries, 1,787 crates; currants, 324 crates; gooseberries, 7,800 pounds; and cherries, 300 pounds. This growth happened despite the 1890s depression and its population drain from Vashon. Those hard times, plus the allure of the 1896 Alaska Gold Rush, combined to create "almost a wholesale exodus from the island…A large number of young men sought work elsewhere, and many families moved away."[6]

By the turn of the century, the bust was over and island agriculture had taken off. In 1901, more than 15,000 crates of strawberries were shipped from the island. The Island Berry Growers Association was formed in 1905. More than 75,000 crates of strawberries were shipped in 1908 and 165,000 crates in 1910; growth continued throughout this era. The first Vashon Fair, sponsored by the Horticultural Society and managed by John T. Blackburn, began the long tradition of island festivals that continues today. The extent of agriculture on Vashon can be seen in the fruit tree inventory compiled by King County horticulturist F.N. Rhodes in 1917. He counted 24,532 apple trees, 8,070 pear trees, 7,995 cherry trees and 4,868 prune trees.

The agricultural boom, like most booms in resource economies, was short-lived. World War I created jobs in Seattle, Tacoma and Bremerton and lured agricultural workers to higher-paying jobs and more reliable work in the cities. After the war, agriculture never fully recovered. Increased mechanization and the first of a series of "green revolutions" increased

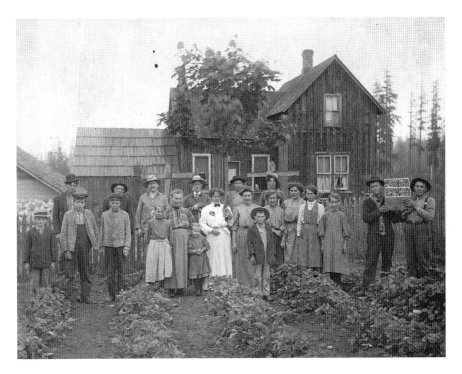

Agriculture was the most important economic driver of the island economy, and Vashon farms supplied produce to the rapidly expanding markets of Seattle and Tacoma. Strawberries quickly became the most important crop, with more than 165,000 crates shipped off the island in 1910. *Vashon-Maury Island Heritage Association.*

productivity, and marginal farms could not compete. Vashon experienced what the rest of the nation experienced: a slow but inexorable slide into an agricultural depression.

Industrially, Vashon was moving into what Carlos Schwantes has termed the "Post-Frontier World." The boom and bust cycles of the 1890s were followed by a brief expansion of the Dockton shipyards at the turn of the century, followed by a collapse with the sale and move of the dry dock to Seattle. A bitter strike, precipitated by the hiring of island men to work overtime, racked the Dockton shipyards in 1895 as workers sought higher wages and more secure working conditions. The dispute was quickly settled in favor of the workers. Within a year, the depression dragged down demand, but after the recovery at the turn of the century, the shipyards returned to actively repairing and building ships. In 1907, workers who chose not to be lured away to the Klondike Gold Rush demanded better pay; rather than submit and pay higher wages, dry dock manager E.C. Warner shut down the dry dock and, within

two weeks, announced its sale to John T. Heffernan of Seattle. The dry dock stayed another year, but in 1909, it was moved to Seattle; the era of the island as a major shipyard ended, although boat construction continued for another two decades at the Martinolich and Stuckey yards.[7]

The beginning of the twentieth century was an era of growth and optimism for the island's future. Some of the proposed schemes mimicked mainland developments. In 1908, an electric railroad/trolley was proposed to link the Heights and Burton to give travelers another route between Seattle and Tacoma. On the surface, this sounded like a good idea, but the "water link" of Mosquito Fleet boats/ferries and the Interurban Railroad that already linked Everett, Seattle and Tacoma served well enough to swamp this idea before it ever got started. A canal through Portage was proposed so ships could sail from Dockton straight to Seattle—an idea echoing construction of the Chittenden Locks and ship canal in Seattle, just as the electric railroad scheme echoed the Interurban. But like the railroad proposal, the notion of opening Portage was overridden by growing demand from Maury Island residents for a land connection to Vashon. In the 1910s, that link was created with two small bridges and an infill roadway. The new link stifled water flow between Inner Harbor and Tramp Harbor.

Island boosterism did find an outlet in the 1909 Alaska/Yukon/Pacific Exposition, which held a "Vashon Day" in September as the exhibition was drawing to a close. More than nine hundred islanders attended "Vashon Day," and delegations from Vashon, Burton, Lisabeula, Cove, Portage, Chautauqua, Vashon Heights, Aquarium and Maury Center listened to John H. James, president of the Vashon Commercial Club, deliver a speech extoling the promise of their home island.

While the island may have had its industrial heyday, Vashon could not remain a center of industry because the island lacked the scale of infrastructure needed for industrial development. Small industries have characterized Vashon's development, but if successful, they tended to move off the island. Numerous small industries started up during this era. The Emmick & Keentz sawmill at Vashon Landing lasted only a few months. The Vashon Island Preserving Company, incorporated by King, Harmeling and Hansen in 1908, operated for three years but then failed. Northwest Canning Company organized in 1910 and built a plant at Vashon Landing. This cannery employed thirty-five to forty people and in 1918 paid $25,000 for fruit and $12,000 for labor. But like other attempts at light industry on the island, this, too, failed as agricultural production dropped during the 1920s; it went into receivership and was bought by National Canning Company, a

subsidiary of Libby's. Other light industries, such as Raeco, which produced a linoleum-type flooring called Raecolith, and the blasting powder plant north of Point Robinson, found the island's isolation and the difficulties of transportation to be barriers to their success and moved their operations to Seattle, where Raeco still exists in the Georgetown area.

The isolation and dependence on ferries, while a deathblow to many industries, was a boon to the growing tourism and recreational economy that arose during this era. In 1895, the Baptist Children's Home opened in Burton; this imposing three-story structure was a residence and school for the children of Baptist Missionaries who primarily worked in China. This home initiated the Baptist presence on the Burton Peninsula and led to the building of what we now call Camp Burton, a retreat on fifteen acres that the Baptist Church purchased in 1919.

Summer homes began to crop up all over the island after 1900. Harbor Heights was platted in 1906 and Vashon Heights in 1909. In 1910, E.M. Gordon bought waterfront land below Vermontville and platted it as Glen Acres; its large dance hall and store, operated by Bennett and Fisher, burned in 1917 and was never rebuilt. Magnolia Beach's summer community had its own store and hotel, and nearby Shawnee was platted by M.F. Shaw. Destination resorts also developed: Frank Hubbell opened Luana Beach Resort in 1918, and the Burton Dance Hall was constructed about the same time. The Swastika Lodge at Dilworth was opened in the 1920s (when the swastika had a very different meaning than it does today). All are examples of the island's growing reliance on tourism.

Vashon was seen by many as a refuge and escape from the big-city life of Seattle or Tacoma. During the Seattle General Strike and the influenza epidemic of 1919, families fled the cities for the "safety" of the island. Even as tourism and summer residences proliferated, the Chautauqua movement that spawned the island's tourism economy was slipping into decline. By 1919, the Chautauqua Assembly Pavilion, built in 1888, was declared unsafe and torn down, and the Chautauqua movement quietly disappeared from the island for good.

During this era, the island's initial southern focus toward Tacoma, with Burton as the commercial center, began to shift northward. Seattle was rising as the regional leader, and as ferry service expanded at the North End and roads were improved to serve automobiles, travel to the North End became easy. By 1920, Vashon town had emerged as the dominant commercial center on the island, and Vashon became the only island in the Salish Sea where the major commercial center is not perched on its shore.

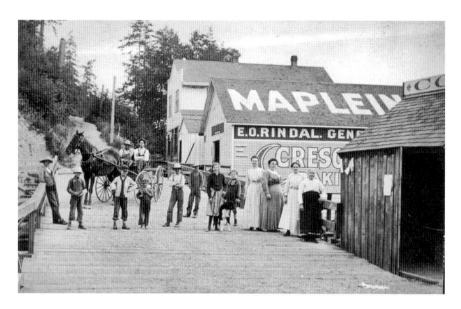

Cove was one of the many separate, self-identified, water-based communities that had stores, post offices, resorts, churches and clubs. Community identity was maintained in part by columns in the weekly newspaper, which reported the activities, visitors and news of the area to the rest of the island. *Vashon-Maury Island Heritage Association.*

The early pattern of local communities—each with its dock, store, churches, post office and community hall—continued into this era. Stores opened at Center (1884), Vashon (1890), Burton (1892), Ellisport (1894), Lisabeula (1902), Dockton (1903), Portage (1903), Cove (1907), Magnolia (1908), Glen Acres (1908), Vashon Heights (1909) and Tahlequah (1921). But as transportation improved, as more businesses concentrated in Vashon town and as owners aged and retired, these neighborhood stores became increasingly untenable. Many lasted into the 1940s, but in 2015, the only one remaining is Harbor Mercantile at Burton.

As Vashon town emerged as the commercial center, all the new technologies and businesses associated with growing towns came to Vashon—the automobile, telephones, electricity, banking, the YMCA, hotels, a newspaper, a mortuary, a meat market, a grocery store, a pharmacy, a real estate office and a blacksmith shop—began to transform Vashon town and the island.

In 1904, Farmer's Mutual Independent Telephone Company was franchised to install a telephone exchange at Vashon. The Island Empire Company installed an exchange at Burton. This began the two-exchange system on Vashon that would soon morph into the Red and Black exchange numbers and, ultimately, into the 463 and 567 numbers we have today.

Farmer's laid an underwater telephone cable from Aquarium to Fauntleroy in 1904, beginning phone service to Seattle that June. At the same time, Island Empire laid cable from Vashon to Gig Harbor for its Burton service. The Farmer's cable was faulty and plagued with troubles, and in February 1908, islanders protested against Farmer's: 80 of the 125 subscribers signed a petition to quit service until a cable to mainland was established as promised. Islanders also protested against Island Empire Telephone and Telegraph Company in April 1909 when the company sought to renew its telephone franchise. (Islanders have always been a contentious lot.) By 1916, there were two hundred telephones on the island; Pacific Telephone and Telegraph at Vashon and West Coast Company at Burton provided service. Later that year, Washington Coast Utilities purchased both companies and also purchased Vashon Power and Light, becoming an island phone and power monopoly.

A similar process took place when electricity came to the island. In 1914, Vashon Electric Company was franchised to install an electric system; it built a steam generator plant at Ellisport. After transmission lines were installed, service began on November 24, when Washington governor Ernest Lister, with appropriate ceremony, pressed a button to inaugurate electric service on Vashon. Originally, electric service shut down at midnight, but in September 1916, around-the-clock operations began. It took years for electricity to reach much of the island—until later in the 1920s, electricity was only available from Burton to Vashon town and Ellisport.

ISLAND POLITICS

Vashon continued to be a political hinterland to Tacoma and, increasingly, to Seattle during this era. King County viewed the island as a peripheral concern, but islanders saw the county as an oppressive presence, even as the county developed island infrastructure by building docks, starting car ferry service and paving roads (although the first paving was not completed until 1920). Although influenced by the emerging Populist and Progressive movements, the island continued to support staunchly conservative Republican candidates. Local politicians did little to change the island's relationship to King County and the State of Washington.

The federal presence was largely felt in the development of post offices—more of them in this era than Vashon had seen before or since. Since communities

weren't yet connected by anything but boat traffic, each had to have its own post office: at Quartermaster/Burton (1890), Aquarium and Lisabeula (1892), Portage (1903), Cove (1904), Colvos (1905), Reaco/Racoma Beach (1907), Dockton and Magnolia (1908), Cedarhurst (1912), Spring Beach (1913), Glen Acres (1914) and Luseata Beach/Camp Sealth (1916). But even as all these local offices were opening, their days were numbered with the introduction in 1907 of the first RFD (Rural Free Delivery) at Portage; another started in 1912 from Burton. Enjoyable as they might have been as social centers, local post offices became redundant when mail went directly to home and farm. The last local closed in the 1970s; only the Burton Post Office remains, still operating as a substation of the Vashon Post Office in 2015.

At the state level, Vashon Islanders served as representatives in the state legislature, but except for attempts to break away from King County to

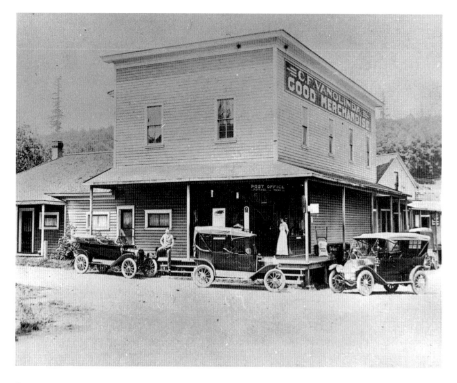

Portage, the link between Vashon and Maury, had a steamer dock and the first automobile ferry dock. Charles van Olinda built its first store in 1903, moving it north in 1906 to build the two-story structure that remains today as a private residence. The island's first Rural Free Delivery originated here, and there was also Sherman's Portage House hotel (1910–16), an Episcopal church and the island's first auto dealership. *Vashon-Maury Island Heritage Association.*

form a separate county, little activity took place in Olympia on behalf of the island. Elected in 1889 to the territorial legislature, John Blackburn was quickly upgraded to Washington State legislator after Washington became a state on November 11, 1889. Miles Hatch from Burton served in the 1895 legislature, and W.H. Clark served three terms in the legislature in 1899, 1903 and 1905.

The State of Washington enacted many of the era's Progressive reforms, but they had little impact on Vashon. When Washington voters approved an initiative in 1914 to restrict the sale of alcohol, illegal stills sprang up to meet the demand. The Wobblies, members of the Industrial Workers of the World, were actively organizing logging camps throughout Washington and mounted a successful work slowdown to demand wage increases. This strike did not seem to have much impact on Vashon lumber mills—perhaps because they were so close to so many available workers from Seattle and Tacoma.

Vashon has always had a strained relationship with King County. During this era of rapid growth, the county poured resources onto Vashon, but never enough to satisfy islanders. Burton was still the dominant town on the island during the 1890s and early 1900s, and the ferry connections with Tacoma kept islanders looking more toward Pierce County as a solution to the issues they had. The shift to a northerly focus came after 1900, when Seattle became the larger city, ferry service improved off the North End and Vashon town grew into the larger commercial center.

As increased use of the automobile created demand for better roads and for paved roads, King County built them. The county also built numerous docks to serve the growing waterfront communities. But when the southern boundary of King County was set in 1901, where it is today, and when the residents of nearby Browns' and Dash Points annexed themselves to Pierce County, Vashon Islanders began a series of efforts to break away from King County. Two factors encouraged the efforts to break away from the county. The South End was connected by economic and social ties to Tacoma because the twelve steamer docks in Quartermaster Harbor were all served by boats from Tacoma. Added to this was the lack of attention by King County to the south part of the island. In July 1903, residents of the southern half of Vashon petitioned county commissioners to annex the southern part of the island to Pierce County. The commissioners agreed if two-thirds of the affected residents voted their approval. In September, Southern Vashon voted down the annexation by a slim majority. A similar effort in 1907 also failed by a few votes.

A few years later, still aflutter with discontent, Southern Vashon islanders took a different tack: in 1911 and 1912, they pursued a movement to calve off a separate county for Vashon in the state legislature. In 1913, islander Ira Case of Magnolia got a bill before the state legislature calling for its creation, but the name had been changed to Bowen County to honor Senator Bowen from King County, who had led the fight for the new county. The bill passed in the Senate in February but failed to make it through committee and to a vote in the House. The Senate renewed the attempt in March and unanimously passed a bill to create a new county for Vashon Island, again named Bowen County. This second attempt also failed to come to a vote in the House; the bill died, the momentum lost.

These vigorous voter campaigns weren't lost on the King County commissioners; after these rebellions, they paid more attention to island issues. The county commissioners made an inspection tour to the island in 1915 as part of the Good Roads Association's efforts to improve roadways. After the commissioners visited again in 1917, efforts to break away subsided. As a small, politically isolated hinterland to Seattle, Tacoma, the state of Washington and the federal government, Vashon has always had a feisty and confrontational relationship with each of the governments that nominally control it.

FERRIES

The ferry wars, which continue today in different forms, first began in the 1890s. As the ferry network began to shift from Mosquito Fleet steamers to diesel-powered car ferries, this forty-year process saw eruptions of bitter and increasingly ferocious conflicts.

The First Ferry War was the West Passage competition between Tom Redding and John Vanderhoef discussed in the previous chapter. The Second Ferry War was fought in Quartermaster Harbor. The Third Ferry War was fought again in the West Passage. The Fourth Ferry War, a short-lived war between the Angus McDowell boats and A.D. Cowan's *Vashonia*, was fought on the East Passage. The Fifth Ferry War was fought between King County at Portage and the Puget Sound Navigation Company at Vashon Heights and Pierce County at Tahlequah.

The second war began in 1905 when the Tacoma and Burton Navigation Company and Vashon Navigation Company both began serving

Quartermaster Harbor. Frank Bibbins and Arthur M. Hunt formed the Tacoma and Burton Navigation Company in 1904 and had its steamer *Burton* built in 1905. Vashon Navigation Company was formed by Captain Chaucey Wimen and John Manson, who had the *Vashon* built at the Martinolich yard in 1905. The stage was set for the second war—a battle with roots much deeper than just two rival boats.

Frank Bibbins started the first regular ferry service in 1890 with the *Sophia*; he had been providing ferry service to the island for eighteen years. In 1895, Bibbins brought in a partner, Captain Chaucey Wimen, who purchased half interest in the *Sophia* and served as master while Bibbins served as engineer. In 1898, they retired the *Sophia* and built the steamer *Norwood*, which ran a regular two trips daily, for six years, between Quartermaster Harbor and Tacoma. But in 1904, the partners fell out: Bibbins left Captain Wimen with the *Norwood* and joined Arthur M. Hunt to form the Tacoma and Burton Navigation Company. With $25,000 in hand, they built a new steamer, the *Burton*. The *Norwood* broke down in February 1905 and was sold, so Captain Wimen, not to be outdone by his ex-partner, went to John Manson of the Dockton dry dock, formed the Vashon Navigation Company and built the steamer *Vashon* at the Martinolich yard in Dockton. Thus began a bitter competition and disastrous rate war that became one of the most storied competitions on all of Puget Sound. In 1907, Bibbins and Hunt built the steamer *Magnolia*, "one of the fleetest little vessels of her class on Puget Sound." But fleetness and seniority were trumped by money, as in 1909, Captain Wimen and Manson bought out Bibbins and Hunt, dissolved Tacoma and Burton Navigation Company and became the monopoly ferry service on Quartermaster Harbor.

While the Second Ferry War was going on inside Quartermaster Harbor, the Third Ferry War was brewing in the West Passage between Nels G. Christensen's series of *Virginia* ferries and the Merchant's Transportation Company's boat, the *Sentinel*. In 1908, Christensen moved his family from Seattle to Lisabeula, "partly to get out of the grocery business, but also to give his sons Vernon and Nels an opportunity to grow up in the country." Still half owner of North Seattle Grocery, he was commuting twice a week and getting annoyed at the unreliable *Sentinel* running the Tacoma/West Passage/Seattle route. When, in 1910, the sixty-foot, gasoline-powered *Virginia Merrill* came on the market for $5,000, he and neighbor John Holm bought it and formed the West Pass Transportation Company. When they dropped the name *Merrill*, the boat became the first of the five boats named *Virginia* working the West Passage. Christensen's first trip from Lisabeula

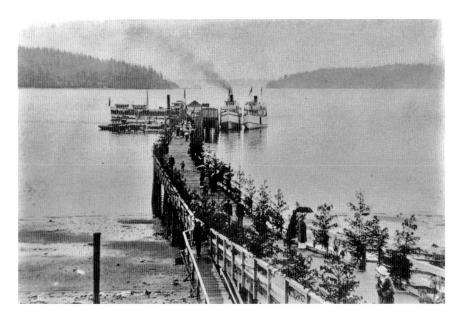

The Strawberry Festival at Burton in 1915, with three steamboats disembarking visitors, promoted the island as a break from urban living. *Vashon-Maury Island Heritage Association.*

was on September 10, 1910; he operated his vessels for twenty-seven years, expanding to serve both sides of the island. His *Virginia* boats were the last of the Mosquito Fleet ferries on the Vashon–Seattle run.

In 1911, Christensen took on Morris Shain, just twenty years old, as a partner to maintain the boat; young Morris worked off his investment in wages and made good within a year. Shain convinced Christensen that they needed a larger boat, so in 1912, Shain designed the *Virginia II*, which they built at Christensen's place just south of the Lisabeula Wharf. With a gasoline engine and Shain's hull design, the *Virginia II* was one of the fastest boats on the Sound. Shain later went on to design yachts; he opened the Shain Manufacturing Company, building Trimmer Craft boats and the sleek, classic Shain cruisers.

The *Virginia II* and the *Sentinel* were in continual competition along the West Passage, and because they were so evenly matched, the competition often turned ugly. Twice in 1913—first in July and then in October—the *Virginia II* and the *Sentinel* collided; no one was hurt, but the *Sentinel* was severely damaged both times. The two companies negotiated an agreement that the *Virginia II* would haul only passengers and the *Sentinel* only freight, but at the end of 1914, Merchants' Transportation withdrew, leaving the West Passage to Christensen's fleet. Christensen then purchased a one-hundred-

foot steamer and named it the *Virginia III*, which in 1918 would work the East Passage. Its steam whistle would be transferred to each of the new *Virginia* boats when they were built. In 1920, Christensen purchased another boat and named it the *Virginia IV*. The two *Virginia*s allowed Christensen to take over the East Passage routes abandoned by Angus McDowell when he retired. The *Virginia V*—perhaps the most famous of the *Virginia* series because it is the last operating Mosquito Fleet boat—was built in 1922 on the beach south of Ollala on the west shore of Colvos Passage. It was powered with the engine of the *Virginia IV* and served on the West Passage for nineteen years until retirement in 1941. Eventually, it was bought and restored by the *Virginia V* Foundation. Its steam whistle still shrieks over Quartermaster every summer during its annual fundraising cruise around the island for the Vashon-Maury Island Heritage Association.

The Fourth Ferry War took place on what islanders called East Passage, along the eastern shores of Vashon. The first ferry to make regular runs on the East Passage was the *Skagit Chief*, a large stern-wheeler that began daily runs in 1895. Three years later, the McDowell Steamship Company opened on the East Passage with the sixty-foot ferry, *Defiance* (1897). McDowell, a Scot born in Northern Ireland in 1850, came to Puget Sound in 1889 after he left Ireland at age fifteen to go to sea. He arrived in Oregon in 1888 and worked the steamboats on the Columbia. In the early 1890s, he worked as an engineer on steam tugs on the Sound and purchased *Defiance* in 1898 to offer a Tacoma/Vashon/Seattle passenger service. He soon replaced it with the newer ninety-three-foot *Dauntless* (1899), and over the next twenty years, he built five new boats—a new *Defiance* (1901), *Dove* (1904), *Daring* (1909), *Dart* (1911) and *Daily* (1912)—all of which worked the East Passage run at some point.

McDowell—whose "D-boat" runs began in Tacoma, stopped along the east side of Vashon and then went on to Seattle—came to dominate the East Passage runs, but not without occasional competition. When he launched the second *Defiance* in 1901, it was to compete with *Sentinel*. Their fare war began at twenty-five cents but soon dropped to a dime. In 1908, the Vashon Steamboat Company formed by A.D. Cowan built the 115-foot steamer *Vashonia* to serve the East Passage. Again, competition was literally head to head: in January 1909, the *Vashonia* collided with *Defiance* at the Portage Dock when both boats tried to land at the same time.

The Fifth Ferry War pitted the King County ferry at Portage against the new ferries at Vashon Heights and at Tahlequah. After the automobile first came to the island in 1907, islanders wanted ferries that carried cars, and

in 1915, they began a pitched campaign to get that from King County that ended in a December 4 vote on where such a ferry would dock. Portage won by 630 votes to 468—the largest vote recorded on Vashon to that time— over Vashon Heights and Vashon Landing for the Vashon terminus; Des Moines won over Three Tree Point and Seattle for the mainland terminus. The clamor for a ferry increased, and as King County built its brick Seattle/ Des Moines Highway, it also commissioned the ferry *Vashon Island*, the first purpose-built, diesel-powered automobile ferry on Puget Sound. King County constructed a ferry dock just north of Portage and a water-level road from there to Ellisport. The Portage/Des Moines service began in 1916 with six daily trips and a fare of ten cents per person; fifteen cents per head of cattle, horse or mule; and ten cents per sheep or hog—the lowest rates on the Sound. The Des Moines Seattle Auto Stage Company provided bus service from the dock to Seattle. Captain Wimen sold his interest in the Vashon Navigation Company and went to work for the county as master of the *Vashon Island* on the Portage run, giving a local touch to the new ferry.

Ferries are islanders' highways. The *Vashon Island*, the first King County ferry, was considered part of the county's road system. This system set the precedent for the Washington State Ferry System, formed in 1953, that is considered an integral part of the state's highway system.

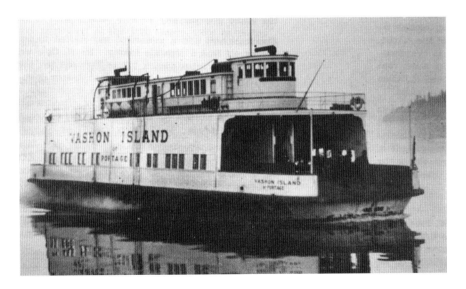

King County launched the diesel ferry *Vashon Island* in 1916 to serve the Portage/Des Moines route, the first automobile ferry service to Vashon. This established the precedent of ferry routes as marine highways. *Vashon-Maury Island Heritage Association.*

In August 1919, after residents of Vashon and Kitsap Peninsula pressed for direct service to downtown Seattle, King County opened ferry service from Seattle to Vashon Heights and to Harper, just north of Southworth. This service set today's three-way route off the North End of Vashon. To celebrate, on the first day of service provided by the ferry *Washington*, islanders threw a big party at the Vashon Heights ferry dock.

Clam Cove, now known as Tahlequah, hosted a third car ferry service that began in 1916. In 1918, with promises from King County for a dock and road to Vashon's South End within a year, Pierce County built a dock at Point Defiance for a proposed ferry to Gig Harbor and Vashon. On May 15, 1920, the Tahlequah/Point Defiance/Gig Harbor ferry service began with a celebration attended by three hundred people. The Tacoma Chamber of Commerce offered a fifty-dollar prize to name the new terminal; Ethel Whitfield, daughter of owners of the Burton Store, won by proposing the name Tahlequah, after the Indian territory capital of the Cherokee Nation, in Oklahoma. She thought the word *Tah-le-quah* meant "water view" or "pleasant water" (in actuality, the name more likely comes from the name *Chalequa* for the Cherokee tribe that is found on a 1597 map). P. Monroe Smock, editor of *Vashon Island News-Record*, read an original poem titled "Vashon Isle" at the opening. The ferry *City of Tacoma* was the first ferry; the fare was five cents. The Tahlequah service was run by the Skansie brothers of Gig Harbor with their boat *Skansonia* until the Washington State Ferry System was formed.

From 1916 to 1921, Vashon Islanders had a wealth of choices for ferries. The *Vashon* served the twelve docks of the Quartermaster Harbor/Tacoma run, while on the East Passage the McDowell boats *Daily* and *Dart* served the eight docks from Maury to Cowley Landing until McDowell retired in 1918 and sold them. Nels Christiansen then moved the *Virginia III* from its West Passage route to the East Passage and replaced it with the *Virginia IV* to serve the seven docks on the West Passage from Spring Beach to Biloxi. These were just the walk-on steamers. Car ferries were at Portage/Des Moines served by the *Vashon Island*, at Tahlequah/Point Defiance served by the *City of Tacoma*, at Vashon Heights/Fauntleroy/Harper served by the *Washington* and at Vashon Heights/Marion Street Dock served by the *Bremerton*. Vashon Islanders had the choice of nine different ferries at thirty-two different docks, a luxury we can only dream of today, when we have only two ferry docks served by four ferries and a population nearly five times larger.

That abundance lasted only five years. As roads improved and linked across the island, traffic shifted to the car ferries; the passenger-only business

would be gone within twenty years, not to reappear until the 1990s, when islanders commuting to jobs in downtown Seattle pressed for a passenger-only service. Once the north and south routes were in place, King County closed the Portage/Des Moines route in August 1921 and moved the *Vashon Island* to Lake Washington, and Vashon was down to the two car ferry services it has today. A few old pilings of the Portage dock and its concrete bulkhead can still be seen south of the Tramp Harbor fishing pier.

Vashon has always been dependent on ferries, and the ferry wars of this era were just the start of ongoing struggles over ferry service, costs and reliability that continue to this day.

THE Sx̌ʷəBABŠ, 1893–1920

In the first decades of the twentieth century, Indians became curiosities to those who wanted assurance that they lived in "the West." In raconteur histories of the island, stories about the Gerands' clam digging and Lucy's sewing abound. These personal but perhaps unreliable reminiscences, as well as the ethnographic data compiled during this time by Harlan Smith, Thomas Waterman and Lynn Waynick, are among the few records of Vashon's sx̌ʷəbabš.[8]

The truth is that in this period, as before, here as nationwide, the island's native people were marginalized and their culture disregarded. As reservation land rose in value, Congress and the courts sought to abolish Indian rights. We do not know how many local sx̌ʷəbabš returned to their ancestral home because the U.S. Census did not count Indians. The Puyallup tribal census of 1937 counted 322 tribal members but does not show how many were sx̌ʷəbabš.

We do know that U.S. educational policy toward Indians affected island sx̌ʷəbabš: islander Rosemary Bridges-James recounted how she was taken out of the Vashon schools and sent to St. Thomas, the Indian residential school for the Puyallup Reservation in Fife. In her testimony, she spoke of being taken from her family and culture and forced, like the other native students, to give up speaking Salish in favor of English.[9]

We also know that strawberry farmers recruited First Nations people from Vancouver Island and the Fraser River Valley to work the fields, introducing a new generation of non- sx̌ʷəbabš Indians to the island.

Lucy Gerand's testimony at the Land Claims Tribunal of the 1920s documented the sx̌ʷəbabš presence on the island. In a series of events over

the next fifty years that Alexandra Harmon characterized as "definitional ceremonies," the Puyallups and other Puget Sound Indians began to claim and assert their shared identity and history, starting down the road toward the Boldt Decision of 1974, which initiated the process of returning many of the original rights abrogated in the 1854 treaty.[10]

CONCLUSIONS

While the era of settlement established the pattern for Vashon, this era of foundation took those patterns and shaped them into the island we know today. During the next era, Vashon would suffer through an agricultural depression, the Great Depression and the Second World War. In the midst of these hard times, islanders began to define themselves as more than a collection of separate shoreline communities. They defined themselves as a single island.

HARD TIMES

1920—1945

Vashon Island's population is spread over its surface in small clusters like fly eggs. Each small community has a name.... Quite naturally each community believes that its residents are the most refined, most intelligent, most desirable, its beach the finest, its view of Mount Rainier or Olympics the most spectacular, its clams the sweetest.[1]
—*Betty MacDonald*

INTRODUCTION: DECLINE, DEPRESSION AND WAR

From 1920 to 1945, Vashon experienced hard times. These hard times are divided into the challenges of the 1920s as the island became more connected and an agricultural depression hit the island, the hard economic times of the 1930s Great Depression and the hard adjustments to World War II in the 1940s.

The island changed rapidly. It went from having more than thirty Mosquito Fleet docks to only two ferry docks as the automobile transformed transportation, from eight independent school districts to one island-wide school district as consolidation took place, from sixteen post offices to ultimately one and from eleven community stores to only three as local community centers disappeared. The island was becoming a single connected island rather than a collection of separate communities.

New technologies also changed Vashon. The number of cars grew rapidly. With cars came demands for more and better roads and ferries. Roads

The arrival of the first automobile on the island in 1907 spurred road construction and encouraged touring. This 1914 photograph of Terkel Hansen's Model T with Charles van Olinda, Henry Weiss and Terkel Hansen was taken at Mount Index. *Vashon-Maury Island Heritage Association.*

connected the island by land routes, and automobile ferries needed more substantial docks and larger boats. The first telephones arrived in 1904, and electricity came to the island in 1915. Coverage was initially small, but as they both rapidly expanded during the 1920s, phones and electricity created other ways to connect the island. The island was becoming one. This transition to a single connected island was voiced by a Maury Island resident who chided the newspaper editor over her use of the term "Vashon-Maury": "This Vashon-Maury stuff…is old, very old, and tends to division rather than the unity of Vashon Island for which we are all striving."[2]

The collapse of three of the original "Big Four" economic engines of the island economy—logging, fishing and mining (farming remained strong in limited sectors)—led to a new island economy and a new island community. The agricultural depression of the 1920s saw the population growth of the pervious twenty years stall and decline from 2,810 in 1920 to 2,798 in 1930. The population had regrown to 3,118 by 1940 because workers came for new war jobs as the Puget Sound region prepared for the coming war and as waves of migrants fled to the coasts as the Dust Bowl crippled the center of the nation.

The war brought a level of economic recovery to the island but also brought rationing, price controls, young men and women serving and dying and the island's Second Internment. Vashon's ethnic Japanese residents were imprisoned in what President Roosevelt called American concentration camps.

These hard times spurred new social, political and economic realities, which gradually developed so that by the end of the Second World War, a very different island had emerged.

A Divided Era: The '20s, the '30s and World War II

This era of Vashon's history is clearly divided into three very distinct periods: the 1920s, the 1930s and World War II.

The '20s: Decline

The transitions that characterize the 1920s are best seen in the population decline as a result of the agricultural depression. The only other time the island has lost population was following the depression of 1893.[3]

The 1920s began with relative prosperity on the island. The labor conflicts of the previous few years were over, agriculture products were still in demand and the community looked to a promising future. The annual Strawberry Festivals resumed, and local communities remained the primary focus, although their importance began to fade. New organizations were formed on the island like the Daughters of the American Revolution in 1922 and the Pioneer and Historical Society in 1923, both of which expressed islanders' desires to connect with their pioneer past and to connect the island as a whole. Relations between the two organizations were strained at times, but they worked together to erect the Pioneer Monument on November 11, 1927, at its present location at the foot of Monument Road.

In 1925, the Vashon Community Club formed, purchased the school property north of Vashon and remodeled the building into the Island Club at the present site of Ober Park. The Vashon Horticulture Society was revived in 1923, and in 1926, the Vashon Lily Association formed. In October 1927, foreshadowing the "Christmas Miracle" of 1998, Reverend Vereide called together twenty islanders to save the Goodwill Farm in what might be called the "Halloween Miracle." The Goodwill Farm was a working farm that provided for indigents. The farm became an important safety net during the Great Depression. It was located north of Vashon at the present site of Vashon Community Care (VCC). All of these represent an island-wide focus rather than the local community focus of the past.[4]

The island economy during the 1920s continued to have an agricultural focus that was in decline, but some of the niche sectors like strawberries, poultry and greenhouses did well. Vashon was one of the first rural communities in the Puget Sound region to experience a rapid decrease in farming after World War I, ferry expenses and difficulties finding labor made large-scale farming difficult. As a result, businesses on the island suffered, and the population declined. Farms were becoming smaller and worked more intensively. The Japanese came to the island in increasing numbers, attracted by available land they could lease that was suitable for strawberries and other garden crops. The number of Japanese residents grew from 90 in 1920 to 140 in 1930, but their total farm acreage dropped from 2,600 acres in 1920 to 1,000 acres in 1931 as farms became smaller.[5]

This decline in farm size was the result of discrimination against the Japanese by land laws that limited their ability to own land. The Washington State Alien Land Act of 1921 extended the existing prohibition against Japanese owning land to include the renting and leasing of land. In 1923, a second Alien Land Act prevented owning land in the name of a child, thus

forcing families to put their land in the trust of friends or a white lawyer. These acts were not repealed until 1966. For native people on the island, there were no specific laws prohibiting landownership after Indians became citizens in 1924. Before 1924, some sx̌ʷəbabš had sold their allotments on the Puyallup Reservation and in doing so gave up their legal status as Indians and were considered for legal purposes as non-Indians. Some of these sx̌ʷəbabš had retuned to Vashon and purchased land and became part of the community, although with limited and prescribed opportunities. The Anchetas, Daniels, Gerand, James, McCully, Rogers, Thomas and Williams families all lived on Vashon at some time between 1920 and 1940.[6]

For other Vashon farmers, the poultry business continued to prosper, with them selling eggs to the Seattle and Tacoma markets, and the Beall and Morgan poultry ranches continued to be nationally recognized suppliers of laying hens. In 1928, 150,000 laying hens produced thirty-five thousand cases of eggs with a value estimated at $447,000. Greenhouses also continued to prosper, as the Bealls began to move into flowers, while the Hoshi, Stanley and Fuller greenhouses continued to supply plants and greenhouse crops for the urban markets.[7]

Fishing continued to decline in the Puget Sound as fish stocks were depleted. The Bearing Sea Packing Company opened the Dockton Cod Fish Dock and continued to operate into the early 1930s. Railroad cars were sent by barge, and the plant shipped an average of one car per month. In 1920, two hundred tons were shipped. Fish traps were still legal, and Theo Berry's traps at Dockton continued to catch salmon, but in decreasing numbers. The scallop fleet out of Cove Dock fished into the 1930s, and the fishing fleet from Dockton began to travel farther north into southeast Alaska to find profitable catches.

Mining in the form of gravel pits continued to produce on Vashon, and during the 1920s, the Pembroke Investment Company extensively developed the gravel pit sites on Maury Island, which had been operating for a number of years at a low level. Construction projects around the Sound boosted out take, and in 1925, Vashon Sand and Gravel purchased the Pembroke sites.

Logging was in serious decline. The Sherman Mill in Paradise Valley closed in the mid-1920s, and the Steen Mill moved from Cove Road to Ellisport in the late 1920s. Steen soon sold the mill to Fuller, which operated it sporadically throughout the 1930s, although it depended on off-island logs for the last several years of its operation. The heyday of logging was over. Large-scale logging on Vashon was no longer profitable, and by the early 1930s, dimensional lumber began to be imported onto the island.[8]

Island electricity had a more stable source when, in 1923, Puget Sound Power and Light Company bought the holdings of Washington Coast Utilities as part of a consolidation and took over all telephone and electric service on the island, laying a "first class" cable from South End to Tacoma. On December 24, 1924, a ship dragged its anchor in high winds and tore out the electric cable to Vashon. Puget Sound Power and Light leased the tug *Roosevelt* (famous from the Peary North Pole Expedition), installed a generator and supplied the island's electricity for three months. In May 1925, a new cable was installed that increased voltage and provided more reliable electricity to the island. Electric lines were extended to Vashon Heights and to Southern Heights so that by June 1926 most communities had electricity.[9]

Some businesses continued to flourish and new businesses opened during the 1920s, but in general the economy was suppressed compared to the pre–World War I era. In 1923, Ed Zarth converted the old Baptist church at Center into a garage and then opened an Overland-Willys dealership. The Stuckey and Martinolich shipyards in Dockton stayed active repairing boats, and Martinolich launched a series of fishing trawlers concluding with the *Janet G* in 1929. In 1920, Standard Oil constructed a fuel depot between Portage and Ellisport near the old Portage/Des Moines ferry dock and provided oil and gas to the island into the 1970s. There was a short-lived miniature golf craze in the 1920s with two new courses opened, one indoors and the other outdoors, and in 1930, the Vashon Golf Club opened.

The tourist economy continued to develop during these years but at a slower rate. The Camp Fire Girls purchased the 160-acre Luseta Beach resort and renamed it Camp Sealth. Camp Burton continued to serve as a Baptist summer camp, and the Methodist Assembly continued to meet at Beulah Park. The resorts at Lisabeula, Glen Acres and Luana Beach; the Swastika Lodge at Dilworth, the Madrona Lodge at Ellisport, the Island Inn at Burton and the Kingsbury Lodge; and the many summer communities like Maganolia, Manzanita, Glen Acres, Corbin Beach, Sylvan Beach, Spring Beach, Summerhurst and others all continued to attract summer visitors.

Vashon during the 1920s was dominated by traditional rural agrarian Republican politics, by concerns over roads, by the formation of water districts and by issues with King County concerning a lack of attention and resources. Island politics remained primarily local, with very few issues beyond the concerns with roads, docks and schools. In 1925, Vashon town organized Water District 19 and added electric pumps to replace the original rams in 1933 after the Vashon Fire. West Side Water was incorporated in 1928 and built a ten-thousand-gallon tank, laid 14,000 feet of pipe

Private cabins like Idle Hour at Spring Beach and platform tents like the one seen next to the cabin were popular summer escapes. *Vashon-Maury Island Heritage Association.*

and appointed John Zarth to be superintendent. In 1931, Heights Water Corporation was formed. It absorbed the old company at the North End, built a new wooden twenty-thousand-gallon tank and laid 14,500 feet of new water mains. The Island Mutual Water system from Center to Portage was formed in 1929, and in 1932, all the systems were connected so there would be water available if any one of the systems shut down. The island was becoming increasingly connected.

The main highway from Vashon town to the Heights Dock was paved in 1920. The new concrete highway was eight miles long, cost $185,000 and would be Vashon's only paved road (and the only paved road on any Puget Sound island) until after World War II. A new road was built from Portage to Dockton in 1925, creating the current Dockton Road. The Washington Automobile Club installed road signs in 1925, and throughout this period, the Commercial Club had a roads committee that was responsible for making recommendations about the expenditure of county road funds. In 1926, county commissioners approved a road from Burton to Magnolia and

then on to Tahlequah that would take another eight years to complete. Road construction in 1929 connected the Dilworth and Glen Acres Roads, built Cunliffe Road and improved numerous blind curves and steep grades. The Vashon road supervisor was an elected position, and there were often heated races for that coveted county job. There was also a continued effort to ensure that what islanders paid in county and state road and gas taxes was returned to the island for road construction and maintenance. This is an issue that still resonates with islanders ninety years later.

The island dutifully voted for Republican presidential and gubernatorial candidates during the 1920s and in 1922 elected Magnolia resident Ira Case to the state legislature, where he served for two terms. But for the most part, island politics during the 1920s were low-key and focused on local issues. Most decisions affecting the island were made by King County and the state. In 1929, after Charles Merry, the locally elected road supervisor was replaced by King County for "being disloyal to the administration," there were stirrings of an effort to create a new Rainier County from parts of south King County and northern Pierce County in the state legislature. This effort faltered but would be revived again four years later.[10]

Vashon College, which had closed in 1910 following a fire, was sold in 1926 to be converted to a tuberculosis sanitarium when the need for sanitariums grew rapidly during this era. A fire in the closed Commercial Building in 1930 led to the college buildings being razed and the campus turned into home sites, ending Vashon's experience with higher education.

The '30s: Depression

With the collapse of the stock market in October 1929, Vashon gradually began to feel the effects of the Great Depression. Early comments seemed to indicate the belief that that Vashon would not be affected. The 1931 *News-Record* noted, "There seems to be no indication of a depression, or of lack of faith in the future." This initial optimism soon gave way to realities and comments about the need to help others, the need for jobs on the island and the ways the government could help the island. By early 1933, the schools were cutting back substantially because of "the great amount of money in unpaid taxes." The Great Depression continued to deepen on the island, and "depression dinners" and "depression dances" became common themes for community activities.[11]

During the 1930s, clubs remained an important part of the island community, and new clubs had an island-wide focus. The Sportsman's Club was formed in 1933, built its clubhouse in 1940 and brought together islanders who sought to maintain hunting and sport fishing on the island. Other new clubs included the Vashon Businessman's Club, the Veterans of Foreign Wars, the Democratic Club, the Republican Club, the Vashon Chorale, the Teacher's Club and the Commonwealth Club—all had an island-wide focus.

There were some bright spots on the island during these years, but the dark clouds of the Depression came to dominate island life. Beginning in the 1920s and 1930s, Vashon came to be known as a refuge for artists and writers. Photographer Norman Edson; illustrator Clarence Gardner, well known for his historical logging scenes; bird painter Edmund Sawyer; writer Betty MacDonald; and many others laid the foundation for Vashon as a community of artists. Another bright spot came in 1933 when Bill Smith of Portage, who played high school football at Burton High School, was named all-American at the University of Washington. He is the only islander to ever receive that honor. Vashon State Bank never failed, reopened successfully after FDR's 1933 "Bank Holiday" and continued to be a secure place for Vashon individuals and businesses to bank. Despite these bright spots, the general welfare of the island became dimmer, and life for most became more difficult.

In the 1930s, Vashon's patterns of discrimination shifted to Filipinos and blacks. Filipinos continued to immigrate into the United States in large numbers, and as more Filipino pickers came to Vashon each year, tensions between the itinerant Filipinos and the local white population developed. In the early 1930s, as economic tensions grew and with more than fifty Filipino workers arriving on the island to pick fruit, dynamite blasted cabins occupied by Filipino workers at Ellisport and Shawnee following earlier fights between Filipinos and whites. In June 1934, "Wearied by repeated complaints from Island parents…F.J. Shattuck, deputy sheriff, has served notice that all Filipinos must be off the Island before the end of the week." Later in the decade, Phillipe Baccaro, a Filipino who married a native woman from the Thompson group in British Columbia, became a labor contractor and brought large groups of Canadian First People to Vashon to pick and to work in the Mukai cannery.[12]

There were very few black residents on Vashon, but with the devastations of the Dust Bowl, many African Americans fled the center for the coasts. A number of black migrants from Arkansas found their way to Vashon and settled in Lisabeula. This led to a June 1934 headline in the *News-Record*

declaring, "Sentiment Voiced Against Influx of Negroes to Vashon Island Districts...the citizenry is decidedly incensed over the influx of Negroes who have taken up their residence...in the vicinity of Burton and Lisabeula. A committee was appointed to take whatever action in the matter seen fit...the majority felt that at least the eleven Negroes who are not legal residents of Washington should be returned to a locality where authorities have the knowledge of handling the race."[13]

The final consolidation of schools into one district was completed during the 1930s. In 1920, there were eight school districts on the island, and by 1940s, there was only one unified school district. In 1928, the island voted to form a Union High School district. A twenty-acre site was selected at Center, and in September 1930, the new high school was dedicated. When the new high school opened, the two former high school buildings were used for the Vashon and Burton Elementary Schools. A 1941 island-wide vote, approved by all but the Columbia District, led to the formation of Vashon School District 402. By the end of this era, the structure of Vashon schools was set for the next thirty years with elementary schools at Vashon and Burton and a single island high school.

As the Depression deepened, the island was hit hard. While the niche economies still employed many islanders, subsistence farming, local fish and shellfish and government work programs provided basic sustenance for many island families.

Vashon agriculture was least affected. The specialized sectors of berries, eggs and greenhouses continued to flourish. The Beall, Hoshi and Stanley greenhouses all continued to employ islanders and supply flowers, seedlings and other garden crops to the markets. Eggs were also in continued demand, as were the laying hens that the Morgan and Beall ranches supplied. And berries—particularly strawberries but also increasingly loganberries,

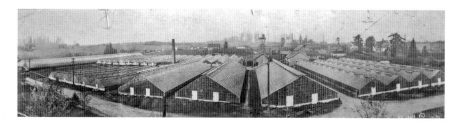

The Beall Greenhouses became a mature business during the interwar years and began to shift emphasis from the garden farm vegetables that grew the business initially toward flowers— particularly orchids, roses and a few other cut flowers. *Vashon-Maury Island Heritage Association.*

raspberries, currants and the new Olympic blackberry (developed by islanders Peter Erickson and his son-in-law, Hallack Greider)—were important and profitable crops. Greider's Olympic Berry Company sold to the Seattle department store Frederick & Nelson, which developed a line of products using the Olympic blackberry. The Hake Winery founded in 1936 produced a number of fruit and grape wines near Dockton and established a tradition that by the 1990s had become a flourishing winery presence on Vashon.

Because the Puget Sound fishery collapsed, the Vashon fishing fleet began to travel north to the coast of southeast Alaska to keep its boats operating and profitable. In 1934, the dangerous trip north for Dockton fishermen became deadly when on July 26, 1934, the fishing boat *Umatilla*, with Captain Lucas Plancich in command, was struck from behind by the battleship USS *Arizona*. It was a moonlit night with calm seas off Neah Bay when the *Arizona* split the *Umatilla*, killing two Vashon crewmen, Lauritz Halsan and John Urosac. The collision resulted in the court-martial of the *Arizona*'s captain for "culpable inefficiency." The *Arizona* was sunk during the December 7, 1941 attack on Pearl Harbor. Island fishermen continued to travel north each summer, but the tragedy of 1934 deeply affected the island.[14]

The Mauk Hotel was built in Burton in 1908 to provide rooms for traveling salesmen and for single teachers. There were numerous hotels on the island until after World War II. *Vashon-Maury Island Heritage Association.*

The modest tourist economic activity of the 1920s suffered even more during the difficult times of the 1930s. What saved the island during the 1930s was the New Deal programs of the federal government and the various state and county projects, all of which brought much-needed jobs and cash to an island that was resource rich but cash poor.

A major setback struck the island in the early morning of April 17, 1933, when much of the center of Vashon Village burned in "the most destructive fire in its history." The fire began in the back of the Transportation Company's garage, and by the time it was discovered at 3:20 a.m., it had burned into the Middling block next door. As the east side of the street burned, the Vashon Theatre next to the Presbyterian church was saved, and the fire was prevented from burning farther south. The fire jumped the street and burned the England & Petersen lumber and feed store, the Met-Cro Garage and the Beall-Hansen Building. When the power lines were cut, water from the North End system could not be pumped, and with inadequate water pressure the fire could not be attacked. The masonry wall of the Deppmann Building to the north and dynamiting the Clark carpentry shop to the south were the only things that contained the fire. Otherwise the entire village would have burned. Later that day, with no power to keep his ice cream cold, Tim Clarke, owner of the Sweet Shop, told everyone to bring spoons and eat the ice cream before it melted. Vashon Village was rebuilt with larger and more substantial buildings that were less susceptible to fire, but the fire dealt a hard bow to a community already reeling from the Great Depression.[15]

Vashon politics turned to New Deal concerns over relief work projects, and Vashon voted Democratic for the first time. The issues included a new county building, new roads, the removal of old Mosquito Fleet docks and continued lack of attention that led to an attempt to form a new Vashon County.

Vashon was already a stronghold of temperance activity when the Eighteenth Amendment on Prohibition was ratified in January 1920. Vashon College had bragged that there were no bars on the island in its promotional brochures and that there was a well-organized and powerful Woman's Christian Temperance Union chapter on the island. During the 1920s, while Prohibition was in effect, there were numerous raids on stills, and nighttime movements of boats running alcohol were a regular sight. When Prohibition was being repealed, many islanders joined the Vashon Island Eighteenth Amendment Society to fight repeal and sponsored a well-attended "Dry Parade" in October 1932. Despite this teetotaling tradition, Vashon voted to become "wet" in August 1933 by a vote of 403 to 313, and

the Beach Tavern, at the foot of the Heights Dock, opened as the island's first legal bar.[16]

The 1932 presidential election was the first time Vashon voted for Democratic candidates. An "unusually heavy vote" put Democrats Franklin D. Roosevelt in the White House and Clarence D. Martin in the Governor's Mansion and changed the balance on the King County Commission. These victories were repeated with even larger margins in the 1936 elections. These changes began to show the shift of Vashon toward being a hotbed of liberal Democratic politics.[17]

The Depression helped cement Vashon's colonial dependence on King County, the State of Washington and the federal government. The Washington Emergency Relief Administration (WERA) was created in 1933 and reorganized the Seattle and King County relief efforts into the King County Welfare Board. This allowed the county to respond to islanders' ongoing demands for county buildings on the island. The county commissioners had provided the first full-time sheriff in 1930 and promised Vashon a county building and jail. The reorganized relief effort allowed the county to finally construct the road depot, a garage for equipment and a jail at Center in 1936 using WERA and Works Progress Administration (WPA) funds provided by the state and federal government. All throughout this period, King County road maintenance and construction provided jobs for more than ninety men. Island women did not do well during this period because the relief efforts tended to define men only as workers and as heads of households.

Various projects at island schools building shelters, remodeling buildings and constructing gyms; sidewalk construction in Vashon town, Burton and Dockton; removal of steamer docks at Colvos, Cross Landing, Kingsbury, Mileta, Maury, Fernheath, Portage, Ellisport and Vashon Landing; and dock maintenance projects at Burton, Tahlequah and Vashon Heights all provided jobs supported by county, state and federal funds. Ten workers, earning forty-five cents per hour, cleaned the Vashon Cemetery in 1933. As late as 1939, thirty-eight men were employed to survey the island and establish clear section lines, and a crew worked at Point Robinson constructing the road down the hill and filling in the meadow with the debris.[18]

The federal government kept the island economy working through the various National Recovery Administration (NRA) and Agricultural Adjustment Administration (AAA) proposals to regulate unfair retail and wholesale competition. Vashon businesses quickly and eagerly adapted NRA-certified practices and placed "Blue Eagle" emblems in their store

windows. Island farmers B.D. Mukai participated in developing the code of practices for berry growers, L.C. Beall worked to develop the code for poultry growers and egg operations and Wallace Beall, president of the Puget Sound Greenhouse Association, helped develop the code for greenhouses. The Civilian Conservation Corps (CCC), the National Youth Administration (NYA) and WERA also provided jobs for islanders. Most of the CCC jobs worked out of Camp Saltwater at Des Monies, the NYA jobs were for "new worker" positions at island businesses and the WERA jobs were primarily with county road projects.[19]

Vashon also responded to the Great Depression in its own unique ways. In 1931, islanders formed their own Welfare Committee by asking one hundred islanders to pledge $0.50 per week to fund relief efforts and provided what relief it could until the state and federal programs took over. Despite all these efforts, the Great Depression was very hard on the island. Teachers were forced to take a 10 percent pay cut in 1932, and high school students were limited to eight pages of paper per week in 1933. Agricultural wages fell to only $0.03 to $0.04 per pound, or about $4.50 per day, which made it difficult to find pickers during the picking season. The traditional Canadian First Nations and Filipino pickers no longer came to the island in the numbers they had in the past, and island farmers struggled throughout this decade to find enough workers.

The Unemployed Citizens League, an organization of unemployed in Seattle, came to the island in June 1932 and attempted to implement a cooperative picking operation that paid union wages. The league took over a leased farm on the West Side and held mass meetings at Lisabeula and Vashon town to explain its plan. The *News-Record* and most island farmers were not impressed and saw the league as a socialist/communist threat to the traditional way of organizing island labor. Because the island was so uninviting to what was seen as a radical approach, and because the response by workers did not develop, the league soon withdrew and islanders continued to slog their way through the hard times.

On the more quirky side, in 1933, when the rest of the island changed to daylight savings time, the South End refused, perpetuating the old Mason-Dixon distinction, and remained on standard time, creating havoc for ferry riders.[20]

Three of the most lasting efforts from this decade were the six-year sequential construction of the Burton-Shawnee-Magnolia-Tahlequah Road, the development of Vashon State Park at Dockton and the construction of the first radio stations/towers on the island.

Islanders on the South End had long pushed for an easier route to Tahlequah from Burton. These efforts began to coalesce when the Burton-Shawnee Road was opened in 1928. The road was extended to Magnolia in 1932 and finally completed to Tahlequah in 1934. Attempts to designate the Tahlequah to Heights Road a state highway, and thus gain state funds to improve and maintain it, never succeeded. The linking of Vashon Heights to Tahlequah by a direct road we now call Vashon Highway was an important part of breaking down the isolation of communities.[21]

Captain Frederick Sherman first proposed a park at Dockton in the 1920s, and in January 1936, a park committee with representatives from every organization and every community on the island was formed to decide how to use the $39,720 allocated by the state for development of a Vashon park. The committee chose the twenty-three-acre site at Dockton, which was known as "Sleepy Hollow," and purchased it for $1,300. Plans were developed for a bathhouse, kitchens, restrooms, parking lots and a caretaker cottage. When the site was cleared between the beach and the road, as many of the maple and native yew trees discovered on the property were preserved as possible. A log seawall was installed, the swampy area was made into three rock-lined lily ponds, the kitchen area with brick stoves was constructed and the bathhouse and changing rooms were built with milled logs. By July, the park was ready, and the first use was the Fourth of July celebration that year. The park was formally dedicated on July 12 and deeded to King County as part of the County Park System.[22]

The selection of Vashon as a site for radio towers made a significant impact on a community seeking jobs and new development. KVI Radio in Tacoma was the first station to see Vashon's central location in the Puget Sound Basin as a way to reach a much larger audience. The KVI engineers determined that the site at Ellisport, locally known as the Sand Spit, would make an ideal site for their new radio tower. Construction of the 444-foot tower and broadcast facility began in July 1936, and in October, the final steps to begin broadcasting took place. The new facility required improved electric service and a large water main, both of which improved those services for everyone in Ellisport. KVI began broadcasting from Vashon on Sunday, November 29, 1936, and initiated an era of radio stations as a significant part of the Vashon community. Vashon was a prominent part of the first broadcast, and two engineers and their families became new island residents. KIRO built its tower and broadcast facility on Maury in 1941 with fifteen employees, and KOMO followed in 1943 and KING (then KEVR) in 1943. By 1948, there were more than fifty radio employees on the island, and they formed the

Left: Oliver Scott van Olinda came to Vashon in 1891. He edited *Island Home* (1893–94), the first publication on Vashon, and the *Vashon Island Press* (1895–97), the island's first newspaper; served as historian for the Vashon-Maury Pioneer Society; and, in 1935, published his *History of Vashon-Maury Islands. Vashon-Maury Island Heritage Association.*

Below: In 1938, George McCormick, on a bet from a neighbor, agreed to walk around the fifty-one-mile shoreline of the island in under twenty-four hours. The "Hike" started at Tahlequah with Sheriff Finn Shattuck firing the starting pistol. *Vashon-Maury Island Heritage Association.*

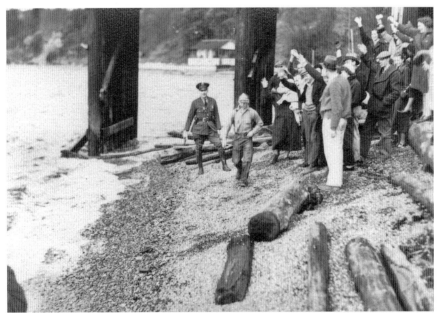

Ki-Mo-Vi-Ro Radio Engineers and Wives Club, named after the four major radio stations: KING, KOMO, KVI and KIRO.[23]

Two defining events occurred during 1935 and 1938 that foreshadowed the more unified island that would emerge after World War II. Oliver van Olinda published his *History of Vashon-Maury Island* in 1935. It was a deeply flawed work, rife with the racial and environmental attitudes of its time and with no interpretation and no analysis, yet it is the first attempt to see the island as a whole. In 1938, after much discussions and speculation about how long it would take to walk the fifty-one-mile shoreline around Vashon-Maury Island, Theo Berry, who owned the store at Dockton, bet George McCormick, owner of the Vashon Hardware Store, that he could not do it in under twenty-four hours. Undaunted by high tides— sometimes wading up to his armpits—and without using paths, roads or bulkheads, George completed the hike in twenty hours and fifty minutes. The event, while trivial on one level, united the island, as hundreds showed up around the shoreline to cheer him on. The Van Olinda *History* and the McCormick "'Round the Island Hike" are emblematic of the shifts that led the island to a new consciousness as one unified community rather than a series of isolated settlements.

The '40s: War

World War II had been raging in Europe for nearly three years and in the Pacific for nearly four years. When Japan attacked the United States at Pearl Harbor on December 7, 1941, the United States became a full combatant in both parts of the war. The Puget Sound region was defined as a "defense sea area," and Vashon became part of the defense network for the war industries in the region.[24]

Vashon began preparing for the coming war in October 1941, when a group of islanders met in the cribbage room of the Alibi Restaurant and quickly began air raid drills and civil defense practices and developed an "Animated Defenseograph" to organize the island's response. Military officials presented information on air defenses and defense planning to island clubs. Thus, the coming of the war was no surprise, despite the surprise of Pearl Harbor, and the island responded quickly. Paul Billingsley was appointed commissioner of the island's Civil Defense; air raid observation posts were set up at Cove, Vashon and Maury; air raid drills were held; blackout regulations were enforced; and all war veterans were identified to form a

sharpshooter corps under Captain John Metzenberg to defend the island. Vashon's civil defense system became a model for other communities, and because of the success of Billingsley's efforts to organize the island, he was appointed state director of Civil Defense. Ruth Black took over for the island and later was appointed the state assistant women's director for Civil Defense.[25]

Vashon developed all of the homefront efforts we have come to associate with the war. Scrap metal, rubber and paper drives became regular occurrences. In a three-week period in October 1942, forty-four tons of scrap metal was shipped from the island, much of it unused or abandoned farm equipment. Rationing for fuel, tires, coffee and sugar were quickly implemented, and the Office of Price Administration set the cost on most consumer items. A cord of wood was set at $13.50. Because of the need for oil during the war, King County suspended oiling Vashon roads, and the roads deteriorated during the war. The Coast Guard closed Quartermaster Harbor to all boat traffic between sunset and sunrise.

Draft registrations began in late 1940 as the United States instituted its first peacetime draft. The island sent a large number of young men and women to serve in the military. The 505 Vashon men and women, 1 out of every 6 islanders, served their country with distinction and honor; 13 of Vashon's young men—Harold Agren, Douglas "Ladd" Bacchus, Thomas Bacchus, Hans Hermansen, Russell Hoflin, John Igraham, John McKinstry, Robert McQuade, Robert Marshall, John Miller, Einar Moe, Oscar Nelson and Robert Shumway—gave the ultimate sacrifice, and their deaths hit the small community hard. Also, 12 Vashon Japanese young men—Mas Kunugi, Yoniechi Matsuda, Jimmy Matsumoto, Don Matsumoto, Glenn Miyoshi, M. Miyoshi, Mas Nakamichi, Tokio Otsuka, Sam Sakamoto, Augie Takatsuka, George Takatsuka and Tom Yoshimura—were imprisoned yet served the country that imprisoned them. Many more served on the homefront as volunteer air raid wardens, air observers, first aid workers, Civil Defense volunteers and workers in the many Puget Sound war industries, as well as in Vashon agriculture. These members of the "Greatest Generation" included 20 women. All those who served and those overseas and on the homefront were an important part of the war effort. Vashon stepped up to do its part for the war effort.[26]

Military personnel were stationed on Vashon for the first time. The closed Center School was reopened as military headquarters for the island, and an anti-aircraft battery, Battery C (Charlie Battery) of the Army Coast Artillery, was assigned to the island as part of the defense of the Seattle-Tacoma area. Vashon clubs joined to create a Serviceman's Club at the

Island Club, and communities at Lisabeula, Ellisport, Dolphin Beach and Burton hosted servicemen at picnics and celebrations. For island teens and twentysomethings, the young servicemen presented new social opportunities for young women to date and for young men to experience what the British, Australians and Kiwis had already experienced of having eligible young men on the island who were "over paid, over sexed, and over here." Two P-38 fighter planes crashed in Colvos Passage in June and August 1942, increasing islanders' awareness of the realities of the war. Islanders rescued both pilots, but one plane still sits on the floor of the Sound because the depth was too deep to allow a recovery.[27]

Although the war was the primary focus of the island, the realities of everyday life did not go away. In January 1943, a crippling eighteen-inch snowfall and several weeks of unusually frigid weather paralyzed the island. Stores curtailed hours, mail was delayed (sometimes for days) and power lines went down, but island children found that the army trucks with chains could be persuaded to pull them up steep hills so they could sled down.

Clubs continued to meet and elect officers, the Vashon Theatre continued to show new films every week, including hits like *Dumbo*, *Air Force* and *Casablanca*; the Burton Pavilion continued to hold weekly dances during the summers; and vandalism and petty theft increased as sheriff deputies were stretched thin and there was little for young people to do. In April 1943, tragedy struck when five high school boys took a small boat sailing in Colvos Passage during a storm. The winds increased dramatically, the boat capsized and four of the five young men drowned. Their loss touched everyone on the island in ways that only intensified the loss of the young men who were dying in the war.[28]

Keeping the homefront running was never an easy task. Pickers for island crops were hard to find, and increasingly, teens and First Nation migrants from British Columbia provided labor to farmers to harvest crops. There was a constant struggle to find enough volunteers to staff the Air Observation Posts, and although the effort was a dramatic success on Vashon, by October 1943 the military had assigned the posts to the Army Fighter Command and military personnel had replaced the volunteers. Tourism declined dramatically as gas rationing limited travel and as other forms of rationing made it more difficult for resorts and inns to serve customers. Camp Sealth continued to operate during the summers, but with dramatically lower numbers of campers.[29]

A Volunteer Fire Department was first formed at Vashon in 1926, and the only fire truck on the island was lost in the 1933 fire. This led to a number of

attempts to form a fire district, and in March 1942, voters approved creating a King County Fire Protection District, which would eventually become the basis of the current Vashon Fire and Rescue.

The war did bring benefits to the island. The *News-Record* newspaper went from four pages with relatively little advertising to eight pages beginning in mid-1942. The Office of War Information paid local papers to run national columns and to have weekly summaries of the progress of the war, and advertising increased dramatically as national corporations and regional utilities ran large advertisements. The amount of local news did not change—but four to six pages of national and regional news expanded the paper. Also, the *News-Record* instituted a weekly "Roll of Honor" recognizing islanders who were serving in the war, and a front-page column kept track of those serving. At the end of the war, the Roll of Honor was formalized by Postmaster and VWF commander John Ober and is now in the Heritage Museum. The payroll of the servicemen stationed on the island and the regular paychecks of islanders working in the war industries of Seattle and Tacoma brought much-needed cash to an economy that had long been cash poor. Plus, the war brought new jobs and responsibilities to women on the island. Many took jobs left by men as they went to war, and many others undertook volunteer work to support the war effort.

Vashon Japanese and World War II

During the 1920s and 1930s, the Japanese became an integral part of the Vashon community. In 1930, the Vashon Island Progressive Citizens' League was formed, a Japanese American organization that sought to "train the new generation to be of service to the community, state and country and in the end to make better American citizens." The league sponsored a program of music and dance in December 1930 with the goal of adding one hundred new books to the school library. The next year, Ujiro Nishiyori, representing the Japanese on Vashon, presented one hundred Japanese Cherry trees to the new Vashon Union High School. At the planting ceremony, Mr. Nishiyori commented:

> *In presenting these trees to the island high school the Japanese Society of Vashon Island expresses a deep appreciation for the educational advantages our children have enjoyed in your schools.... The trees, which we present*

today, are our gift to a community, which has treated us and our children as neighbors and friends rather than people of another race and country. It is our hope that in the years to come these trees, symbol of the land of our birth, may grow and flourish, making more lovely our Vashon Island. In the same manner we trust that our beautiful friendship may continue to grow as our children work side by side in our splendid Island schools.

Later that same year, Noboru Hoshi presented the high school with a number of evergreens, which were planted and added to the appearance of the grounds. The *News-Record* commented, "Mr. Hoshi's gift is greatly appreciated. The Japanese residents of the Island have done much toward beautifying the high school grounds."[30]

Japanese youth played sports in the schools and often composed a significant part of winning sports teams. The Japanese consul visited the island regularly, Vashon Japanese visited Japan and Japanese visitors visited their relatives on the island. The Mukai Rock Garden received national

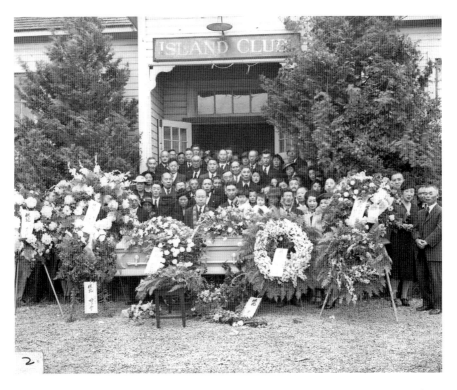

The 1940 funeral of Hatsuguma Tanaka at the Island Club represents the important role Japanese Americans held on Vashon. *Vashon-Maury Island Heritage Association.*

recognition, and the PTA sponsored a fundraising tea party at the garden. The Japanese on Vashon were an important part of the community.

The attack on Pearl Harbor on December 7, 1941, dramatically changed the lives of Vashon's Japanese residents. When the attack occurred, the *News-Record*, with Agnes Smock as editor, called for respecting our Japanese neighbors and for "calm and good behavior." At the Vashon High School assembly on December 10 called to hear FDR's speech asking for a declaration of war, Mr. Ostrom, the highly respected history teacher, asked for tolerance for Japanese classmates. Tensions were high as further attacks seemed possible, and the island implemented the Civil Defense plans developed earlier that year.[31]

Since many of the Issei, or immigrant Japanese, were not citizens, they were considered "enemy aliens" and thus did not have the same rights as their American-born children, or Nisei, who were American citizens. On February 7, 1942, twenty-eight sheriff's deputies and an undisclosed number of Federal Bureau of Investigation (FBI) agents raided the Vashon Japanese, looking for any indications that they might be "disloyal" or have contraband. The agents seized firearms, dynamite and radios; arrested fifteen Vashon Japanese, including Ujiro Nishiyori, president of the Japanese Citizens Association; and detained three in Seattle: Sam Kamimoto, Frank Owada and Yoshinaga Usui. These three were ultimately imprisoned at Fort Missoula and were not returned to their families until nearly a year later, when they were reunited at Tule Lake Internment Camp.

Many of the Japanese on the island destroyed anything Japanese, including photographs, records, books and clothing, in an effort to demonstrate their loyalty and out of fear of being considered disloyal. When the president declared a West Coast Exclusion Zone on February 19, 1942 (now known as Remembrance Day), their world was capsized. The Mukai family went into self-imposed exile and left before the twenty-mile travel restriction was imposed in late February, but the remainder of the Vashon Japanese waited and prepared for the Evacuation Order, which was enforced on May, 16, 1942. The Japanese from "Kitsap County (Bremerton Navy Yard), Vashon and Maury Island, rural Pierce County, Tacoma, and parts of South King County" were ordered to report to assembly centers. Vashon's assembly center was at the Island Club, which is now Ober Park.[32]

The Vashon Japanese were taken by special ferry to Pier 52 in Seattle and then marched to the King Street Station, where they were put on a train with curtains drawn on a three-day journey to the Pinedale Assembly Center in California. Agnes Smock's editorial was titled, "We Part with Mutual

Regret." From Pinedale, the Vashon Japanese were moved to the Tule Lake Relocation Center in the northern California desert, where they remained until moved to other camps when Tule Lake became a "segregation camp" following the administration of the "loyalty questionnaire" in the winter of 1943. The Vashon Japanese were scattered from Tule Lake and ended up at six of the nine different camps, including Minidoka in Idaho, Heart Mountain in Wyoming, Topaz in Utah, Jerome in Arkansas and Manzanar in California, in addition to Tule Lake.[33]

While the Vashon Japanese were imprisoned in these American concentration camps, many Vashon Islanders were friendly and stayed in contact with their Japanese neighbors. Many others were more overtly discriminatory. The story of the *News-Record* newspaper is one example. Prior to June 1942, when Agnes Smock was editor, the *News-Record* was a supporter of the Vashon Japanese, reporting events in the Japanese community, treating the Japanese just like every other immigrant group on the island and pleading after Pearl Harbor to remember the Japanese on Vashon as friends and neighbors. When Smock sold to newspaper in June 1942 to Phillip Garber, the tone of the newspaper immediately turned anti-Japanese. Articles referred to "Hirohito's molasses-colored lads," supported the call to "Work Those Japs Under Armed Guards" and stated that "[w]e don't want them back on the Pacific Coast nor on this island." This editorial change in the *News-Record* would culminate in the newspaper's supporting Governor Monrad Wallgren's attempt to prevent the Japanese from returning to their homes in the exclusion zone and helping to foster an anti-Japanese sentiment among some islanders.[34]

Mary Matsuda Gruenewald recounted the example of Sheriff Finn Shattuck, who agreed to manage eleven Japanese farms and to whom the Matsudas and ten other Japanese families entrusted their farms. He visited the Matsudas and the other Japanese families at Tule Lake Camp and attempted to renegotiate the leases or buy the farms at a reduced rate. When he was refused, he mismanaged the farms, either by intent or through incompetence. The Vashon Japanese could not organize a response to Shattuck's failure to manage their farms properly because, by then, they had been scattered to five other concentration camps when Tule Lake was converted to a security camp. When the Matsudas returned at the end of the war, they were forced to begin legal action to recover the lost income from the farm. When offered a settlement, Yoneichi refused, calling it "blood money," and ultimately dropped the suit rather than embarrass the sheriff.[35]

Another overt act against the Japanese of Vashon occurred in late January and early February 1945 when an inebriated twenty-two-year old, Harold Burton, who had been on the Vashon High School football team with Japanese teammates, and two underage friends burned three homes owned by Japanese that were boarded up—one of which had family goods stored while they were imprisoned. The *News-Record* under Garber reported the fires in a column about police and fire activities that week and noted that the houses were "abandoned" and the fires were of "unknown origin." The *Seattle Times* reported the man arrest for arson on March 2, 1945, and on May 23, 1945, reported that he was fined $1,000 or eleven months in jail for the arson. The young man, Harold Burton, "said he believed the Japanese would not return to the island if he burned their houses" and "that he did not care for Japs 'because they always thought they were better than we were.'" One of the homes burned belonged to the Miyoshis, who were imprisoned at Tule Lake and whose sons, Hareo and Masaru, were serving in the military at the time of the fire.[36]

On the other hand, many on the island helped their Japanese neighbors as they could. They stayed in touch as their friends moved from the Pinedale Assembly Center to other camps. Boy Scout Troop 495 gave its troop flag to the Japanese Boy Scouts who were evacuated so their friends could keep their part of the troop together in the concentration camps. On Evacuation Day, May 16, 1942, when the Vashon Japanese were moved off the island, more than two hundred fellow islanders were at the Vashon Heights Dock that Saturday morning to say goodbye to their friends and neighbors. Others, like Maurice Dunsford, operated the Mukai Cold Processing Barreling Plant, and Phillipe Baccaro operated the Mukai farm. Mack Garcia worked the Matsudas' farm during the war as he had for the six years before the Matsudas were imprisoned.[37]

For the Vashon Japanese, the war shattered their community, and it would never fully recover. The Japanese community went from a vibrant, integrated part of island life with more than 120 members to fewer than 40 by the best estimates. Census data for Japanese as a racial category would not be collected again until 1970, so all we have are estimates. We do know that fewer than half of the thirty-four families on the island in 1940 returned after the war and that most of these were families who owned land and thus had something to return to. This was indeed a period of hard times for our Japanese friends and neighbors.

FERRIES

At the beginning of the era, Vashon had the best ferry service it would ever experience. By the end of the era, the Mosquito Fleet was gone and Vashon had only automobile ferries. The Mosquito Fleet was at its peak, with boats serving the east and west sides of the island and Quartermaster Harbor. There were three automobile ferries—at Portage, Vashon Heights and, beginning in 1920, at Clam Cove, which was renamed Tahlequah in a Tacoma Chamber of Commerce contest to name the South End ferry landing. Ethel Whitfield of Burton won with name Tahlequah (meaning "water view") from the city in Oklahoma. This extraordinary level of service options would not last. In 1922, the Portage/Des Moines route was abandoned in favor of Vashon Heights at the North End. There were attempts to revive this service through the 1920s, but they never succeeded. In the early 1930s, Mosquito Fleet service began to be curtailed in favor of automobile ferries, and by 1940, the last of the Mosquito Fleet boats had stopped serving the island.

Ferry wars erupted in the 1930s after a relatively peaceful 1920s, as the Great Depression put pressures on all aspects of ferry service. This was still an era of private ferry ownership, except for the short-lived King County route from Portage to Des Moines, and it would not be until after World War II that public ownership of ferries would develop more fully.

In April 1925, a new ferry route from the Heights to Fauntleroy opened in addition to the route from the Heights to the Marion Street Dock in downtown Seattle. The addition of Fauntleroy was significant. When islanders were polled in 1939 about which route they preferred—Fauntleroy or Marion Street—they chose Fauntleroy because it meant service every hour and a half instead of service every two hours. This choice saved Vashon from becoming another Bainbridge Island, with easy access to downtown Seattle, and helped preserved the rural character of the island well into the 1980s and 1990s.[38]

New ferries were added in the 1920s and 1930s. In 1921, the steamer *Vashona* was launched for the Quartermaster Harbor route, and the venerable *Virginia V* was launched in 1922 for the West Pass route. The *Virginia V* still plies the waters of Puget Sound today as the last working steamer on the West Coast. In 1931, the *Concordia* was launched to replace the *Vashona*. Its stern was cut off, and it looked stumpy at fifty-nine feet long, as at under sixty feet in length it only needed two instead of three crew members. This smaller vessel allowed service to continue into 1940, with several suspensions

of service during the winters because of low usage. In 1930, the ferry *Vashon*, the "finest" and "largest" ferry on Puget Sound, costing $200,000 and carrying ninety cars and 1,500 passengers, was launched for the Vashon Heights route and christened by "Miss Vashon Island" Mary Berry. In 1929, the Washington Navigation Company launched the ferry *Skansonia*, built with the help of the Martinolich Shipyard crew from Dockton, for the Tahlequah route, and three years later, the ferry *Vashonia* was launched by "Island Queen" Margaret Peterson, also for the Tahlequah route.[39]

In the late 1920s, a ten-year contract with the Skanzie's Washington Navigation Company guaranteed two-hour service to Tahlequah from Point Defiance, and a fifteen-year contract with the Kitsap Transportation Company guaranteed three round trips to the Marion Street Dock and four round trips to the Fauntleroy Dock. These agreements provided relatively stable ferry service through the early part of the 1930s. As the Great Depression began to affect the Puget Sound region, the first of a series of ferry strikes and service disruptions began that lasted until World War II forced ferry owners and unions to cooperate to support the war effort.

This era of good service and new boats came to an end in 1933 when the Ferryboatman's Union of Puget Sound called a twenty-four-hour strike against Black Ball and won recognition of the union. A 1934 strike just before Memorial Day weekend sought a six-day workweek and a guarantee that salaries would not be lowered. In 1935, a series of strikes by the Ferryboatman's Union against Kitsap County Transportation Company stopped North End runs. The strike lasted for thirty-three days and was suspended so the parties could arbitrate. In the meantime, the Black Ball Line bought out Kitsap County Transportation Company and gained monopoly over all the major Puget Sound ferry routes. Another fifteen-day ferry strike by the Masters, Mates and Pilots Union over wages and an eight-hour day, as well as a 1936 strike that stopped the Quartermaster/Tacoma routes, led to the formation of the Ferry Service Improvement Association, which supported state-run ferries. This was the beginning of a campaign to form a state ferry system, but it would take another fifteen years before it was successful.

A 1937 strike just before the Memorial Day weekend led King County to provide emergency service to Vashon Heights with the ferry *Washington*. Riders at Tahlequah held a dock party to thank Washington Navigation Company for not striking and keeping the South End service going. And the Department of Public Service held hearings and submitted a report about ferry service that concluded that Vashon ferry service should not be

considered independent of other Puget Sound ferry service, thus tying the fate of Vashon ferry service to ferry service all over Puget Sound. Another strike in August 1939 lasted twenty-two days, and King County again put the ferry *Washington* on emergency service; this led to an important development for Vashon's community and ferry history.

When islanders learned that there was going to be a ferry strike beginning on August 3, more than two hundred islanders showed up at the Vashon Heights Dock and tried to seize the ferry *Elwha* before it left the island on its last run to Harper, near Southworth. Thirty islanders had already boarded the ferry when it pulled out so no more could join them. Emboldened by the 1936–37 Detroit sit-down strikes, islanders seized the ferry when it landed at Harper to prevent it from abandoning the island without ferry service. They spent the night, Elmer Harmeling cooked a meal and they were prepared to stay as long as needed. The next day, the ferry owner's insurance company asked the sit-down strikers to leave, which they did. As the strike dragged on, a Vashon Ferry Users Committee was formed to represent the island, and the State of Washington explored the possibility of a state-run ferry system. Attorney General G.W. Hamilton ruled that the state could run a ferry system but could not seize the privately owned ferries and docks to create a ferry system. The strike was ended by arbitration after twenty-three days.[40]

Three significant developments emerged from this 1939 strike. First was the action, by what would become known as the Vashon Vigilantes, to seize the ferry and occupy it in the island's first major act of civil disobedience. The Vashon Vigilantes would reappear in 1948 to protect the Vashon Ferry District and periodically since then, like in the 1971 Rock Concert incident and in the 2013 Rumble Strip Incident. The second significant development was the push for a publicly owned ferry system. Even though the state legislature defeated a bill in 1939 to create a state ferry system, ultimately this effort would come to fruition with the 1948 formation of a Vashon Ferry District and in 1952 with the formation of the Washington State Ferry System. The third significant development, and perhaps the most important of all, was the 1939 poll in which islanders noted that they preferred service to Fauntleroy rather than the downtown Marion Street Dock, which saved Vashon from becoming just another bedroom suburb.

After the struggles of 1939, ferry service saw relative stability for the next seven years. The completion of the Golden Gate Bridge in 1937 brought surplus California ferries to Puget Sound, revitalizing the aging Puget Sound fleets, and in early 1940, a federal arbitration granted ferry workers pay increases and ensured that there would be no strikes until the end of 1941.

During 1941, the Ferryboatman's Union and the Puget Sound Navigation Company (Black Ball) signed a three-year contract that ensured no strikes and no service interruptions.[41]

With the onset of World War II, the pressures for uninterrupted transportation for war workers and the large numbers of passengers resulted in increased profits for the Black Ball Line, even though ferry fares decreased. However, the quality of service declined, as ferries were stretched thin and deferred maintenance began to take its toll. Irate passengers at Tahlequah protested the use of the antiquated *Vashonia* and finally got relief when the *Quilliyute* was brought in as a replacement. The *Yankee Boy* began to provide passenger service from Dockton to Tacoma for war workers. For the first time, Vashon saw large numbers of commuters to off-island jobs. There had always been a few regular commuters, but the war effort created many jobs for underemployed islanders. Many others moved to the island as housing became scarcer on the mainland. Gene Sherman, who grew up on the island and worked for Boeing during the war, commented that when he was growing up in the 1920s and 1930s, he did not know anyone who commuted to work off-island; by the end of the war, though, there was a large group of regular commuters. Ferry service ran relatively smoothly until the end of the war.[42]

THE SX̌ʷƏBABŠ, 1920–1945

During the 1920s and 1930s and into World War II, the sx̌ʷəbabš of Vashon Island confronted three distinct challenges to their continued presence on the island. The first was the Land Claims Tribunal Hearing, where Lucy Gerand's testimony, for the first time, accurately recorded and established the extent of native people's occupation of the island. The second was the continued presence of a few sx̌ʷəbabš families who continued to live on Vashon and who worked primarily in the traditional resource extraction industries on the island, which were in their dying stages, or as domestics for prominent island families. The third was the taking of native children from their families and placing them in Indian schools, primarily the Cushman Indian School and Saint George's Indian School in Tacoma, where they were taught to renounce their native heritage and to learn the ways of the dominant Euro-American culture that had displaced their ancestors nearly one hundred years before.[43]

This was a difficult time for the sx̌ʷəbabš, their Puyallup brethren and other Puget Sound Indians, but they began to define themselves and reassert their rights from the 1854 treaty, primarily with the 1927 Land Claims Hearings. This began a series of legal efforts to reestablish native treaty rights that ultimately led to a recognition and development of native culture that had not been seen since the "middle ground" of the early nineteenth century.[44]

CONCLUSIONS

The hard times of this era came in three waves. As the boom times of the first two decades of the twentieth century ground to a halt, Vashon lost population, jobs and farms and saw the rapid decline of the natural resource economy that had built up the island so quickly. Agriculture, fishing, logging and mining did not disappear, but they slowed so that the "wage workers frontier" closed and, with it, the young men and young families who flourished in an expanding resource economy began to leave. The Great Depression of the 1930s followed the hard times of the 1920s and slammed the island even harder. With the island being rural and based on natural resources, it meant that although jobs were hard to come by, the basics of food and shelter were not as difficult to find as they were in the urban areas of Seattle and Tacoma. As the region and the island began to pull out of the Great Depression, a different kind of hard times began with World War II. Sons and daughters serving overseas, shortages of basics, fears and uncertainties all made living on the island difficult. The hard times of this entire period helped forge a stronger, more resilient island. The island that emerged from the war was a more unified community and was poised for changes that would begin to transform Vashon into the island we know today.

AN ISLAND COMMUNITY

1945–1980

From 1945 to 1980, Vashon's population doubled, fueled by postwar suburbanization, prosperity and off-island jobs. Most were newcomers or newborns of the baby boomers; only a quarter of the island's Japanese returned from internment camps. The island formed its own ferry district, the precursor of the state's ferry system, and most islanders welcomed the idea of a cross-sound bridge. The Nike Missile Base at Sunrise Ridge brought the Cold War and nuclear warheads. The Beall Greenhouses enjoyed national prominence early on but could not survive the 1970s. Ski manufacturer K2 became the island's biggest employer, ever. Artists and writers moved here, starting a thriving arts scene. And around 1970, the "hippies" arrived, meeting with everything from open arms to guns and sudden haircuts.

A cultural and generational turnover occurred as established islanders engaged with the latest comers: professionals and commuters with their own values. What emerged as the "one-island" consciousness hinted at decades before by Van Olinda and McCormick became the mindset held by most islanders.[1]

1945–1980:
An Island-Wide Identity Emerges

The postwar epoch began with Vashon forming its own ferry district and supporting plans for a bridge. The era ended with a King County Community Plan that proposed to "keep Vashon Island the way it is." The shift from mainland-focused ambitions to preferring the island "the way it is" developed during this era. For a while, Vashon attempted to have it both ways: return to its prewar roots as a rural, Republican-voting farm community even while seeking links outward with reliable ferries and a bridge. The return to the past had some success, the bridge ended in failure and the forces of the mid-1960s and 1970s—Vietnam War, the Boeing Bust, the baby boomers and their counterculture—pulled the island in directions that would lead to the community we recognize today.

After the War, Seeking Normalcy

The period from 1945 to 1960 opened with war's end and ended with the grand opening of the new Kimmel's Shop-Rite, the island's first shopping center and supermarket. After the war, islanders sought to restore what was: farming continued to flourish, the annual festival restarted, Republican politics returned, ferry disputes were renewed and the same leadership continued. But new forces were at play, such as rapid population growth, the baby boom, the promise of a cross-sound bridge, a Civic Assembly, new island industries, a new newspaper and a suburban-style commuter economy. Returning veterans became important leaders on the island, stepping into this role with expertise honed by their war experiences. Veterans led in the return of the annual Vashon Festival, suspended during the Depression and World War II, and they stepped up to restore the Island Club as a community center.

When the Vashon Theatre burned on February 24, 1946, the Island Club became the temporary cinema until investors led by Lloyd Raab built a new theater. The new Art Deco theater seated 550, cost $100,000 to build and was opened on May 29, 1947, with *Two Guys from Milwaukee* and *The Big Sleep*. In 1952, Lloyd Raab hired Jac Tabor to paint the theater's murals, scenes from a Muu-inspired South Seas fantasy, in exchange for a yellow 1950 Buick convertible. The murals still inspire both awe and dread in moviegoers.[2]

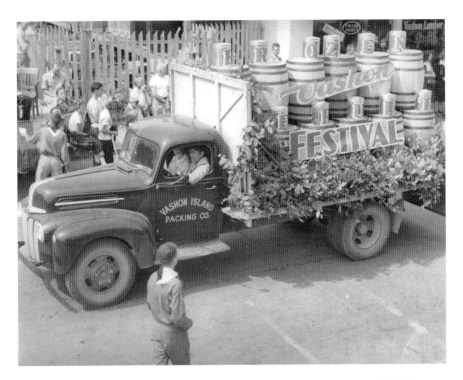

The Island Festival resumed after World War II as the Peach Festival. Milton Mukai drove the Mukai family's Vashon Island Packing Company (VIPCO) truck in the annual 1948 Peach Festival Parade. *Vashon-Maury Island Heritage Association.*

Two events rocked the island: the Maury Island Incident in June 1948 and the 7.1 magnitude earthquake of April 1949. Although the earthquake caused minor damage to chimneys and foundations and a landslide near Shawnee, the island escaped the thirty-second shaking largely undamaged. The sighting of a disintegrating "flying saucer" by Harold Dahl and Fred Crissman caused even less damage—some supposedly hot metal fragments they claimed hit their boat and killed their dog—but is now largely accepted as a hoax. Despite this, the Maury Island Incident has fascinated conspiracy theorists and alien invasionists ever since.[3]

Other disasters marked this period. In 1950, the Falcon's Nest, a log cabin mansion on Heights Hill that frequently hosted island fundraisers, burned to the ground. That same year, a blizzard brought fourteen inches of snow and three weeks of bone-chilling weather—nine days below ten degrees. The storm's strong winds forced the cancelation of ferries, damaged the North End dock and undermined the Heights Grocery building, which slid into the sound. The thaw caused major landslides at Shawnee, Colvos and Vashon

Heights. On April 2, 1956, a Northwest Airlines Stratoliner crashed off Point Robinson shortly after takeoff. Island boaters were first to the rescue, soon joined by the Coast Guard and a passing air force floatplane. Although five died in the crash, thirty-eight passengers and crew were rescued.[4]

The island fought over beach access when Tahlequah residents went to court in 1947 over a long-used path to the ferry that crossed private land. When the landowner blocked the path, the court case split the community and forced a compromise when the court found in favor of the owner. A similar dispute over access to "KVI Beach" erupted ten years later when the radio station owners attempted to block access to its popular beach. At the hearings on March 17, 1957, "living witnesses" confirmed a 1939 agreement between Ellisport residents and Puget Sound Broadcast that the construction of the radio tower would not prevent public use of the beach. The radio station relented, and today KVI Beach remains one of the most popular public beaches on Vashon. Another kind of access was created when the new Judd Creek Bridge, built in anticipation of a link to the cross-sound bridge to come, was opened in 1953. At the opening ceremony on April 25, dignitaries cut a string of "bananas and snowballs" symbolizing that the island's south-north divide was now united by the bridge.[5]

Several events during this period still resonate on the island today. The first Fourth of July 'round-the-island hydro race, begun informally in 1951, started a tradition that still shatters the peaceful dawn every July 4. In 1959, the main intersection at Vashon town got a tricolor traffic light. Islanders were slow to adjust to the "sophistication of the new red, green, and yellow traffic signal," and after it was replaced in 1965 by a simple red blinker, islanders began to consider it a point of pride to not have any "real traffic lights" on the island.[6]

ECONOMIES OLD AND NEW

All the former resource industries, except agriculture, disappeared shortly after the war's end. As Puget Sound fish stocks crashed, the fishing fleets of Vashon dwindled to a few boats working out of Dockton and Burton. As for logging, the last stands of old-growth timber were cut in the Cedarhurst area after the war, all the sawmills closed and logging was reduced to clearing for new homes. Mining of the gravel pits on Maury Island was only for local needs. Island farmers continued to produce strawberries, currants, stone

In 1956, Vashon State Bank, founded in 1909, was sold to People's Bank, and the old bank building on the northwest corner of the main intersection was torn down in 1961 after a new bank building was constructed behind it. *Vashon-Maury Island Heritage Association.*

fruit, apples and eggs, but they struggled. The cherry infestation in 1946 destroyed more than 3,500 trees, and the peach blight in 1948–49 ended that niche.

New businesses emerged: Chris Crecelius and Leonard Bonifaci founded Olympic Instruments, and the Kirschners brought a new plastics company that would ultimately become K2. The Vashon State Bank was sold to People's Bank in 1956. The small community stores began to close as island shoppers were drawn to newer stores in Vashon town.[7]

GOVERNANCE

The island remained mostly Republican during and after the war. In 1948, Vashon voted 101 for Dewey and 758 for Truman. In 1952, 1,313 voted for Eisenhower and 698 for Stevenson, and again in 1956, 1,291 voted for Eisenhower and 749 for Stevenson. But political allegiances were about

to shift. In 1956, islanders voted for Democrat Warren Magnuson for the Senate, and in the governor's race, Republican Anderson beat Democrat Rosellini by two votes.

Islanders began to take charge of their own issues. A Vashon Sewer District administration was formed in 1947 and, after King County found 98 percent of septic systems faulty, constructed a sewer system for the island's center. In May 1949, an attempt to form a hospital district lost 142 to 757. But King County remained the dominant force. The county extended Seattle's street grid to island roads. It developed the new dump and began to charge fees—a controversial move. It helped turned Inspiration Point into a scenic lookout, did several planning studies and aided islanders' quest for a cross-sound bridge. But many felt that the island was a neglected "stepchild" of the county. In 1952, the Vashon Businessmen's Club sponsored a petition to incorporate the island as a 4th Class town. The state legislature ignored it, thus saving Vashon from the disastrous local control experienced by other islands.[8]

GROWTH

Soon after the war, issues of growth came to the fore. School populations boomed, the proposed cross-sound bridge promised thousands of new residents and islanders started voicing concerns about Vashon's water resources.

Island population grew by nearly two-thirds between 1940 and 1960, much of it from the "baby boom," all those youngsters born between 1945 and 1964. The school district built new elementary schools near Vashon in 1953 and Burton in 1954, soon followed by a middle school and high school. Each year set new records for school enrollments, and each year saw improvements to school facilities—lights for the high school football field in 1948 and new land in 1949 for a centralized campus.

This boom was also seen elsewhere: in new island churches, in the Vashon Theatre's weekend double features and Saturday matinees, in the opening of a bowling alley, in the removal of the last log cabin on Main Street to make way for the new Brenno Shell Service Station, in the opening of a Youth Activity Center, in Little League Baseball coming to the island and in Vashon High School finally able to field a respectable football team that ended a thirty-three-game losing streak in 1957 by beating the Evergreen Wolverines, 7–2.

More commuted from Vashon than ever. The 1954 "Vashon Island Report" by King County reported that 62 percent of employed islanders commuted to off-island jobs, 77 percent of family heads were employed and of the remaining 23 percent, 18 percent were retired and 5 percent were unemployed. About 83 percent of families owned cars; 17 percent owned two. To accommodate commuters, the North End Dock was given the two slips it has today, and the new ferry *Klahowya* was added. Vashon Highway was straightened north of Vashon town to speed the commute. In 1954, Harlan Rosford purchased Island Transit from Trailways and began twenty-six years as the island's only bus driver.[9]

The island has always had artists, but now the world took note. Betty MacDonald became a local celebrity when her bestselling book *The Egg and I* was made into a movie in 1947. The libel trial then brought against her by the Albert Bishop family for depicting them as country hicks Ma and Pa Kettle brought her further notoriety. Locals were even more impressed with her very successful *Mrs. Piggle-Wiggle* series and her book about life on Vashon, *Onions in the Stew*, published in 1955. New arrival Bill Speidel, humorist and founder of Seattle's Underground Tour, published *You Can't Eat Mount Rainier* in 1955 and *Sons of the Profits* in 1967. Island artists Norman Edson, Art Hansen and Fred Eernisse formed the Vashon Arts League, which would become Vashon Allied Arts. The Vashon Garden Club won a state award for its 1950 Flower Show featuring a blossom-draped Vashon Bridge. Naturalist and bird painter Edmund Sawyer made Vashon his home. Island native Art Hansen won a Pulitzer Prize for his lithographs in 1952. In 1958, C.L. Garner of Burton had a one-man show of his historical paintings at the Washington State Historical Society. Vashon had become an incubator for the arts.

The 1960s and 1970s: The Roots of Change

The 1960s and 1970s were decades of contrasts. The early 1960s were full of promise and hope as John F. Kennedy, the civil rights movement and the Great Society seemed primed to unleash a new spirit of change. By the late 1960s and 1970s, this optimism had disintegrated into the quagmire of Vietnam, the violence of assassinations and riots and seismic social division. Vashon was not immune to these larger forces.[10]

Some change was simple and technological: for instance, zip codes were implemented in 1963, and in 1964, "567" telephone numbers joined "463"

in the local phone book. Others changes came within community events. The McCormick "Hike Around Vashon" record was broken by thirteen-year-old Gordy Steen in 1965, quickly followed by others, with Charles Brough ultimately setting the record at fifteen hours and fifty-two minutes. When Randi Kellogg began a six-year battle with kidney disease, islanders contributed more than $18,000 to purchase a dialysis machine (in 1971, her brother, Scott, donated a kidney that was rejected; she died of kidney failure in 1972). Island baton twirler Judy Nakashima took first place at the state competition. In 1973, Rich and Sue Wiley's Victorian home above Burton was featured in *Redbook*'s Christmas issue. Jay and Joan Becker purchased the local newspaper in 1974.

Some change took the form of disasters. The Columbus Day storm of 1962—the most powerful cyclone to hit the United States in the twentieth century—wrecked havoc, downed trees and cut power. The next year, a 6.5 earthquake shook the island. What shook islanders more than these natural disasters were the human ones: the assassination of President John F. Kennedy in November 1963 and the Landers Fire that year that killed Mr. Landers and all five children, as well as his wife five days later. In 1974, the island was shocked by the murder of Tina Jacobsen, nineteen, and Gaelisa Burton, eighteen, off to camp on the Washington Coast and found there stabbed to death. A Moclips man was found guilt of the murders.

In 1971, Vashon had its brush with violent protest when two disgruntled men firebombed the county courthouse on Main Street after sheriff deputies shut down a street dance. John Charles Newton received five years of probation and twenty-five days in jail, and Patrick John Murto received a three-year deferred sentence. Six years later, Vashon town burned again when a fire ignited in storage behind Bud's General Store. The fire destroyed six businesses in the core of the village because gusting winds and low water pressure hampered firefighters.[11]

CHANGES IN LEADERSHIP

The leaders of the depression and war eras began to retire, passing the baton of leadership to a new generation. Older organizations like the Royal Arch Masons or Eastern Star declined as energetic new clubs the Eagles, Soroptimist, Rotary, Jaycees and Kiwanis arose.

In the fall of 1963, Operation Jigsaw, with the slogan "Let's Pull Together," set up quarters in the Coffee And restaurant to develop a massive community study of zoning, tax, water, recreation and other issues. Its community survey found that improving the water supply was the island's top issue. The group then developed the island's first comprehensive plan and proposed a body to represent islanders to King County. Despite controversies over the name, the structure and the refusal of the chamber of commerce to join, the new "Civic Assembly" began to make recommendations about ferry service and road repairs. In June 1966, Operation Jigsaw presented the results of thirty-seven community meetings with more than five hundred islanders to the King County Planning Commission, proposing zoning to limit high-density housing, development of recreation facilities, opening the passage at Portage, canceling the Vashon Parkway proposal, not building the Vashon Bridge and protecting Vashon from the "blight and sprawl" of mainland suburbs. These recommendations ultimately became the basis for the 1978 King County Community Plan for Vashon. This was a major shift from the early 1950s "Vashon Island Story," which had proposed virtually the exact opposite. How island attitudes had changed![12]

Environmental Awareness

Attitudes protective of the earth developed during this era and would become key to island identity. A 1965 State Department of Health survey found the water systems on Vashon to be the "worst in the state," and King County listed deficiencies in forty-four of the island's water systems. Consequently, FHA loans were suspended for eight months the following year. Eight years later, the county found only eight water systems "acceptable" and threatened a ban on building permits unless water systems became certified. Water quality is still a hot-button topic on Vashon.

Environmental stewardship grew after the first Earth Day in 1970. In 1971, the ferries started storing wastes in holding tanks rather than pumping it into the sound, and glass recycling began at the King County Dump. The 1971 King County Open Space Initiative, which sought to preserve the island's rural character; the 1974 effort to limit the removal of ground cover and trees without a permit; and the 1976 Shoreline Management Act that limited development of waterfront properties all increased awareness but also sparked efforts to separate Vashon from King County.

The "Gas Crises" of 1972 and 1979 heightened environmental awareness. Ferry service was slowed and reduced to save fuel, and gas stations limited fueling to alternate days and a five-dollar maximum. Fuel came to the island only on Mondays and Wednesdays. Residents waited in mile-long lines to purchase gas. The *Beachcomber* claimed that gas shortages here were worse than any other place in King County.

Environmental awareness went sky-high in 1970, when mobile air testing by the Puget Sound Air Pollution Agency found that sulfate drift deposits from the ASARCO smelter in Ruston were higher on Maury Island than elsewhere on Puget Sound. Tests in 1972 by the agency, partnering with Seattle–King County Health Department, found high levels of lead and arsenic in children, animals and soils on the island's southern exposures—pollutants traced to the ASARCO smelter. The findings led to the creation of Island Residents Against Toxic Emissions (IRATE), co-chaired by Sonia Rotter and Sylvia Nogaki, to oppose ASARCO. ASARCO, dismissing the claims of pollution as "unscientific," refused to comply with air pollution laws. The Clean Air Act of 1973 established limits on emissions of arsenic and other heavy metals, but ASARCO was granted exemptions. This led Mike and Marie Bradley, residents near the Tahlequah Y, to take the fight to the courts in 1983. Mike and Marie, with attorney Bill Tobin, argued that ASARCO's emissions constituted trespass and nuisance. ASARCO argued that the trespass was indirect because the pollutants were deposited not by ASARCO but by the wind, so the legal definition of trespass didn't apply. The court ruled that since modern scientific methods could link the smelter emissions to the deposits on the Bradleys' property, the concept of indirect trespass was obsolete. The Washington Supreme Court upheld this principle in 1985, and the Bradleys' victory in *Bradley v. ASARCO* became one of most important American environmental cases in recent times. Three islanders had the courage to hold ASARCO responsible for the pollution it created and in the process removed legal shields long protecting industrial polluters.[13]

AGRICULTURE AND FISHING: DECLINE AND COLLAPSE

The Vashon farmer's Grange remained strong until the 1970s, purchasing the Heights Community Club building and sponsoring youth groups and a yearly Grange fair. But like all island farming and fishing efforts, these were dying efforts.

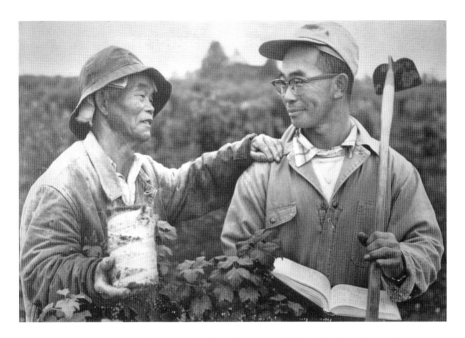

The Japanese Americans who returned after the war excelled at farming, just as they had before. In 1957, Yoneichi Matsuda, seen here with his father, Heisuke, was named Conservationist Farmer of the Year by the King County Soil Conservation District. *Vashon-Maury Island Heritage Association.*

Edward R. Murrow's broadcast of "Harvest of Shame" on Thanksgiving Day 1960 focused attention on housing and working conditions for migrant pickers. Vashon responded with a migrant worker's health clinic in 1963, and five island churches sponsored daycare, education and programs for children. Rummage sales raised funds to purchase refrigerators for all the camps and a washing machine for one of them. The next year, the state provided $4,000 to support migrant children. But the number of migrant workers had dropped—only 670 workers came to fill a need for 1,800.

The need for pickers worsened in 1968, when King County refused to grant a migrant worker permit to Augie Takatsuka, who lost half his crop. By the next year, migrant pickers were completely prohibited. When, in 1974, federal laws required pickers to be at least twelve years old, farmers lost yet more pickers and couldn't complete their harvests. The island's largest growers, Robert and Betty Sestrap of Wax Orchards, and Yoneichi Matsuda, Tok Otsuka and Augie Takatsuka were featured in a 1977 *Washington Farmer-Stockman* article that highlighted concerns about loss of farmland, which in King County had dropped from 153,000 acres to 55,000 in twenty-six

years. King County soon developed its Open Space Initiative, which created $50 million of voter-approved bonds to purchase development rights from farmers and keep their land in agriculture. The Sestraps, Otsukas and Takatsukas all put land into the program so they could keep farming.[14]

Fishing experienced similar challenges from outside forces. The U.S. Supreme Court Boldt Decision in 1974 ruled that under the 1854 treaty, Northwest Indians had the right to one-half of all the fish that would normally pass the Indians' "usual and accustomed" fishing places. This decision reestablished Indian treaty rights and led to a flowering of Indian culture that had not been seen since the mid-nineteenth century. But non-Indian fishermen were stirred to action, leading here to a "fish-in" protest off Ellisport on October 1–2, 1974; three island fishermen, Wayne Cornett, Don Cornett and George Yurisich, were arrested. But in the long run, the Boldt Decision forced Indian, commercial and sports fishing interests to work out their differences and develop policies to preserve salmon runs while giving fair access to everyone.[15]

NEW BUSINESSES

Beall Greenhouses nearly disappeared during this period, losing its status as the island's biggest employer to K2 Skis, which became the largest employer ever on the island.

K2 began as Kirschner Manufacturing Company in Texas and moved after the war to Vashon, where Otto, and his two sons, Don and Bill, took up working with plastics and composites. Kirschner purchased the old Winter's Florist Building on Vashon Highway just north of Center. Bill was an avid skier, and in 1961, he started work on fiberglass skis. Production of K2's "Holiday" recreational ski began in 1964, and K2 soon developed racing skis that came to dominate World Cup skiing. To finance expansion, Bill Kirschner sold K2 but remained as chairman. By 1971, K2's 240 employees were producing three hundred pairs of skis per day. The production facilities were expanded in 1973, and the company diversified by producing cross-country skis in 1977 and purchasing JanSport in 1978. By 1980, K2 employed more than 500 people and had become Vashon's largest employer.

Between 1960 and 1980, Vashon gained businesses familiar to many readers. The new Thriftway supermarket complex opened, as did a Robo-Wash car wash, James Hair Design and a Dairy Queen. Chuck Green and

Al Forsyth started Island Industries, featuring their "Vashon Valkyrie" model rocket. In the 1970s, Books by the Way, Vashon True Value Hardware (now Ace), the ARCO service station across from K2 and the Spinnaker Restaurant all opened. The U.S. Post Office moved one block off Vashon Highway. Toward the end of the 1970s, Foss Miller formed Pacific Research (better known as Sawbones), Luke Lukoski and Sylvia Nogaki formed Island Spring Tofu and developer Thom Lane opened Vashon Village north of town.

GOVERNANCE

The school board focused on building the new McMurray Intermediate (now Middle) School, which opened in the fall of 1969, and a new high school that opened in 1973. The Fire District continued to upgrade its equipment and communications under Chief Wilbur Spencer, and in 1969, it began an effort under new fire chief Craig Harmeling to form an island-wide fire district.

The biggest change in governance came as the new Civic Assembly began representing island concerns to county and state. The Civic Assembly polled

King County agreed to supply the books and librarians if the community would build a library. About $10,000 was raised, and the library was built in 1945. The Vashon Island Memorial Library was dedicated to those who served in World War II. *Vashon-Maury Island Heritage Association.*

islanders on everything from parks and pools to healthcare and ferry service. The 1971 health survey led to the Vashon-Maury Health Services Center. The Civic Assembly was instrumental in building support for a new library in 1967, to pass Forward Thrust bonds in 1968, to purchase Wingehaven Park in 1969, to bring county social workers to the island, to develop plans for the Island Club to become a county park and renaming it Ober Park in 1971, in planning the new King County Pool in 1974 and in 1978 bringing the Toll Bridge Authority, the ferry system and Metro Transit together to coordinate bus and ferry schedules.

King County built the Jensen Point boat ramp in 1964; removed docks at Biloxi, Manzanita and Dockton in 1966; opened a sheriff's office in 1971; and began to develop Dockton Park as a marine park. In 1976, a parks and recreation study proposed expanding the island's facilities, causing many islanders to opine that bigger parks would draw too many off-island users. The island has always had an uneasy relationship with King County. When the county fenced the dump and began collecting fees in 1970, opposition and legal action followed, the fee collection kiosk was set on fire and one islander even mounted a "garbage-pult" on his pickup so he could catapult his trash over the fence and into the dump without paying the fee.

ARTS

The arts flourished during the 1960s and 1970s. The Vashon Arts League, which was formed in 1949, set up at the old Lisabeula School in 1963 and changed its name to Vashon Associated Arts (VAA). Under the leadership of Shirley Speidel, in 1966 VAA converted the Scout Cabin at the Island Club into an arts center. The organization also became a recognized nonprofit, making it the oldest community arts organization in the state. When the Scout Cabin was demolished and Ober Park was built, the organization, by then named Vashon Allied Arts, struggled for nearly ten years until Chris Wheeler Beck instigated a board and a vision to open an arts resource center at Sunrise Ridge. In 1979, VAA spent two years in the old Lutheran church on Bank Road (now the Heritage Museum), naming it Blue Heron Center. In 1981, VAA moved its Blue Heron Center to the old Odd Fellows Hall at Center.[16]

The arts found ample support on this island. The Seattle Symphony, under the leadership of Milton Katims, brought a series of Family Concerts featuring local musicians; a foreign film series came to Vashon; the All-Island

Choir formed; Vashon Community Players, the precursor of Drama Dock, began theatrical performances; Vashon artists were featured in Seattle and Tacoma newspapers; Vashon Allied Arts began art classes, workshops and a Friday Forum speaker series; and Sharon Munger opened Barnworks Studio, which became part of a Vashon Art Studio Tour. Vashon was becoming known for its commitment to the arts.

Social Movements: Feminism, Religious Revival and the "Hippies"

Influenced by the movements of the 1960s and 1970s, islanders increasingly expressed a progressive, pro-environmental, arts-oriented attitude.

To keep up with population growth in part inspired by a mid-'70s religious revival around the country, the Presbyterians and Methodists expanded their secondary buildings in Vashon town. The Episcopal, Lutheran and Catholic congregations all raised the buildings they use today. The Baptist Assembly Grounds at Camp Burton expanded, and a new retreat center was constructed. Island churches often were involved in the social movements of the 1960s: the newly formed Vashon Ministerial Association led efforts to bring county social workers to the island, to support the Cesar Chavez La Raza grape boycott and to support the migrant workers who came to work harvests. Although the churches were active, an Operation Jigsaw survey found that 61 percent of islanders were not churchgoers.

Nonetheless, the community did not accept all religious activities. In 1977, Louis Hillendale brought his Wesleyan Community Church of twenty families from Illinois and established a "New Fellowship" on forty acres on the South End. The community had fled controversy in Illinois, and many here saw, in their charismatic leader and share-all lifestyle, the makings of a cult. A series of scandals in the late 1970s and early 1980s led to court cases and the eventual collapse of the community.

As the women's movement brought awareness of women's rights, island women begin to move into leadership positions—a shift that has only grown. Nancy Nelson, one of the founders of the new *Beachcomber* newspaper, won numerous awards for her journalism. Lorraine Kimmel became a leader in the Retail Grocers Association. Linda Dawson from Vashon became the first female editor of the *Gonzaga Law Review*. In July 1968, the Vashon Fire

Big changes came to Vashon when the new Kimmel's Shop-Rite Shopping Center opened in 1959 and the new Thriftway Shopping Center opened in 1961. *Vashon-Maury Island Heritage Association.*

Department accepted its first women volunteer firefighters. The change in traditional gender roles had begun.

During these years, Vashon was largely outside the turmoil of the Vietnam War. Initially, Vashon-Maury Islanders supported the war. St Patrick's in Dockton contributed to a servicemen's chapel for Thanksgiving services. Vashon Presbyterian Church sent packages to servicemen serving in Vietnam. For Christmas, Ed Joslin and the Jaycees sent thirty Christmas packages to Vashon servicemen in Vietnam. Twelve island men died in the Vietnam War. David Davies, John Raaum, Frank Selden, David Hake, William DeVore, Danny Barnes, Donald Holke, John Stewart, J. Anthan Theodore, David Mace and Larry Ferrell were killed between 1966 and 1970. Larry Wallace is not on the Vietnam Memorial Wall in Washington, D.C., but Eric Ireland and Al Bradley, who developed the Vashon Vietnam Memorial, chose to include him because he died after returning home in 1986 as a result of injuries and PTSD suffered in Vietnam. By the early 1970s, opinion had slowly turned against the war, leaving the community deeply divided.

Into the midst of this division, the "hippies" arrived. Many think of hippies as a '60s phenomenon, but that counterculture didn't become widespread

until the early 1970s. There were precursors: in the early 1960s, the Island Club held Hootenannies. Local dances had British-inspired bands like the Plymouth Rockers and the Gay Caballeros, as well as with rock-and-roll bands like the Doiley Brothers and Rock Island Express. Glue sniffing and smoking at teen dances scandalized. In 1968, Vashon High School students were caught smoking pot on a music field trip, and sheriff's deputies seized a marijuana crop growing near the Heights. "Vashon Weed" had become a valuable commodity up and down the West Coast, and Vashon had a reputation as "Weed Island."[17]

The community was badly split in reacting to the new "long-hairs." Many felt that Vashon's "live and let live" attitude should be extended to the hippies, while others were hostile—like the three loggers who held down seventeen-year-old Tony Ortega and cut his long hair. Many shops featured "No Shoes, No Shirts, No Service" signs, and Island Mart had a sign that read "This is Earth day: Wash-A-Hippie." The high school and churches held assemblies to foster conversations between "hippies and straights," while at another community meeting in May 1970, many protested distributing food stamps to them. To this day, some islanders

The Jesus Barn became a symbol of the new counterculture when the hippies living in the old Sherman House in Paradise Valley painted the word *Jesus* on the barn. It collapsed in 1983. *Vashon-Maury Island Heritage Association.*

refuse to shop in certain stores because of the way the owners/staff treated them when they first arrived as young hippies.

Pitched animosity met a 1970 Vashon Rock Festival on Memorial Day weekend at Steve Krammerer's farm in Paradise Valley. Some islanders feared another Woodstock, the 1969 "Aquarian Exposition: 3 Days of Peace & Music" high point for the new counterculture. In response to the perceived threat, some citizens called for patrols by an armed "Sheriff's Deputy Auxiliary." Other islanders were aghast at the idea: at a hearing, more than seven hundred attendees shouted down the idea; the auxiliary was never formed. Rumors of another rock concert at summer's end excited the sheriff to send out twenty extra deputies on saturation patrols, but the festival never materialized.[18]

John Hinterberger of the *Seattle Times* wrote about "Vashon and Hippies—No Love Affair" in October 1971, estimating that 200 to 700 hippies lived on an island of 6,500. The island's laid-back attitude made hippies feel like they "fit in so well here; we're just like the straights," while the island's rural seclusion and cheap rentals of old farms and summer homes made the livin' easy. Jim Smith, who purchased the Portage Store in 1969, along with friends Billy Sandiford and Jakk Corsaw became the "Portage Three," creating a real "scene" through Corsaw's art, the hijinks of the Billy Sandiford Day Parade and the laid-back style of Smith's Portage Store. Rick Tuel—whose R. Crumb–like comic, *Offshore*, printed in the *Vashon Loop*, reflected counterculture attitudes—was a Vietnam veteran who "fell into hippie ways" once he returned from Southeast Asia to Vashon. Reflecting back during 1998 interviews, islanders assessed the impact of the hippies. Fred Schlick, judge and insurance man, thought that "the hippies were very noticeable with their odd clothes and long hair and two big dogs." But he also thought they contributed by fostering the anti–Vietnam War sentiment and by introducing pot to the island.[19]

Hippies came to define Vashon to the outside world. Vashon was rural, laid-back, accepting…and a good place to grow marijuana. As berry farming faded away, a more lucrative agriculture quietly set down roots. When another rock concert was proposed to raise money for the Food Bank, no one overreacted. Four local bands—Doiley Brothers, Clugwater, Lyon and Fiddler—played for a good cause. The hippies were merging into the island community.

THREE ISSUES: FERRIES, THE BRIDGE AND THE NIKE BASE

Ferryboats, a bridge, a missile base—the fate of those during this period determined, in large measure, what living on Vashon is like today.

Ferries

In 1945, the ferries serving Vashon were privately owned; by 1980, they were publicly owned. Bridging this transition was the Vashon Ferry District. Reliable ferries and cheap fares had ended after World War II, replaced by arguments, strikes and shutdowns. The Black Ball Company (which ran the Vashon ferries), the state, ferry employee unions and ferry customers all had conflicting needs and agendas. The situation became so severe that from 1948 to 1951, Vashon decided to run its own ferry system.[20]

Captain Alexander Peabody, Black Ball Line owner, developed a monopoly of ferries servicing Puget Sound. At the end of 1946, Peabody announced reductions in service and a 30 percent fare increase to cover loss of revenue after the war. Islanders rushed to Olympia to meet with Transportation director Paul Revelle. One month later, five hundred people at a mass meeting raised $1,500 to fight the fare increase, organizing a caravan to Olympia to lobby for a state ferry system. When Peabody applied for another 30 percent increase, another six hundred flocked to a mass meeting by the Vashon Businessmen's Club.

Calls for a state system began during the 1930s strikes, but these actions by Peabody fanned the public's desire for a state takeover. A bill was passed in 1947 that allowed counties to organize special ferry districts. When a strike in March 1947 shut down service for a week and Peabody was granted a 10 percent rate increase, islanders set up a special election for that September. King County Ferry District No. 1 (Vashon Ferry District) was approved 316 to 38; George McCormick, Charles Law and George Wall were elected its commissioners, and they put together a ferry system from scratch.

Meanwhile, Peabody and the state continued to wrangle in court. The new Vashon Ferry District negotiated to rent the Fauntleroy Dock and purchased the thirty-four-car ferry *City of Tacoma*, and King County made the forty-five-car ferry *Lincoln* available. On March 1, 1948, two-ferry service between Vashon and Fauntleroy began. The South End had passenger-only

service on the *Gallant Lady* and the *Else III* until car ferry service began on May 1 when commissioners obtained the *Kitsap*. The Vashon Ferry District was up and running.

But Peabody was back: in March, Peabody and King County agreed on Black Ball–run service between Fauntleroy and Harper (Southworth), while the Vashon Ferry District ferries would serve the Fauntleroy/Vashon run. This set the stage for one of the more memorable events in Vashon's history: the emergence of the Vashon Vigilantes.

Captain Peabody announced that he would run his ferry *Illahee* from Vashon to Fauntleroy, starting on May 15, 1948. The Vashon commissioners were advised that if the *Illahee* landed at Vashon, Peabody would have the right to continue service to the island. When they decided to keep it from landing, the Vashon Vigilantes were born. George McCormick, who owned Vashon Hardware, opened his doors so Vigilantes could get axe handles or other long tools to keep the *Illahee* from docking. The Vigilantes waited with two sheriff's deputies at the north dock, well supplied with coffee and doughnuts to keep their blood up. When the *Illahee* got near enough, the Vigilantes stuck out their long-handled tools and shoved it away. The ferry attempted to land again and was again pushed back. After a few tense moments, the *Illahee* retreated to loud cheers. Peabody never again tried to regain service to Vashon.[21]

Just in case Peabody's boats returned, the Ferry District commissioner organized a group at the dock for the next several weeks, but it was not needed. When calm returned, the commissioners took up the mundane hassles of running a ferry district with worn-out boats, limited funds and criticism from those who opposed public ownership of ferries. The Vashon Vigilantes passed into island lore and were cheered whenever they marched in parades to commemorate their defense of the Vashon Ferry District and their victory over Black Ball.

The Vashon Ferry District found that it had all the problems the Black Ball ferries had. The commissioners were constantly dealing with getting boats that met Coast Guard standards. The decrepit *Lincoln* was in constant danger of losing its certification. When the *City of Tacoma* lost its certificate, the *Skansonia* was quickly added to the North End route. Rates were low, but commissioners announced that they needed a 20 percent increase in traffic to keep a two-boat schedule. Storms sank the Tahlequah slip in February 1949, and then, in January 1950 and in early 1951, storms forced the ferries to briefly shut down. But the challenges were lightened by popular support. In September 1948, Mrs. James Betts designed a Ferry District flag: white

with a green pine tree in the center and a white map of Vashon within the tree. New leaders came forward: Leo Long replaced commissioner Charles Law, who resigned in December 1948, and Paul Billingsley became a commissioner in June 1949. In a February 1950 ferry meeting attended by 750 islanders, the commissioners received a unanimous vote of confidence. Vashon was not going to let Captain Peabody and his Black Ball fleet return.

After the Vashon Vigilantes incident, the State of Washington once again offered to purchase the Black Ball Line, but Peabody refused. In September, the state increased its offer, and Peabody and his stockholders agreed to sell. They were taken to court, and the Washington State Supreme Court ruled the purchase illegal under state law. Governor Wallgren lost to former governor Arthur Langlie in that fall's election, in part due to the ferry mess. Langlie got the legislature to change the law so the purchase would be legal, and on December 30, 1949, the state announced its purchase of the Black Ball Line. The Washington State Ferry System was born. One year later, on June 1, 1951, the Vashon Ferry District turned its fleet over to it, and the Sportsman's Club threw a thank-you party to let commissioners and personnel take a bow.

The new Washington State Ferries were considered a temporary solution until bridges across Puget Sound could be built. Governor Langlie predicted that "[w]ithin seven years there will be very few ferry boats on Puget Sound. New structures now being designed will be more economical than ferries. I feel safe in predicting that within 10 to 15 years people will be traveling across Puget Sound at one-half to a third of present ferry charges." Of course, the cross-sound bridges were never built, and meanwhile, the State of Washington had a ferry system to run—one it had thought was temporary and one it had little experience operating.[22]

Initially, the state ferries made a profit, but by the early 1970s, the system's needs and inflation's impact had made it more dependent on state support. The purchase in 1953 of two Maryland ferries brought the *Rhododendron* and the *Olympic*, and in 1954, the state built the *Evergreen State* and then the *Klahowya* and *Tillicum*. Six *Issaquah*-class ferries built in the late 1970s modernized the fleet. However, the *Issaquah* had a temperamental new propulsion system; the boat rammed the Fauntleroy Dock in December 1980, seriously injuring passengers, closing the dock for a month and forcing Vashon ferries to Colman Dock in downtown Seattle. The new boats only drove the ferry system deeper into debt, more and more dependent on state funding instead of fares. Thus rose the ongoing argument in the legislature over whether ferries are part of the state highway system and should be supported by state transportation funds

or whether the ferries are a "luxury" for "rich islanders" whose fares should be covering the full cost of the ferry system.

While the state system was plagued by all the usual problems, it stabilized ferry service for islanders. Ferry workers became state employees, decreasing labor disputes. An Inlandboatmen's Union strike in December 1976 shuttered most ferries for five days, but single ferries continued the run between Vashon and Fauntleroy and in the San Juan islands. The Masters, Mates and Pilots Union went on strike in 1976 for four days, but again, provisions were made for Vashon and the San Juans. After wildcat strikes in 1980 and 1981, the state passed legislation making strikes by state employees illegal.

For Vashon Islanders, few major changes in ferry service occurred after the state took over. Docking moved to Southworth in 1958, a time- and cost-cutting move. The ferry *Hiyu* was specially built for the Tahlequah/Point Defiance Route and went into service in July 1967, replacing the thirty-eight-year-old *Skansonia* and its beloved skipper, James Kier, who retired at the same time. In the mid-1960s, the Civic Assembly proposed rush-hour changes to the ferry schedules. In the 1970s, the state first began considering passenger-only ferries to downtown Seattle, an idea finally realized in the early 1990s. (The state also explored using Boeing hydrofoils for passenger-only service, but they were too costly.) In 1973, senior citizens got lower rates. After the oil embargoes, in 1978 the system and Metro Transit considered aligning ferries and bus service.

Perennial complaints focused on fares and frequency of service, just as they do today. In 1954, islanders boycotted the ferry's cafés when the price of coffee was raised to fifteen cents. Islanders protested 9 percent fare increases in 1959, in 1966 when fares increased by 8 percent and again in 1969 when fares rose another 8 percent. When the state attorney general in 1969 ruled that it was legal to sell round-trip tickets on the mainland and allow "free passage" off the island, the ticket booths on Vashon closed and the ferries moved to the system of single tickets that we have today.

The law authorizing local ferry districts had remained on the books. Years later, in 2007, after the state discontinued its passenger-only ferry, King County stepped up and revived King County Ferry District No. 1 (the official name of the original Vashon Ferry District) so the county could run its own passenger-only ferry between Vashon and Seattle.

As prosperity grew over the years around Puget Sound, ferry traffic rose faster than fares could cover costs. As the state wrestled through the 1970s with the rising cost of its ferry system, the old idea of a bridge reemerged.[23]

The Bridge

The Cross-Sound Vashon Bridge was one of the most significant island events that never happened. Had the bridge been built, Vashon would have become another Mercer Island, and the quirky rural enclave we have today likely would have been swallowed up by the sprawling suburbia of Puget Sound.

The idea of bridging Puget Sound arose in the 1920s, and increased traffic across Puget Sound during World War II bred the notion that bridges connecting the peninsulas to the mainland would boost the region's economic growth. The State of Washington's ferry system was to be temporary until these bridges were built.

Lake Washington Floating Bridge and Agate Pass Bridge at Bainbridge Island (1940), the Tacoma Narrows Bridge (1941) and the Hood Canal Floating Bridge (1961) were part of a proposed series of cross-sound bridges at Vashon, Bainbridge, Edmonds and Port Townsend. Plans eventually focused on a single bridge at Vashon, with a floating bridge from Fauntleroy and a high-suspension bridge to Southworth. Bridges from Port Orchard to Bainbridge Island and from Bainbridge Island to Bremerton would complete the system, their cost covered by tolls and by ending three costly ferry routes.

Vashon Islanders liked the bridge proposals, but other groups did not. The Port of Tacoma wanted a second bridge built at the Narrows; it finally got it in 2007. The men and organizations on the water—pilots, major shipping lines and tugboat and towing companies—all argued that bridges would interfere with marine traffic. From both islands and the Kitsap Peninsula, only a few lonely voices protested that a bridge would ruin the rural feel of their communities.

Most Vashon Islanders agreed that a bridged island was a "United Island," a slogan put out by the Vashon Ferry District and the Vashon Chamber of Commerce. In 1950, islanders organized a "Let's Build the Bridge" campaign, and "Dream Bridge" was the theme of the annual Vashon Flower Show, with a model of the new Vashon Bridge as its centerpiece.[24]

The 1951 King County Planning Commission study and 1952's "Vashon Island Story" and "To Build a Better Community" from the chamber of commerce projected Vashon's population to grow to 10,000 by 1970—about what we have today in 2015—and eventually to 52,000. Along with this growth would come more zoning regulations, industries on north Maury Island, three saltwater parks, playgrounds, community buildings water and sewer expansions, more churches, more roads, eleven more elementary schools, four junior highs and three high schools. Vashon Parkway would

become a four-lane expressway starting at a North End cloverleaf and cutting straight down the island to south of Burton. The bridge would mean big changes for Vashon, and islanders wanted them. At a 1952 chamber of commerce meeting, 144 of the 150 who attended "enthusiastically" supported the bridge. When the state legislature appropriated another $82,000 for planning, it projected a five-year construction of the Vashon Bridge, with an opening in 1958.[25]

The Cross-Sound Bridge Bill was easily approved by the legislature and signed by Governor Langlie in 1953. The proposed bridge would have been the largest floating structure ever built, stretching 11,666 feet long, using 300,000 tons of steel and costing an estimated $100 million. The *Vashon Island News-Record* celebrated with a full-page spread on the bridge. The next year, the Vashon Bridge received approval by the Toll Bridge Authority and the Army Corps of Engineers. Then the state ferry system came calling for funds to retire its bonds. The state deficit grew to nearly $1 billion. Plans were shelved—Governor Langlie declared that the bridge was not "dead" but rather had to wait until it was "financeable." By 1958, its estimated cost had grown to $193 million.

In 1958, the first opposition from Vashon appeared in a letter to the *Beachcomber* saying that the bridge would "destroy rural life" on the island. One year later, funding bills passed the state House but tied in the Senate, leaving Lieutenant Governor John Cherberg to cast the deciding vote. Cherberg, recognizing how divided opinion was about the bridge, voted to send the bill back to committee. Vashon was saved from having a bridge by one vote. Despite periodic efforts to revive it, the bridge was dead, and Vashon was saved from becoming "Mercerized," as some say, into just another "edge city" in Pugetopolis. "I cannot picture this [Vashon] as a Mercer island," wrote Nancy Nelson, *Beachcomber* news editor, in 1968. That island "once had Vashon's charm. Then it got a bridge."[26]

Although funding died, the debate would not. At a February 1960 hearing on a "Cross Sound Turnpike/Bridge," three hundred islanders sat for a presentation that assumed the "bridge will be built." In the mid-'60s, claiming it "best for the state," new governor Dan Evans recommended a $132.2 million project that would build a floating bridge to Vashon, a suspension bridge across Colvos and a bridge across Sinclair Inlet to Bremerton. But for the first time, Vashon Islanders protested that a bridge might bring the mainland's "blight and sprawl" to the island. Community meetings with more than five hundred islanders recommended limiting high-rise apartments, creating more recreation areas, opening a channel at Portage, canceling the

Vashon Parkway, preserving Burton and limiting outdoor advertising. Civic Assembly president John Pearson said that Vashon islanders were interested in "maintaining the area as a residential community."[27]

The bridge had its last gasp in the 1967 legislative session. In May 1966, the Highway Commission and Toll Bridge Authority pinpointed Vashon for a cross-sound bridge. Given the choice of bridge over higher ferry fares, 80.7 percent of more than 1,300 islanders polled by the chamber of commerce chose the bridge. That September, the Puget Sound Regional Transportation Study, a six-year, $1.6 million project notable for being one of the nation's first large-scale regional planning exercises, recommended building the Vashon Bridge. But spiraling costs stopped it each time. Vashon would remain a rural enclave safe from urban sprawl.[28]

Nike Base

During the Cold War, when Seattle was perceived as vulnerable to attack by air, a Ground Observer's Post was set up with seventy air defense volunteers. In 1953, Air Defense Anti-Aircraft Charlie Battery of the 513th Air Defense Battalion was stationed on Vashon (near today's Eagles Aerie) with anti-aircraft guns.

In 1956, the government purchased island land to house anti-aircraft missiles—one of twelve sites in a defensive ring around Seattle. The Nike Base had three parts: the Sunrise Ridge administrative site, the Oakwood Terrace sixteen-unit housing complex just north of Sunrise Ridge and the missile launch site on Paradise Ridge. Battery A of the 433rd Anti-Aircraft Artillery Missile Battalion operated the base until it closed in 1974.

In the late 1960s, although few islanders knew about them, Vashon became a depository of nuclear warheads. The Nike Ajax missile was replaced by the heavier Nike Hercules—four missiles in one, armed with a nuclear device designed to destroy whole squadrons of bombers. Two other sites in the defense ring received Hercules missiles; the other bases were closed.

The Nike Site was decommissioned in 1974, and on September 22, 1976, the U.S. government turned the Sunrise Ridge property over to the Vashon-Maury Health Services Center (VMHSC), which moved its clinic into one of the military buildings. Granny's Attic thrift store, operated to support island healthcare, opened in two other ex-military buildings.

The Paradise Ridge site was deeded to King County, which, by 1983, didn't want it. Islanders proposed a park and recreation district to voters,

who approved, and in 1985, the new Vashon Park District acquired Paradise Ridge and nearby land. Oakwood Terrace and eighteen aces of Sunrise Ridge that VMHSC didn't take were sold to private individuals. Today, Sunrise Ridge is the home of the Vashon Health Center, the Food Bank, Voice of Vashon Radio, the Fruit Club's test orchard and two sports fields (Granny's Attic moved in 2014 to the IGA Shopping Plaza in Vashon town). The Paradise Valley launch site was converted into an equestrian park.

The Cold War legacy of the Nike Base continues on Vashon through the public parks at Sunrise Ridge and Paradise Ridge; the "Nike Kids," the children of the servicemen stationed on Vashon who married island young women and stayed to raised their families; and the realization that Vashon once was a depository for nuclear warheads.

CONCLUSIONS

By 1980, a more cohesive island community had emerged on Vashon, with the first inklings of the politically liberal, environmentally aware, arts-oriented rural enclave it would become by the beginning of the twenty-first century.

A NEW VASHON

1980–2015

Vashon retains its Mayberry-meets-Burning-Man character.[1]
—*Ethan Todas-Whitehall*

Those who grew up on the Island remember when the Island had more farms than BMWs.[2]
—*Mike Rotter*

Beginning in the 1980s, new groups of islanders came to Vashon, creating a transformation as dramatic as any of the past. They all sought the semirural lifestyle of an island close to the amenities of metropolitan centers and included the counterculture generation, who came in the 1970s and early 1980s; urban professionals, who began to arrive in large numbers in the 1980s; retirees and the wealthy, who came in the 1990s; the lesbian, gay, bisexual and transgendered (LGBT) community, which arrived starting in the 1990s; Hispanics, who arrived in the early 2000s; and younger families after the 2008 Great Recession significantly lowered the cost of homes. These newcomers often settled in the homes of farmers and merchants, the generation of the island past.

These new groups were spun from America's 1960s cultural revolutions. The hippie revolution shook up the island a bit when it first arrived, but the real transformation began as this generation built homes, started families and developed professional careers. Urban professionals and "urban flight" commuters supplemented this change, and when others joined them, a very

different community materialized. Two things enabled this demographic turnover: first, the increase in ferry capacity in the 1980s and early 1990s, and second, governmental regulations that affected development.

As the Seattle economy and housing prices boomed in the 1990s, Vashon became a rural haven in a rapidly expanding urban sprawl that engulfed other Vashon-like places. The island became gentrified as retirees, professionals and individuals with significant wealth (sometimes all combined) "discovered" Vashon.[3]

It didn't happen overnight; in fact, post–World War II growth slowed after 1990. Many felt that the island was becoming "one-third artists, one-third environmentalists and one-third lawyers." In the first decades of the twenty-first century, gentrification, deepening class divisions, population changes, hyperinflated housing prices and a growing conflict between development and preservation interests created a struggle to determine what the character of the island would be.[4]

The story of Vashon at the beginning of the twenty-first century is one of fulfillment of the trends and patterns that molded the island throughout the twentieth century. There is now a highly regarded artists' community with numerous active arts organizations and individual artists. The economy has shifted from natural resources to human resources, and agriculture has shifted to small subscription and specialized farms. While the island likes to think that it's sufficient unto itself, islanders, like most westerners, have turned to county, state and federal governments to support efforts to preserve the island against mining expansion, oil spills and the untempered development seen on the mainland. Today's islanders share a group identity, unallied to the small, water-based communities of the past. Like its iconic Bicycle Tree, the island embraces its uniqueness.

THE EMERGENCE OF A NEW VASHON

A Cultural Mashup

Modern Vashon has been molded by gentrification. Gentrification occurs when "higher income households displace lower income residents… changing the essential character and flavor of that [community]." The arrival of wealthier people increases property values, leading to changes in the character and culture of a community: properties improve, new

lifestyles arise and pre-gentrification residents are often displaced. Early gentrifiers are often low-income artists, bohemian communities, women and the LGBT community, and they establish a more sophisticated culture, attracting even more people who seek the urban culture without the city. This describes Vashon.[5]

Two major factors fostered gentrification on Vashon. The first was the change in ferry capacity in the 1990s and the increase in ferry costs after the passage of Initiative 695 in 1999. In the late 1980s, the state ferry system increaseed auto capacity by 31 percent and passenger capacity by 54 percent. Passenger capacity expanded again in 1990 when the passenger-only ferry *Skagit* began a Vashon-downtown Seattle run. Initiative 695 removed the car tab fees, which were a major source of funding for the ferry system. Fare increased dramatically to keep the ferry system running. The result was more urban professionals ambling off Vashon to downtown jobs, creating a demographic shift: Vashon became older, richer and whiter as the surrounding mainland changed.[6]

The second factor was limits on development that resulted from state and county restrictions on growth and from the growing awareness that Vashon had only a single-source aquifer. Both made the island a more expensive place to live. The 1983 Carr Report ultimately led to the Ground Water Management Plan of 1998, the Ground Water Protection Program of 2001 and the Vashon-Maury Island Watershed Plan of 2005. The Vashon-Maury Island Groundwater Protection Committee monitored and advised King County on water issues and developed water awareness reports—2010's "Liquid Assets" and 2012's "Assessing Our Liquid Assets"—that were sent to all islanders. This new awareness started "water wars" as Vashon's water districts limited shares and expansion despite demand.[7]

Adding to the awareness of limits on water were governmental regulations that began in the 1970s with the Open Space Initiative that preserved farmland. Wax Orchards and Augie Takatsuka's and Tok Otsuka's farms were all preserved this way. The 1972 voter-approved Shorelines Management Act sought to "prevent the inherent harm in an uncoordinated and piecemeal development of the state's shorelines." In 1990, the legislature passed the Growth Management Act, which forced local jurisdictions to plan how to control growth and preserve the environment. This legislation led to development of the Vashon Community Plan, which led to the Vashon Town Plan in 1985 (revised several times since) and, ultimately, to King County's 2005 Critical Areas Ordinance, which restricted development on vulnerable landscapes.[8]

Both the restrictions on development that came from regulations and limits on water and the kind of population growth that came from increased ferry capacity and increased costs of ferry travel worked together to gentrify the island. This new gentrification of the island led to a cultural clash among a range of opinions about the identity of the island as the twenty-first century emerged.

Island Identity

After the slowdown during the Boeing Bust of the 1970s, Vashon's population resumed its postwar growth rate. But in the 1990s, as island demographics shifted, growth dropped to the lowest rate since the 1920s.

Enhanced methods of getting on and off the island, coupled with the growing awareness of the Pacific Northwest as *the* place to live, attracted individuals who could afford the rising home prices and the rising costs of commuting, as the ferry fares increased. California's real estate boom rippled north, sending urban-suburban West Coast property values soaring; Californians, accustomed to high house prices, saw Vashon and other Puget Sound communities as affordable. The influx of newcomers who could afford expensive properties and

The Plancich net shed at Dockton is one of the last remaining working net sheds in Central Puget Sound. *Terry Donnelly.*

costly ferry commutes has given this rural place the feel (as some newspapers wrote) of a "Martha's Vineyard West."[9]

The demographics of Vashon today reflect a population that is older, whiter, wealthier, more educated and more homeowning than the rest of Pugetopolis. There are also two "hidden" demographics on Vashon, small but growing. One is its lesbian/gay/bisexual/transgender (LGBT) population— the highest LGBT percentage of any community in the state of Washington. This population is largely "hidden" because census data does not record sexual preference and because this population, which is largely couples and families, has no single gathering place nor any need to be recognized as a discrete population. Vashon is a "comfortable place to be comfortably out." The second "hidden" population is the rapidly growing Hispanic population, attracted largely by the availability of "underground" economy jobs here, the "live and let live" mantra of the island and the sense that the island is below the "radar screen" of the National Immigration Service. Hispanics feel comfortable on Vashon, and their businesses have flourished.[10]

With Seattle and the Pacific Northwest often touted as *the* places to live—in 1989, *Money* tagged Seattle as "America's Most Livable City"— younger tech-based professionals and "empty-nesters" have been drawn here. Vashon shared in the growth and rising affluence of a region basking in the dot.com boom. Computers, e-mail and the Internet tied Vashon into a "virtual" community. Facebook groups like "Vashon Old Pictures and Stories" and "VashonAll" have nearly 4,000 members each; Yahoo Group "VashonFreecycle" has more than 2,200. Hundreds of websites, Facebook groups and Yahoo groups promote a dizzying array of Vashon organizations, businesses and individuals. Cellphones, tablets and laptops are everywhere, allowing islanders to stay connected in a much more instantaneous community than was ever possible before.

Island Economics

By 2015, the original "Big Four" (logging, fishing, farming and mining) had long ceased driving the island's economy. Mining continued into the early 2000s, but when the Glacier Mine closed, only the local Vashon Sand and Gravel operation remained. A few fishing boats from Dockton still made their way to Alaska each summer and a few small logging operations continued, but the central role of these resource extraction industries was over. After the 1970s Boeing Bust, Vashon's economy experienced an economic roller

coaster: the slow growth of the 1980s, the gentrification boom of the 1990s and early 2000s and the Great Recession of 2008, its effects still felt in 2015.

Housing sales were sluggish through the 1980s and then soared in the 1990s. The first $1 million property on Vashon sold in 1997, and the first $2 million property sold in 2006. The median price of property peaked at $537,000 just before the Great Recession hit, had dropped to $337,000 by 2012 and in 2015 (at the time of this writing) have not returned to 2007's heights. Some folks voiced concerns about ostentatious "McMansions," but most islanders, with their usual suspicion of regulation and limits on private rights, turned a deaf ear.[11]

Island retailers shifted from small-town retail toward more tourist-oriented, wealth-servicing businesses as big-box stores emerged and as online shopping developed. In 1980, Vashon town still had its Sears, Western Auto, Leighton's department store, Sprouse-Ritz variety, a shoe store, a locksmith, a furniture store and other vendors of small-town needs. By 2015, none remained. Main Street's stores now serve a more leisure lifestyle, with boutiques, galleries, restaurants and the Vashon Pharmacy, which expanded into housewares, wearables and tourist tchotchkes. Thriftway was bought in 1965 by Norm Matthews, who built a shopping center around the store in 1974. He transformed Thriftway into an upscale urban shopping complex; in 2014, he won the Washington Food Industry Association's Excellence in Operations Award. Vashon's Thriftway now rivals any of Puget Sound's upscale groceries. Only two franchised restaurants have ever served Vashon: Dairy Queen, which opened in 1954, and Subway, built in 2005.

K2 began the era with layoffs, as a lingering recession and years of poor snow conditions nationwide led to declining sales. In 1981, K2 laid off 175 employees but picked up through the late 1980s and the 1990s, and at its height, it had more than 850 employees, many from off-island. But production slowed in the late 1990s; the plant closed in July 2001, the distribution center moved to Fife in 2002 and the main office moved to Seattle in 2006. The island's largest employer was gone.

With the exception of Beall Greenhouses and K2, most island businesses had fewer than 25 employees. One exception is Pacific Research, better known as the "Bone Factory" or "Sawbones." It was formed in 1977 by Foss Miller to build composite bones, joints and medical models, sold worldwide. In an act of incredible generosity, Miller sold the company to its 135 employees in December 2010, making it an employee-owned corporation. Another interesting small manufacturer is the Vashon Design Lab, opened by Peter Scott in 2010 to create low-cost, efficient stoves for developing

"Sawbones" (the "Bone Factory") is a division of Pacific Research Laboratories. Founded in 1978, it is now the island's largest manufacturer, making artificial bones and other materials for surgical training. *Pacific Research/Sawbones.*

countries. In 2013, Burn Design stoves received more than $4 million in loans to further develop and produce its stoves.[12]

The Great Recession made itself felt on Vashon, but not evenly on all. Many with significant wealth, recession-proof work or conservative retirement incomes felt it less. Home foreclosures spiked on Vashon, and home sales declined. Demands on the Vashon Food Bank and sales at Granny's Attic increased. In August 2008, five island nonprofits—Interfaith Council to Prevent Homelessness, Vashon Community Care Center, Vashon-Maury Community Food Bank, Vashon HouseHold and Vashon Youth & Family Services—agreed to pool resources during the economic downturn. Washington Mutual, which had a Vashon branch, collapsed and was absorbed by Chase Bank; Bank of America closed its branch. Credit unions stepped into the breach: Puget Sound Cooperative Credit Union was recruited by a group of concerned citizens, and Our Community Credit Union opened a branch.

What flourished was tourism, served by B&Bs and the rapid growth of the Vacation Rental by Owner (VRBO) business. By 2015, there were more than 125 VRBOs on Vashon. The year 2009 saw competing editorial commentaries in the weekly *Beachcomber* by Melinda Sontgerath supporting the growth of tourism and Mik Kuhlman opposing it. Tourism might be

controversial, but it brought needed dollars. The Annual Isle of Vashon Motorcycle Classic, the Sheepdog Trials, Saturday Market, Vashon Brewing Company's Cliff's Beer, Seattle Distillery, Vashon Winery, Dragonshead Cider, Nashi Orchards, the Lodges on Vashon, Giraffe, the President of Me and many more all serve ever more tourists. *Sunset Magazine* featured Vashon as one of the West's top twenty fantasy towns, highlighting the farmers' market and local cafés.[13]

The "shadow" economy on Vashon flourished, much like the cash-strapped barter days of the settlers. Exchanges of accommodation for building, gardening or maintenance, under-the-table cash payments for work done "off the books" and a growing Hispanic workforce that often preferred cash all contributed to a healthy hidden economy. Islanders with wealth were willing to pay for services, as were aging islanders who were no longer as able to do for themselves.

Island Agriculture

Farming continued into the 1980s, but by 2015, agriculture had transformed into something very different from twentieth-century farming. The last large commercial strawberry harvest was at the Matsuda Farm in 1985; other berry farmers shifted crops or reorganized as U-picks. Wax Orchards made its juices and preserves into the 1980s, as did Maury Island Farm with its condiments and jams. Misty Isle Farm ran Black Angus cattle on its five hundred-plus acres, but it disappeared when owner Tom Stewart moved off the island in 2006 and was killed in a 2010 helicopter crash.

Farming did not disappear, but it did transform into smaller specialty farms and local farm-to-table operations, which often requires one of the farmers to seek employment off the farm to make ends meet. Greenman Farm, Hogsback Farm, Lost Spring Farm, Pink Tractor Farm, Sea Breeze Farm and Sun Island Farm are just some of the small farms that have emerged on Vashon. Kurt Timmermeister's Kurtwood Farms is a good example of a small farm that developed into a successful business. After purchasing and restoring the landmarked 1881 Harrington-Beall Log House, Kurt, a former chef, began with specialty dinners, wrote two books about his farm, created acclaimed hand-made cheeses and ice cream and then opened KurtFarm Shop in Seattle.

The Vashon Island Growers Association (VIGA) promotes small farms selling local produce. In the mid-1980s, a small farmers' market opened on

the privately owned Village Green. In 1998, VIGA received a grant to build the current shed structure, and in 1999, when the property went on sale, Martin Koenig raised $325,000 so VIGA could purchase the Village Green. The Saturday Market is now a vital part of Vashon and an attraction for both tourists and islanders.[14]

Vashon has thriving wineries, cideries, breweries and distilleries. Ron Irvine, whose *The Wine Project* (1997) chronicled the history of winemaking in Washington State, began promoting the state's wines when he opened Pike & Western Wine Shop in 1975. Ron purchased Vashon Winery in 2001 and has mentored island winemakers ever since. His 2008 Pinot Noir was the first wine from commercially grown Vashon grapes since the Hake Winery closed in the 1940s. Vashon Winery along with Chris Carmada's Andrew Will Wines, George and Linda Kirkish's Palouse Winery and Bill Riley's Maury Island Winery have all won awards for their wines. In 2014, Andrew Will Winery, which moved to Vashon in 1994, was named one of the top one hundred in the world by the *San Francisco Chronicle*. Vashon's Annual CiderFest, begun in 2008, features locally produced ciders, including Irvine's Vintage Blend Cider, Wes and Laura Cherry's Dragonshead Cider and Jim Gerlach's Nashi Orchard's Perry. Vashon Brewing Company's Cliff's Beer is a growing island microbrewery, providing beer in growlers and kegs to avoid the cost and waste of bottles. Seattle Distilling produces gin, vodka and whiskey, as well as a liqueur using Orca Blend coffee from nearby Vashon Island Coffee Roasterie.[15]

Finally, the newest innovation in Vashon agriculture (with a long, illustrious, illegal history) is legalized marijuana production. After voter-approved legalization by the state in 2012 and endless development of the permitting process, the first public meetings about implementing the law took place on Vashon in 2013. Shango Los formed the Vashon Island Marijuana Entrepreneurs Alliance (VIMEA) in October 2013 as "an advocacy and trade organization for legal marijuana produced on Vashon." Tempers flared when companies Def Clown West and Bakkos Holding (Edipure) considered using the empty K2 plant as a production facility for marijuana products. Anti-drug/marijuana advocates and advocates for community use of K2 clashed with proponents of marijuana processing in a contentious debate over the appropriateness of the operation, the rushed permit process and the need for island jobs. When the state opened application for permits in 2014, more than a dozen permits were submitted for the island. An editorial, opinion pieces and letters to the editor all jammed the *Beachcomber* in early 2014 until the companies withdrew the proposals in May. In the

meanwhile, without much fanfare, Kevin Bergin quietly opened Island Cure Collective, a medical marijuana store, in February 2014; by the end of the year, Vashon Velvet, Susan Reid's legal marijuana grow operation in an old horse barn near the South End, was growing and selling marijuana. A new era in Vashon's agricultural history had begun.[16]

Island Ferries

Five modern ferry wars have characterized Vashon's relationship with the Washington State Ferry System since 1980. The first was the move to make ferry workers part of the state civil service, which effectively ended ferry strikes and unexpected shutdowns (but not delayed or canceled sailings because of "staffing issues"). The second was the 1984 attempt by residents of Fauntleroy to close the dock and the subsequent implementation of permit parking in the Fauntleroy neighborhood. The third was the mid-1980s to early 1990s increase in capacity and addition of passenger-only ferries, which opened the door to gentrification. The fourth was the passage of Initiative 695 in 1999, which drastically cut funding from automobile license tabs and led to service cutbacks and constant fare increases. And the fifth was King County opening passenger-only ferries from Vashon to downtown Seattle.[17]

The 1980 twelve-day Easter Weekend Strike, the one-day 1981 wildcat strike in April and engineer's strike in May were the last ferry strikes. That May, ferry workers became part of the state civil service (which prevented them from striking), and in August 1981, a Governor's Commission noted that ferry workers had the right to negotiate wages but were subject to binding arbitration. The mid-1980s brought tough times: ridership was down because of the Boeing Bust, the fleet was aging and needed replacements, the new *Issaquah*-class ferries (often called the "citrus class" because they were seen as lemons) were plagued by control system problems that led to accidents and the system was running larger deficits each year. Charges of high salaries, nepotism and racism also rocked the system.[18]

The residents of Fauntleroy have always been troubled by the ferry dock in their midst. As the lines and the number of Vashon cars parked in the neighborhood grew, the relationship became strained to the point where, in 1981, Fauntleroy neighbors appealed to the city to impose overnight parking limits. Tensions increased when the ferry system began to repair the dock. Fauntleroy organized and asked the state to move the Vashon traffic to

Colman Dock in Seattle and to remove the dock in the neighborhood. The ensuing court case and vigorous defense of keeping the dock at Fauntleroy, led by Jeanne Snell and the Vashon Community Council, ended up keeping the dock at Fauntleroy.[19]

Vashon felt less isolated after Washington State Ferry System ramped up capacity in the mid-1980s. The new *Issaquah*-class ferries had an increased capacity of nearly 100 cars, and the introduction of the 230-car passenger-only ferry *Skagit* running between Vashon and downtown Seattle route dramatically improved the commute. About the same time at Tahlequah, the 34-car ferry *Hiyu* was replaced by the 48-car ferry *Rhododendron*. Helping make this work for commuters was the matching of bus schedules: island buses rode ferries to Fauntleroy and onward, other buses met arriving ferries at Fauntleroy and at Point Defiance buses linked commuters to the new Transit center at Tacoma Community College. Not since the 1920s, when the Mosquito Fleet as well as the new car ferries served the island, had transit to/from the island been so available.[20]

Ferry fares have increased steadily since 1999, when Initiative 695 eliminated the Motor Vehicle Excise Tax. Between 2001 and 2006, fares increased 62 percent, service was cut by 28 percent and fares have continued to rise. The ferry system has suggested ways to lower costs, and islanders have petitioned the legislature to fully fund the system, all with little success. The "Wave to Go" electronic ticketing system was introduced in 2007, but fares stayed high. When the ferry system proposed significant cuts to service in 2008, only half of the one thousand people who came to the hearing could squeeze into the McMurray auditorium. The *Rhododendron* was replaced by the *Chetzemoka* for the south run in January 2012; with sixteen more cars, it nearly eliminated overloads. Today's issues are the many sailings canceled because of "crew issues," problems at the Fauntleroy Dock and continually rising fares, all of which have kept the Vashon Ferry Advisory Committee busy.[21]

The state had explored the idea of fast passenger-only ferries, including using Boeing hydrofoils, in the 1980s, but reaction was mixed—some predicted that passenger-only ferry service threatened Vashon's rural lifestyle. The service finally began in 1990 with the *Skagit* to downtown Seattle, but it was expensive to run—$2 million each year to carry 350 islanders to jobs in Seattle. When the state first considered dropping the service, more than 300 islanders filled the high school auditorium to protest. In 2005, the ferry system reduced runs from sixteen to six and then to four and discussed a takeover with Metro, and the legislature passed a law (as it had in 1947) to allow counties to create ferry districts. King County took over the state

passenger-only service and established its King County Ferry District in April 2007, the costs covered by a property tax. That August, islander Captain Marcia Morse, one of the few female skippers in the state ferry system, took command of the passenger-only ferry. King County chartered ferries until it could begin construction of its own in 2014. In 2015, the purpose-built passenger-only ferry *Sally J. Fox*, named after the island's outspoken ferry advocate, began serving the run, ensuring that passenger-only ferries would continued to operate into the foreseeable future.[22]

Island Governance: Hinterland and Dependence

Vashon has always been a political and economic hinterland, with decisions largely made by outside forces—which many islanders like. Although islanders have some influence, governments, organizations and individuals not on the island make the decisions. During this era, Vashon completed its shift from a Republican to a Democratic stronghold, re-created the Community Council as a community forum and then lost it, sought to secede from King County and failed, established a working Town Plan, rejected a proposal to create a Hospital District and battled King County over a number of specific issues, from elves collecting donations to putting grooves in Vashon Highway.

The shift to Democratic politics on Vashon is best seen by comparing the elections of the 1970s and the 2000s. The shift started in the 1970s: Vashon voted for Republican presidential candidates but Democratic Senate and House candidates, while splitting state elections between Republicans and Democrats. In 1980, Republican Ronald Reagan won the island with 1,515 votes to Jimmy Carter's 1,280 votes and John Anderson's 585 votes (which if lumped together for a single candidate would have outvoted Reagan). Thirty years later, Democrat Barack Obama won the island by 77.8 percent, Referendum 74 legalizing same-sex marriage passed by 78.6 percent and Referendum 502 legalizing marijuana passed by 71.8 percent—left-wing votes all. Vashon was redistricted following the 1990 census from the Thirtieth District, which included parts of South King County and North Pierce County, to the Thirty-fourth District, which included west Seattle and Des Moines. Vashon has become reliably Democratic.

Local politics was centered in the Community Council, which was revived by Jean Ameluxen, Pat Longhi and John Pearson as a community forum in 1976. The council's voice to the King County Council was strengthened when it became part of the six Unincorporated Areas Council in 1994. But

the Community Council lost its legitimacy in 2010–11 in conflicts over the relocation of the Vashon Library to the K2 site, ending when the board resigned rather than comply with state public disclosure laws. Gestures to bring a Vashon voice to the county council have been made since but have not jelled. The concept of a town hall forum is admirable; the reality, however, was that meetings rarely had more than fifteen or twenty attendees.[23]

Vashon islanders made one last attempt to create their own government by attempting to incorporate as a city, as Bainbridge Island did in 1991. Led by Carol Campbell of the Vashon Island Committee for Self Government, in 1994 the committee gathered 448 signatures on a petition to incorporate Vashon. In May, the County Council requested that its Boundary Review Board consider the proposal. Opponents of incorporation took the proposal to the courts. Citizens for Rural-Oriented Government (CFROG) intervened in the lawsuit, as did a member of that organization, attorney Laura Wishik. The case was appealed to the Washington State Supreme Court in 1995, which upheld the lower court decision that because Vashon was outside the designated urban growth areas of King County, Vashon "cannot under current law be incorporated." This was the final attempt, first tried in 1912, by islanders to break away from King County.

Islanders have always taken issue with King County. Many feel that the county does not adequately serve the interests of the island or that the county has thwarted development here. In 2005, a group of property rights advocates attempted to recall King County councilman Dow Constantine, who represented Vashon, because of his support of a county ordinance that limits development on environmentally sensitive land. Islanders may dislike King County for many reasons, but they can thank it for keeping Vashon rural, keeping it from becoming another Mercer or Bainbridge Island.[24]

Because of land-use decisions by state and county, growth on Vashon has largely been channeled into Vashon town. The Vashon Town Plan, begun in 1983 and revised regularly, provides the framework for development on the island. As a result, Vashon has remained, according to Patrick Christie, a "suburban-rural place in a sea of urban growth."[25]

For the second time, islanders attempted to create a hospital district to serve islanders. The first attempt failed in 1949. In 2006, with both the clinic and the local nursing home pleading for financial support, interested islanders organized a special election for a hospital district in February 2006. The vote failed dramatically when 71 percent of islanders voted no.[26]

Tension rumbled again between King County and islanders in 2012 when the county began cutting "rumble strips" into Vashon Highway to warn

drivers who were straying off the road. The plan, years old, was announced, but few foresaw its bone-rattling impact on bicyclists. In April, when King County contractors began gouging rumble strips into the highway's shoulders—where bicyclists ride—several island bicyclists confronted the contractors and came close to fisticuffs until the sheriff arrived. The county suspended the road cutting until members of the bike community could meet with county officials. The county agreed to reduce the depth of the rumble strips but continued the project.[27]

NEW SENSIBILITIES

New ferries brought new people and new values. Arts awareness, already high, flourished. A historical awareness freed itself from the Pioneer Society's focus on early settlers, and an environmental awareness grew after the success of the Bradleys' ASARCO case. These shifts in sensibility helped slow development on the island, connected islanders to their past and attracted like-minded newcomers, furthering the island's demographic and cultural shifts.

Environmental Sensibility

Vashon's growing environmental awareness, sparked by the Bradleys' ASARCO case, had at its core the intent to keep the island rural. Local developments kept the focus on Vashon's ecosystems: the Vashon Land Trust, begun in 1989; the dramatic and contentious fight over the expansion of the Glacier gravel mine on Maury Island; the oil spills of 2004 and 2005; and the emergence of local environmental organizations such as Vashon Nature Center. All made islanders aware of the uniqueness and fragility of the island's ecology.

The Land Trust was formed in December 1989 by a group of interested islanders spurred to raise funds to purchase Whispering Firs Bog. In 1992, David Warren came on as director. The organization grew rapidly, with strong donor support to create the Fern Cove Reserve (1994); establish conservation easements (1995); take on management of Fisher Pond, donated by Bill Fisher (1998); and purchase a building for a headquarters (1998). The Land Trust has accomplished an amazing range of successes,

Preserve Our Islands fought a long, drawn-out legal and political battle against the expansion of the Glacier Mine on Maury Island. Islanders formed a killer whale on the beach at the Glacier site in 2009 to protest the proposed expansion. *Ray Pfortner.*

from preserving Christensen Pond (2000) to restoring Shinglemill Creek (2006), sharing watershed stewardship with King County at Ellis Creek, creating the Raab's Lagoon Preserve with the County and the Cascade Land Conservancy (2008), beginning the Judd Creek preservation effort (2008) and working with state and county to purchase land to further preserve Whispering Firs Bog and expand Island Center Forest. The most recent effort revisits one of the organization's original goals of preserving Vashon farmland by purchasing the Matsuda Farm (2015).

When Glacier Northwest announced plans in 1998 to expand its surface gravel mine on Maury Island, islanders gave it a protracted fight. The gravel mine had been open since the early 1900s, one of three on Maury's east shore. The northernmost became the site of a still-to-be-developed King County park with RV sites, campgrounds, picnic areas and beach facilities. The middle mine was recontoured in the late 1960s and developed into a housing tract named Gold Beach. The southernmost had been continuously mined since the 1940s, shipping around ten thousand tons of gravel annually. With SeaTac's third runway project in mind, Glacier Northwest requested a permit to mine 7.5 million tons of gravel per year. To do this, the company needed to remodel its dilapidated pier and loading facility, which had been

built on land now owned by the State of Washington and managed by the Washington State Department of Natural Resources.

In 2000, Commissioner of Public Lands Jennifer Belcher, whose department is chartered to manage sensitive habits and preserve wildlife, designated Quartermaster Harbor and the east shore of Maury Island an Aquatic Reserve because of its diverse set of habitats, its role as a salmon migratory corridor and rearing habitat, its spawning grounds for forage fish and its migratory and resident bird habitat.[28]

Once the scale of the expansion of Glacier became apparent, a group of local homeowners and other islanders led by Sharon Nelson formed Protect Our Islands (POI) to fight the expansion. The potentially disastrous effect on home prices, the island aquifer and habitats and wildlife, as well as the sheer size of the project, drove opposition. Glacier Northwest countered POI's arguments by projecting regional gravel "consumption of 13 tons of gravel per person in the region, and the significantly reduced impact of barging rather than trucking gravel" as reasons to expand the mine. Nelson called the struggle "a lot more of a long shot than I realized."[29]

Glacier and POI grappled over the permits necessary to remodel and expand on state-owned land. In 2002, Glacier submitted a permit application to King County to expand the dock, which in 2004 was denied by the Department of Development and Environmental Services. Glacier Northwest then sued the county and appealed its decision to the State Shoreline Hearings Board, which reversed the decision. In October 2004, after a significant oil spill in Dalco passage, the Maury Island Aquatic Reserve was formally established by Commissioner's Order for a period of ninety years. Then King County, Preserve Our Islands (POI), People for Puget Sound and the Washington Environmental Council all filed separate appeals of the Shoreline Hearings Board's decision. In January 2005, King County Superior Court judge Sharon Armstrong issued a temporary stay on King County's permits for Glacier's dock.

The battle moved through the courts. Later, in 2005, the Court of Appeals ruled in favor of Glacier. POI petitioned the Washington State Supreme Court to hear the case. The Army Corps of Engineers then got involved, discussing endangered orcas with the National Marine Fisheries Service and debating whether to grant a federal dock permit. When in 2008 the Corps of Engineers approved Glacier's construction of the dock and the Supreme Court denied hearing PIO's challenge, the situation looked bad for the opponents of the mine.[30]

Three things changed the outcome and eventually forced Glacier to sell the site to the State of Washington. Candidate for commissioner of public lands Peter Goldmark, a mine opponent, defeated Doug Sutherland, a mine supporter. Governor Chris Gregoire launched the state's effort to restore Puget Sound. In 2009, U.S. District Judge Ricardo Martinez issued an injunction that halted construction. Glacier saw Judge Martinez's ruling merely as a delay, but then, as Dan Chasan remarked, "somewhat unexpectedly, peace broke out."[31]

A very public protest organized by POI and the Backbone Campaign, with more than five hundred protesters at the Glacier site, gave the issue visibility. In 2009, the Cascade Land Conservancy (CLC), at the urging of POI, reopened talks with Glacier. The same individuals were involved and the issues and positions had not changed, but what had changed was the atmosphere created by Judge Martinez's decision and the growing public awareness of how the Glacier fight was a part of the larger fight to save Puget Sound. A boat trip to the mine site in August 2009 with Allen Hamblen, CEO of CalPortland, owner of the Glacier site; Shinji Matsui, president of Taiheiyo USA, which owned CalPortland; Michelle Conner and Gene Duvernoy from the CLC; and a phone call while on board from former Environmental Protection Agency director and Puget Sound champion Bill Ruckelshaus seemed to shift the direction of the negotiations. The dedicated money on the table from King County ($19.1 million from the Conservation Futures Fund) and from the state ($14.5 million from the ASARCO settlement) was enough to allow the two sides to reach agreement. Following extended negotiations, the sale of the site was announced on December 28, 2010. King County took possession on January 8, 2011. More than six hundred islanders turned out to celebrate POI's victory, with Sharon Nelson declaring that "Glacier totally misjudged our community."[32]

Two oil spills in Dalco Passage between Vashon and Tacoma awakened islanders to an *Exxon Valdez*–style threat. Neither spill was as large as it could have been, but the October 2004 spill, which occurred at night, spread before it was discovered and closed Quartermaster Harbor for days; cleanup took weeks. The January 2005 spill was discovered and contained quickly, but this second spill in three months spurred islanders to form Vashon Oil Incident Support and Education (VOISE). In March 2010, Conoco Phillips settled on payments to clean up three island sites polluted in 2004.

The Vashon-Maury Island Audubon Society, Vashon Forest Stewards, Vashon Beach Naturalists, Sustainable Vashon, Vashon Hydrophone Project

and Cedarsong Forest Kindergarten are all educational organizations that promote understanding of the environmental issues that confront islanders. One of the most active is Vashon Nature Center, founded by Bianca Perla, who grew up on Vashon and earned a PhD in ecology at UW before returning to the island to raise a family. The center's mission is "to build a community of Islanders and visitors who connect with local natural wonders and with each other through research, education, and citizen science." With the help of the island's many professional and amateur naturalists, biologists and ecologists, the center explores the island's rich biodiversity to create a living legacy of information about the animals, plants and environments that are Vashon. Beginning in 2012, the center's annual "bioblitz" identifies as many plant and animal species as possible in a twenty-four-hour period at a given location. The center published Perla's *Vashon-Maury Island Field Guide* in 2013.

Heritage Sensibility

Islanders' interest in their history developed early, with the Pioneer Society in the 1920s. But it was not until the 1970s that more substantial efforts were made to tell a broader history. Roland Carey's local history *Isle of the Sea-Breezers* was published in 1976, and his carefully researched and annotated *Van Olinda's History of Vashon-Maury Island* was published in 1985. Carey's collaboration with pyrography artist Marshal Sohl produced a series of extraordinary burnt-wood maps detailing the histories of island sites.

Heritage awareness has been fostered recently in three ways. First, the Heritage Association was formed in 1978 from what remained of the Pioneer Society and started planning for a museum. It took more than ten years, but in 2001, the group purchased the former Lutheran church at Vashon town's western edge. The museum officially opened in 2006 and has hosted numerous special exhibits, including the award-winning "Home of Record: Vashon and the Vietnam War" and "Vashon Island's Native People: Navigating Seas of Change." Second, Jim Sherman and Brian Brenno started a Facebook group, "Old Vashon Pictures and Stories," which swelled to more than 3,800 members, who post photographs, stories and memories of the island. This has become one of the most active ways in which people interested in Vashon's history share information and images. Third, there has been an amazing

flurry of publishing about Vashon's history. Directed by Marj Watkins and Garland Norin, Vashon students collected island stories for *Past Remembered*, printed in 1978; it was followed by Norin's *Past Remembered II* in 1991 and the Heritage Museum's *Past Remembered III* in 2008. During the 1990s, the *Beachcomber* published heritage articles written alternately by Mary Jo Barrentine (daughter of George McCormick, island circum-rambler) and Mary Matthews. Dan Chasan, following the publication of *The Waterlink* in 1981, has written often about island environmental and historic issues, particularly for the online magazine *Crosscut*. Pamela Woodroffe's *Vashon's Agricultural Roots: Tales of the Tilth* (2002), Jean Findlay's Vashon chapter in *The Mosquito Fleet of South of Puget Sound* (2008), Bruce Haulman and Terry Donnelly's "Time & Again" articles in the *Beachcomber*, Bruce Haulman and Jean Findlay's photo history *Vashon Island* (2011), Karen Dale's *Garden On, Vashon!* (2013), Chris Austin's series "It's Your History" in the *Beachcomber* and the publication of this interpretive history have all revealed more of Vashon's past.

Arts Sensibility

In this period, the foundations to support island arts were laid. In 1981, Vashon Allied Arts moved to the former Odd Fellows Hall at Center, named it the Blue Heron and began to transform into the powerhouse arts organization it is today. That same year, VAA began its annual Art Auction and opened a craft shop that would become the Heron's Nest. A group of island potters held a Potter's Tour that grew into the biannual Studio Tour, which in 2014 featured fifty-three artist's studios. VAA helped launch the popular First Friday Studio Cruise, developed the annual Island Quilt Raffle, began the Arts and Humanities Lecture Series, provided a stage for island musicians and still works to foster one of the most vibrant arts communities in western Washington.

But VAA didn't create this art scene by itself. Island groups like Drama Dock, UMO, Vashon Chorale, Vashon Opera, Vashon Chamber Music, Vashon-Maury Chamber Orchestra, Church of the Great Rain, Free Range Folk Choir, the Salish Sea Concert Series and Vashon Dance all expanded. Performance spaces like the O Space, Concerts in the Park, Vashon Theatre's National Theater and Royal Shakespeare Theater broadcasts; and venues like the Red Bike, Snapdragon, Minglement, the Coop, the Jesus Barn and Spoke have all played host to great performances. An arts section in the

Vashon Allied Arts (VAA), founded in 1966, is the oldest community arts organizations in Washington. The women who established VAA's various arts programs gathered at the fortieth-anniversary celebration in 2006. *John Sage.*

Beachcomber, plus online calendars like the Vashon Calendar and Vashon Events, promote art events. In 2015, there is rarely an island evening without some kind of arts programing.

RURAL LIFESTYLE AND URBAN EXPECTATIONS

Vashon's gentrification also brought urban expectations to bear on a rural community. One of the unique things about Vashon is the "mash-up" rather than the divisions that result from gentrification. In many communities, the lines of divison are defined by wealth, education and employment. On Vashon, the lines of division are defined by skills, interests and issues. Expensive homes sit on the beach next to modest cabins, urban professionals and alternative farmers work together on nonprofit boards and longtime

residents and newcomers unite to support issues, and the result is a community less defined by traditional measures of divisions and more defined by the positions taken on each particular issue. Vashon is a community defined not by the size of your wallet but rather by the size of your imagination. The amazing range of individual expertise and experience found on Vashon has often professionalized organizations and changed their approaches to issues for the better. But sometimes organizations became mired in the gap between urban expectations and some deep-rooted values still held on this semi-isolated island. Islanders became involved based on the issue rather than whether they were old-timers or newcomers, wealthy or poor, PhDs or high school graduates.[33]

The Successes

The successes from 1980 to 2015 were many, and islanders proudly regard them as indicators of what makes this community so special. The organizations mentioned previously, as well as others like Granny's Attic, Vashon Island Pet Protectors (VIPP) and the Park District, have all helped make Vashon what it is today.

Granny's Attic began in 1973, when Vashon-Maury Health Services Center was started in a house in Burton. A group of women volunteered as receptionists; as the place prospered, they organized health center volunteers and proposed a thrift store to help fund the center. Granny's moved to Sunrise Ridge in 1975 and to Vashon town in 2015. Granny's has provided more than $2 million of support for the health center and today supports other health providers as well, contributing more than $250,000 each year.[34]

Vashon Island Pet Protectors, established in 1984, is dedicated to improving quality of life for Vashon's companion animals. Its volunteers host a no-kill animal rescue operation. Its annual "FurBall" fundraiser, which began in 2002, is just part of the quirkiness that defines Vashon. BaaHaus Animal Rescue Group, formed in 1997, provides a similar protection for farm animals.[35]

The anti-bridge movement, the "Christmas Miracle" of 1995 and the growth of the Food Bank all demonstrate successes won by this community. The 1992 "Bridge Meeting"—where more than two thousand islanders turned out to oppose the Vashon bridge proposal with signs reading, "If You Build It, They Will Come," "Bridges Bring Death" and "Don't Mercerize

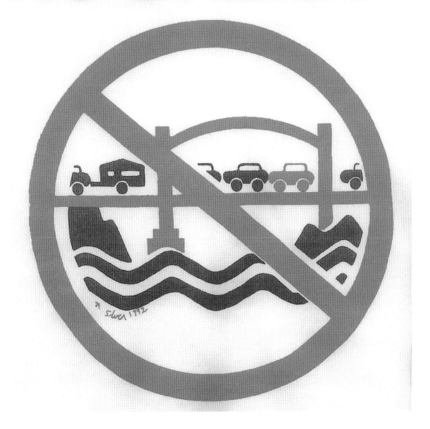

In 1992, when the Washington State Department of Transportation held hearings on constructing a Vashon bridge, more than two thousand islanders attended, carrying signs reading, "If You Build It, They Will Come" and "Don't Mercerize Vashon Island" and sporting the "No Bridge" logo designed by local artist Nancy Silver. *Nancy Silver.*

Vashon Island"—showed the shift in opinion about the impact that a bridge would have on the island.

The December 1995 "Christmas Miracle," which saved Island Manor Nursing Home and led to the creation of Vashon Community Care, is another example of how islanders pulled together to preserve part of the community—and also a measure of how new wealth aided island causes. The facility opened as the Ellsworth Ranch in 1908 and became the Goodwill

Farm twenty years later and then a nursing home in 1944. The owners announced its closure in 1995 because of daunting upgrade requirements. Led by Ted Kutscher and Ted Clabaugh, thirty islanders pledged loans to guarantee the lease of the property and, within two weeks, organized the nonprofit Vashon Community Care to keep the facility afloat. The group quickly found that an entirely new facility would be needed within five years because of the old building's condition and new regulations for care centers. VCC's board accepted the challenge, enlisted the cooperation of Providence Health System to purchase the property and built a new facility that opened in August 2001.

The Vashon Maury Community Food Bank, which began in the 1970s, became a nonprofit in December 1991 and moved to Sunrise Ridge in 1993. Gentrification, the rising cost of living and the closing of K2 spun off record numbers of clients, and the Great Recession of 2008 only increased the demand. The Wednesday Night Dinner, an outreach to islanders in need begun by Sally Carlson in 1990 at the Episcopal church, expanded to nightly dinners at several churches, organized by the Interfaith Council to Prevent Homelessness.[36]

Successes continued with the emergence of Vashon HouseHold in 1989, Voice of Vashon in 1999, the O Space in 2005 and Vashon BePrepared in 2007. Vashon HouseHold was formed in 1990 by a group worried about affordable housing on the island. Rising housing costs were pushing teachers, tradespeople, business owners, artists, seniors and others from their own communities. By building, renovating and assisting with housing, Vashon HouseHold has helped hundreds of islanders remain.[37]

Voice of Vashon was formed in 1999, and by 2014, all its dreams were realized with 1650 AM providing emergency broadcast, KVSH 101.9 FM giving local DJs the opportunity to spin often local music and Comcast Channel 22 for Voice of Vashon television. All of these broadcasts are also available online. After nearly eighty years of mainland stations and content, Vashon finally broadcasts its own voice.[38]

O Space opened in 2006 in the former SBC Coffee warehouse to provide a community performance space. Owners Janet McAlpine and David Godsey of the UMO Ensemble developed the facility with a performance hall, classrooms, meeting rooms and gallery space. A dizzying array of performances come to the O Space.[39]

Community Emergency Response Team (CERT) classes that began in the mid-1990s gained added emphasis with the Nisqually earthquake in 2001, which spurred islanders to create Neighborhood Emergency Response

Organizations (NERO) and the Vashon Disaster Preparedness Committee (VDPC). In 2007, Vashon BePrepared coordinated emergency responses under the operational control of Vashon Island Fire and Rescue and won the King County Community Preparedness Award in 2012.[40]

Two recent successes are the formation of Island GreenTech in 2010 and the DOVE Project. Started in 2011, the DOVE Project works on domestic abuse issues. GreenTech is a loose coalition of islanders founded by Tag Gornall, Bob Powell and Rex Stratton to encourage green enterprises and jobs. It quickly expanded its scope to many projects, including the Vashon Electric Vehicle Association (VEVA), drawing Puget Sound Cooperative Credit Union (PSCCU) to the island as an alternative to big banks after the Great Recession of 2008 and funding the replacement of Vashon Theatre's obsolete projection system by raising more than $80,000 in two months. GreenTech also supports Zero Waste Vashon (ZWV) and the Vashon Tool Library.[41]

These successes and many others have strengthened our community. Gentrification brought experience and expertise to Vashon that joined with other island strengths. Together, these qualities often brought success to organizations, although not always.

The Conflicts

It hasn't been all roses and successful fund drives. Change brings out conflict. The conflicts are the result of the mash-up of intrests, as some seek to maintain island uniqueness through an organizational style and others seek to maintain it through a more casual, organic style. What makes these confrontations so significant is that at their core, each is about island uniqueness, but on each issue, each side defines that uniqueness differently. And the sides are fluid, with individuals moving back and forth across this divide based on each particular issue. There have been several major conflicts that reflected this tension: Vashon schools, the Vashon Fire District, the "Great Library War," Vashon Park District's Vashon Fields and Vashon Allied Arts' new Performing Arts Center.

Vashon schools have always generated controversy. Between 1980 and 2015, the school district confronted two significant challenges with superintendents. The first involved Superintendent Stu Adams, who had led for twelve years but in 1984 was challenged by new, younger teachers, parents with new expectations and his own traditional but out-of-sync approach.

When Adams invoked Spiro Agnew's barb, those "nattering nabobs of negativity," to describe his distractors, it was clear that he had lost touch with a growing segment of the community. A petition by 1,044 requested his contract not be renewed, and the board complied. The second came in 2007, when Superintendent Mimi Walker was placed on administrative leave for "lack of candor and transparency." The board terminated Walker for "paying herself overtime…not authorized by the Board." This was another example, like Superintendent Adams, where rising expectations for professional standards conflicted with more informal managerial styles. Not coincidentally, school levies failed both in 1980, as the Adams controversies began, and again in 2008, when VSD proposed an elaborate expansion. Despite these controversies, Vashon Schools did finally realized the dream, first envisioned in the late 1940s, of a centralized campus when Chautauqua Elementary was built in the early 1990s. In 2014, the district built a new high school there that has won awards for its design and its environmental footprint.[42]

Vashon Fire and Rescue has often had trouble reading island culture. In the late 1980s, the Fire District, the post office and King County tried to impose the county's street numbering grid on the island. Vashon still had rural routes and unmarked street names; police and fire responders understandably wanted locations they could find. But islanders wanted their streets to reflect community. The street name committee met for months over the street names submitted, and some wanted to add even more names. The committee submitted its proposal at a December 1987 Community Council meeting, where a list of additional street names was proposed. As the meeting began to review each suggested addition, Martin Baker moved that all submitted names be accepted. With a quick second and approval, the meeting was done: Vashon streets would be a mix of names and numbers.[43]

The second issue that disrupted the Fire District was the purging of many longtime volunteers that led to introducing paid firefighters to replace what had been a volunteer department. When longtime fire chief Craig Harmeling was forced out and Randy Cogan became chief, his iron-handed style led many dedicated volunteers to leave the Fire District, which then allowed those seeking to hire professional firefighters to claim that they could not get enough volunteers. The introduction of paid firefighters did not go smoothly, and the process became ugly, with claims of favoritism and little tolerance for disagreements within the department and the board. A revolving door of chiefs and commissioners created a department that made a series of questionable decisions that culminated while Jim Wilson was chief. Proposals for a new ladder truck, a new manned fire station at

Inspiration Point, a different provider of emergency ambulance service and moving dispatch and 911 emergency call service off-island all led to turmoil. When Wilson left under a cloud of controversy, Mike Kirk, a longtime volunteer, was appointed interim chief in 2006 and began to heal many of the conflicts. Hank Lipe was hired in 2009 to lead and restore lost respect. But conflict still rose: in 2009, Lonore Hackett sued the department for discrimination against women and won. Changing values affected the Fire District at all levels, and the traditional ways of doing things blended uneasily with attempts to create what some wanted to see as a more professional department.[44]

Another clash was what Dan Chasan dubbed the "Great Library War." Vashon loves its library, which has twice the circulation of any library in a like-sized community. The "war" began in 2004 when county residents approved a library expansion bond. The combatants included the imperious director of the Library System, Bill Ptacek; several headstrong Vashon Park District Board members, including Bill Ameling and David Hackett (who will resurface in the Vashon Fields debacle); members of Vashon Community Council; and state and county politicians. When the park board refused to allow expansion at Ober Park, the Library System proposed moving the expanded library to the mothballed K2 site a mile south of town, where developers wanted to make it a community resource campus and had quietly rezoned the K2 site from Industrial to Community Business without going through the normal public process. Many thought that moving the library far from town did not serve the community, ran counter to the state Growth Management Act's intent to limit sprawl in rural areas and made a mockery of community planning. The lines were set for the fight to begin.[45]

Heritage Group Limited—the K2 group that wanted to attract the Health Center, Granny's Attic, school district offices, island nonprofits and recreational facilities to the site—wanted the library as an anchor tenant. A Community Council survey found that 80 percent of islanders wanted to keep the library at Ober Park. The largest Community Council audience ever turned up for the November 2008 meeting, where the council refused to discuss the K2 rezone. The war was on. Islanders pressured both the Park District and Library System to reopen negotiations, and at a contentious King County Library Board meeting in June 2009, with several hundred islanders in attendance, the board heard impassioned testimony from islanders and chose Ober Park and a remodeled library. In August, questioned about the rezoning and the appearance of favoritism to the K2 group, the Community Council resigned rather than release their e-mails. Thus ended the Community Council, the chief casualty of the "Great Library War."[46]

Vashon Park District began in 1983 when King County proposed returning the abandoned Paradise Ridge Nike launch site to the federal government. This spurred islanders, led by Ruth Anderson and Dan Carlson, to propose a Recreation District; after two failed votes, the district was approved by voters, and what would become Vashon Park District was formed. The new district quickly created parks at the Paradise Ridge Nike site, purchased Lisabeula and took over parks jettisoned by King County. Wendy Braicks, new director in 1990, expanded with programs, summer camps and even more parks (often in cooperation with the Land Trust) at Milita Creek Preserve, Ober Park, Fern Cove and the Belle Baldwin House, Tramp Harbor Dock, Wingehaven, Point Robinson, Fisher Pond and the Village Green. Vashon Park District was an island gem and had well-established community support.

However, that support changed dramatically with the Vashon Fields Project north of town. The board, spearheaded by Bill Ameling, David Hackett and baseball coach Joe Wald, insisted on state-of-the-art sports fields. The first indication of overreaching came when they rode roughshod over a neighboring family's access and plantings. A fifty-year informal agreement was tossed aside; when construction began, the family's access was constrained and trees heedlessly removed. The fields' design was so poorly executed and the permitting process so poorly handled that King County ordered the project stopped in April 2011.

At the same time, after assuring the state that the district had the required matching funds, which it does not seem to have had, and with funding exhausted, the board began razing other park programs to cover its lack of foresight. The "Fields Folly" only deepened in 2012 when the board cut the budget by $124,282, eliminated longtime programs, withheld funds from the Keepers of Point Robinson and fired new director Jan Milligan because she apparently warned the board that it was bankrupting the Park District with the Fields Project. In September, King County revealed that the district had not obtained water permits to keep the fields watered, and the mess grew as another $88,864 was cut from the budget. When supporters and former board members offered advice and when 250 islanders petitioned to meet with the board about the financial irregularities, the park board rejected both offers. By 2013, Vashon Parks was in disarray: the Fields Project had ballooned to a nearly $3 million fiasco, there was a budget deficit, King County reprimanded it for poor cash management and the state auditor's office reported that the district had failed to curb expenses when revenue fell, secretly borrowed money and ignored laws governing construction projects.

Under community pressure, the board passed a much leaner budget, laid off employees, increased fees, hired a new director and formed a citizens' review committee for the project, beginning a long, slow effort to recover from its failures and rebuild community trust.[47]

Vashon Allied Arts had wanted to build a performance center since 1981, but it was only a hope until arts patron Kay White, Vashon Chorale member, initially offered $3.5 million around 2007 to build the center and ultimately contributed more than $10 million in construction funds and operational reserves. Plans began, and in April 2008, VAA purchased the McFeed's building just north of the Blue Heron, and then the additonal parcels to the east, for the new "arts facility." The next May, VAA was awarded $1.1 million from the state and $75,000 from King County to begin the project, although most of the state funds were not used because construction was delayed.

VAA consulted Drama Dock, Vashon Chorale, Vashon Opera, other groups and many individual artists and then rolled out plans at Strawberry Festival 2011 for a $16.6 million, twenty-thousand-square-foot, three-hundred-seat, state-of-the-art theater and gallery. Many islanders loved the plans; the Blue Heron was cramped, not well suited as a gallery or performance space and desperately need parking space. The proposed center addressed these issues. Many islanders, including some of those consulted, scratched their heads. Others, in true Vashon spirit, objected to the planning process, the wisdom of building two new theaters (plans for a new high school included a theater) and the facility's design, which seemed out of scale for the neighborhood. All through 2012, the opposition questioned VAA's sensitivity to the community, to the environment (the site has a wetland) and to the Center neighborhood. Numerous articles, op-ed pieces and commentary from both sides appeared in island media. During 2013, another $2 million in state funds secured by Senator Sharon Nelson and a $2.5 million fundraising effort announced by VAA ensured that the project would proceed. Murals by island artists adorned McFeed's building when the official groundbreaking took place that October. Despite a five-month delay from rising costs and the Seattle building boom, McFeed's was demolished in April 2015, and construction began in May. The renamed Vashon Center for the Arts is scheduled to open in 2016.[48]

These conflicts and successes reflect some of the growing pains brought by gentrification, as the organizational approach of some islanders, both new and old, rubs against the informal style of other islanders, both old and new.

CONCLUSION

As Vashon was "discovered" beginning in the 1990s, gentrification, brought by higher ferry capacities and property values—rising in part due to a limited water supply and government-regulated limits to growth—changed the island. The adjustments of recent years grew from love of the arts, heritage and environment—support typical for a well-heeled, well-educated population. It is a measure of how much Vashon is treasured that these newcomers feel they have just as much a stake in this beloved place as those who have lived here for a while.

In the 1980s, Vashon began a transformation that is still unfolding. The changes that have started to mold twenty-first-century Vashon are difficult to pinpoint today, and their consequences are impossible to foresee. But hopefully a future historian will write a history that will help us better understand what we are experiencing now.

ENDURING PATTERNS

In writing this *Brief History of Vashon*, five enduring patterns emerged that have characterized Vashon Island. These patterns form the central analytic ideas for this book. These patterns emerge, shift and are redefined, but always within a recognizable form. These patterns are what form much of the continuity that marks a history defined largely by change.

VASHON ISLAND EXCEPTIONALISM

Vashon Islanders have always thought of themselves as exceptional and unique, and in many ways, the island is an exceptional and unique place. Yet Vashon is part of a larger region and is a kind of a prisoner of the larger social, political and economic forces at work in the Pacific Northwest. The reasons people come here, the experiences they have, the jobs they hold and the patterns of their lives are really not exceptionally different from their contemporaries on other Puget Sound islands and on the mainland of the Puget Sound Basin. The island's small-town, rural, inclusive lifestyle within twenty minutes of the center of a large modern city is what makes Vashon unique. The mash-up of urban expectations and sensibilities with rural styles and perceptions creates a community that is at the same time warm and friendly and small town–like yet also culturally, socially and politically progressive and cosmopolitan.

EPILOGUE

Isolation versus Dependence

The mythology of pioneers is one of isolated, independent, self-reliant individuals who conquer the wilderness and transform the land into an area connected to its surrounding region and to the larger nation from which they came. Vashon, as a part of the Pacific Northwest, remains an isolated island in a rapidly expanding urban Pugetopolis. Until recently, Vashon Islanders have always sought to be more connected to the mainland—better, cheaper, faster ferries and a bridge. But now, islanders seek to remain isolated and "underdeveloped" to preserve the island's unique lifestyle while paradoxically continuing to seek better, cheaper ferry service. The Daniel Boone Paradox is at work. Each generation of residents has reinterpreted its own history to reflect this struggle between isolation and connectedness. Vashon has always been heavily dependent on government (federal, state and county), ferries, outside markets and migration. Periodically, the island has considered separating from King County, but in reality the island is a net importer of county resources. Vashon has always depended on ferries—from the earliest Mosquito Fleet to the first county Portage/Des Moines ferry, the Vashon Ferry District and the modern state ferry system. Vashon has always been dependent on outside markets, off-island jobs and tourism for its economic well-being. And Vashon has always depended on newcomers moving to the island to promote growth and change. This interplay of isolation/connectedness has created a metaphoric semipermeable membrane around Vashon in which the outside world influences the island but in muted and filtered ways. Islanders influence the outside world in similarly filtered and muted ways. Thus, islanders can see themselves as exceptional and unique and yet also be proud of being current and on the forefront of social and political issues.

Resource to Service Economy

Vashon began as an extractive resource economy. For the sx̌ʷəbabs, the early settlers and residents into the middle of the twentieth century, the natural resouces of the island drew them here. Fishing, farming, logging and, later, mining all drove the economy. The depletion of these natural resources led to the collaps of the economies they drove and forced islanders to shift into the service economy we have today. The interplay of people and the resources

on Vashon has always defined the island. At the beginning of the twenty-first century, the resources that attract residents to Vashon are no longer extractive natural resources but the more intangible resources of natural beauty, semirural small-town lifestyle, close to urban amenities.

LEADERSHIP

Because Vashon has never had a local government—except for taxing districts like fire, sewer, cemetery and water—the island has depended on groups of leaders to provide a voice. In each generation, a group of leaders emerges, and as those individuals age and retire, other new groups of leaders emerge. The leaders of the settler generation that provided guidance into the 1890s was replaced by a new group of businessmen (and they were largely men at this time) that led the island into the middle of the twentieth century. In the 1950s and 1960s, new leaders (for the first time including significant female leaders) emerged who brought a different kind of professionalism and expertise that led the island into the 1980s. In the 1990s, this group was replaced by trailblazers (a majority of whom were women) who brought additional new expertise and experiences to the island. As we approach the third decade of the twenty-first century, a new group of leaders is beginning to emerge that will lead the island into the future.

CONSOLIDATION

The story of Vashon is a story of consolidation. Community stores, ferry docks, schools, greenhouses, gas station/garages, farms, restaurants, hotels and other businesses have gone from many to few over the past one hundred years. At one time, there were fourteen community stores on the island. These were small general stores, the "7-Eleven" stores of their day. Today, there are only two, one at Burton and one at Center. At the height of the Mosquito Fleet, there were thirty-three ferry docks on the island. Today, there are two. Vashon once had fourteen school districts, two high schools and a college. Now it has one school district, one high school and no college. Vashon is the only island in the Salish Sea where the main town is not on the water. In the 1890s, Vashon focused south toward Tacoma, and Burton was

poised to become the major financial and retail center on Vashon. There were thriving small business areas and stores at most of the major steamer docks. But Burton and these other communities were bypassed, and the small retail center at Vashon town emerged as the dominant commercial center as the focus shifted north toward Seattle. Of course, there is also the name. Originally named Vashon's Island by George Vancouver and split into two islands by Charles Wilkes, it is now shifting back to being considered one island again.[1]

If, as David Guterson declared, "islands are ideas," then the ideas behind these enduring patterns are what helped to define Vashon during each era of its history.[2]

NOTES

Introduction

1. Cronon, "Why the Past Matters."
2. Limerick, *Legacy of Conquest*, 81–88.
3. Stein and Phillips, *Vashon Island Archaeology*; Kruckeberg, *Natural History of Puget Sound*, 382–84.
4. White, *It's Your Misfortune*, xiv.
5. White, *Land Use, Environment, and Social Change*; Limerick, *Legacy of Conquest*.

Chapter 1

1. Guterson, "Citizens of Paradise."
2. Rose, *Feminism and Geography*.
3. Zahir, personal communication.
4. MacDonald, *Onions in the Stew*.
5. Martin and Wright, *Pleistocene Extinctions*.

Chapter 2

1. Ballard, "Mythology of Southern Puget Sound."
2. Reynon, personal communication.
3. King County Planning Commission, *Vashon Study*, 146; Kruckeberg, *Natural History of Puget Sound*, 384; Martin and Wright, *Pleistocene Extinctions*; Taylor, "Anthropological Investigation"; Vanderwal, "Compositional and Textural Variations."

4. Suttles, *Coast Salish Essays*, 256–57ff.

5. Kruckeberg, *Natural History of Puget Sound*, 386; Matson and Coupland, *Prehistory of the Northwest Coast*, 301ff.

6. *Annual Report of the Commissioner of Indian Affairs*, 1852, 170; Gibbs, *Indian Tribes*, 41; Taylor, "Aboriginal Populations," 425; White, *Land Use, Environment, and Social Change*, 161–62.

7. United States Court of Claims; Smith, *Archaeology of the Gulf of Georgia*, 393–94; Hilbert, Miller and Zahir, *Puget Sound Geography*, 71ff.

8. *Annual Report of the Commissioner of Indian Affairs*, 1852; Gibbs, *Indian Tribes*; Taylor, "Anthropological Investigation"; White, *Land Use, Environment, and Social Change*.

9. Andrews and Berry, *Nature of an Island*, 7; Buerge, *Campsites and Mounds*, 11; Waterman, "Puget Sound Geography," 185.

10. Waterman, "Puget Sound Geography"; Stanley, "Search for Laughter"; *News-Record*, 1937; Smith, "Puyallup of Washington"; Ballard, "Mythology of Southern Puget Sound."

11. Buerge, *Campsites and Mounds*, 7; Smith, *Archaeology of the Gulf of Georgia*, 394; Waterman, "Puget Sound Geography."

12. White, *Land Use, Environment, and Social Change*, 20.

13. Harmon, *Indians in the Making*, 7–8.

14. Gunther, *Ethnobotany of Western Washington*, 20–22.

15. Smith, *Archaeology of the Gulf of Georgia*, 394–99.

16. Ibid., 395.

17. Gunther, *Ethnobotany of Western Washington*; Turner, *Food Plants*.

18. Holm, *Northwest Coast Indian Art*.

19. Gunther, *Ethnobotany of Western Washington*.

20. Buerge, *Campsites and Mounds*, 2–3.

21. Ibid., 4.

22. Ibid., 3; Turner, *Food Plants*; Gunther, *Ethnobotany of Western Washington*, 21–22.

23. Buerge, *Campsites and Mounds*, 4; Morgan, *South on the Sound*, 19.

24. Buerge, *Campsites and Mounds*.

25. Suttles, *Coast Salish Essays*.

CHAPTER 3

1. Harmon, *Indians in the Making*.

2. Menzies, *Menzies' Journal of Vancouver's Voyage*.

3. White, *Land Use, Environment, and Social Change*.

4. Taylor, *Aboriginal Populations*, 162; White, *Land Use, Environment, and Social Change*, 2–4.

5. White, *Land Use, Environment, and Social Change*, 28ff; O'Brien, "Coming Full Circle."

6. Blumenthal, *Early Exploration*, 167; White, *It's Your Misfortune*, 57.

7. Harmon, *Indians in the Making*, 41ff, 55ff.

8. White, *It's Your Misfortune*; Harmon, *Indians in the Making*.

9. Harmon, *Indians in the Making*, 61–62, 68.

10. Ibid., 114; White, *It's Your Misfortune*, 518.

11. Harmon, *Indians in the Making*, 118–19, 153.

12. Tyler, *Wilkes Expedition*.

13. Blumenthal, *Early Exploration*.

14. Haskell, *Wilkes Expedition*.

15. George T. Sinclair Journal.

16. Harmon, *Indians in the Making*, 104–5, 136–44.

17. Ibid., 146–50, 157, 161.

18. Schwantes, *Pacific Northwest*, 125; Gerand, 647; White, *Land Use, Environment, and Social Change*, 44.

19. Kappler, *Medicine Creek Treaty*.

20. Ibid.

21. White, *Land Use, Environment, and Social Change*, 61–65; Harmon, *Indians in the Making*, 153.

22. White, *Land Use, Environment, and Social Change*, 94–98; Kluger, *Bitter Waters of Medicine Creek*.

23. White, *Land Use, Environment, and Social Change*, 89, 101ff; Kluger, *Bitter Waters of Medicine Creek*; Harmon, *Indians in the Making*, 226; Shackleford, "History of the Puyallup Indian Reservation."

24. White, *Land Use, Environment, and Social Change*, 140, 153, 172; Harmon, *Indians in the Making*, 242, 244, 253.

25. White, *Land Use, Environment, and Social Change*, 177–78.

26. Ibid.

27. Ibid., 200; Harmon, *Indians in the Making*, 284.

28. Harmon, *Indians in the Making*, 282–83, 377; White, *Land Use, Environment, and Social Change*, 204.

Chapter 4

1. In Loutzenhiser and Loutzenhiser, *As Told by the Pioneers*, 67.

2. Chasan, *Waterlink*.

3. Buerge, *Campsites and Mounds*, 1; White, *Land Use, Environment, and Social Change*.

4. Van Olinda, "History of Vashon-Maury Islands," x.

5. White, *It's Your Misfortune*, 57.

6. Van Olinda, "History of Vashon-Maury Islands"; Lynn, *Lieutenant Maury's Island*; Chin and Chin, "Legacy of Washington State"; Chin, *Golden Tassels*; *Tacoma Herald*, July 16, 1878.
7. Museum of History and Industry.
8. Vashon College, 6th Catalogue, 1898.
9. Loutzenhiser and Loutzenhiser, *As Told by the Pioneers*, 113.
10. Payton, "Spirit of Chautauqua."
11. Ibid.
12. Carey, *Van Olinda's History*.
13. Carey, *Sound of the Steamers*.
14. Van Olinda, "History of Vashon-Maury Islands," 34.

CHAPTER 5

1. Bagley, *History of King County*.
2. White, *It's Your Misfortune*.
3. Schwantes, *Pacific Northwest*.
4. White, *It's Your Misfortune*.
5. Sunstrom, "Mukai Garden."
6. Van Olinda, "History of Vashon-Maury Islands."
7. Schwantes, *Pacific Northwest*.
8. Thrush, *Native Seattle*.
9. James, *Hands Across Time*.
10. Harmon, *Indians in the Making*.

CHAPTER 6

1. MacDonald, *Onions in the Stew*.
2. *Vashon Island News-Record*, August 1929.
3. Larson and Haulman, Vashon Census Project.
4. *Seattle Daily News*, October 1927.
5. Sunstrom, "Mukai Garden"; Larson and Haulman, Vashon Census Project.
6. Harmon, *Indians in the Making*; Larson and Haulman, Vashon Census Project.
7. Carey, *Van Olinda's History*.
8. *Vashon Island News-Record*, February 1930.
9. Ibid., June 1926.
10. Ibid., July 1930.
11. Ibid., June 4, 1931; July 23, 1931; January 14, 1932; January 28, 1932; February 16, 1933; January 11, 1934.
12. Ibid., May 1930; June 1943; Folz, "Storytelling."

13. *Vashon Island News-Record*, June 14, 1934.

14. Ibid., April 20, 1933; Hall and David, "Battleship U.S.S. *Arizona*."

15. *Vashon Island News-Record*, May 1933.

16. Ibid., May 1931; August 1933; January 1934.

17. Ibid., November 1932.

18. Mullins, *Depression and the Urban West Coast*; *Vashon Island News-Record*, January 1930; February 1936; October 1932; May 1939.

19. *Vashon Island News-Record*, August 1933; December 1933; February 1934; Larson and Haulman, Vashon Census Project.

20. *Vashon Island News-Record*, May 1931; May 1932; February 1933; June 1932; July 1932.

21. Ibid., July 1928; October 1932; March 1934; February 1937.

22. Ibid., January 1936; February 1936; July 1936.

23. Ibid., January 1936; June 1936; July 1936; August 1936; October 1936; December 1936; Vashon Radio website.

24. *New York Herald Tribune*, December 13, 1941.

25. *Seattle Post-Intelligencer*, February 22, 1942; *Seattle Times*, May 17, 1942.

26. *Vashon Island News-Record*, September 1942; October 1942; March 1943; October 1943.

27. Ibid., December 1942; August 1943; *Seattle Times*, July 11, 1942; Aviation Safety website.

28. *Vashon Island News-Record*, January 1943; April 1943.

29. *Seattle Post-Intelligencer*, June 1943; *Vashon Island News-Record*, October 1943; June 1943.

30. *Vashon Island News-Record*, March 1932.

31. Ibid., December 1942.

32. Ibid., February 1942; Gruenewald, *Looking Like the Enemy*; *Vashon Island News-Record*, May 1942.

33. Gruenewald, *Looking Like the Enemy*; Densho Archive; Larson and Haulman, Vashon Census Project.

34. *Vashon Island News-Record*, December 1941; May 1942; May 1943; June 1942; June 1943; January 1945.

35. Gruenewald, *Looking Like the Enemy*; Yoneichi Matsuda, personal letter.

36. *Vashon Island News-Record*, February 1945; *Seattle Times*, May 23, 1945; War Relocation Administration.

37. *Vashon Island News-Record*, May 1942; Gruenewald, "Storytelling."

38. *Vashon Island News-Record*, April 1925.

39. Ibid., May 1930; April 1932.

40. Ann Irish, personal communication.

41. Pickens, *Ferries of Puget Sound*.

42. *Vashon Island News-Record*, February 1943; July 1943; Gene Sherman, personal communication.

43. United States Court of Claims; Larson and Haulman, Vashon Census Project; James, *Hands Across Time*.
44. Harmon, *Indians in the Making*.

CHAPTER 7

1. Ruth Anderson, personal communication.
2. Sherman, personal communication; Peter Ray, personal communication.
3. Crowley, "Dahl and Crissman Report"; *Vashon Island News-Record*, 1950.
4. Haulman, "Other Maury Island Incident."
5. *News-Record*, April 1953.
6. *Beachcomber*, July 1959.
7. *News-Record*, 1946; *Seattle Post-Intelligencer*, 1947.
8. *News-Record*, 1949, 1950, 1952.
9. Ibid., 1954.
10. Nussbaum, "Great Divide."
11. *Beachcomber*, 1971; *Tacoma News Tribune*, November 2, 1977.
12. Operation Jigsaw Proceedings.
13. *Beachcomber*, October 15, 2013.
14. Ibid., August 1965; May 1966; June 1966; June 1968; May 1974; *Western Farmer-Stockman*, 1977; *Beachcomber*, January 1979; May 1972.
15. *Beachcomber*, October 1974.
16. Vashon Allied Arts website.
17. *Modern Farmer*, November 1, 2013.
18. *Beachcomber*, June 1970; August 1970; "Those Dred Hippies of Vashon."
19. *Seattle Times*, October 24, 1971; "Those Dred Hippies of Vashon."
20. Irish, personal communication.
21. *Seattle Times*, May 15, 1948.
22. *Spokane Review*, March 8, 1950.
23. *Seattle Times*, February 1, 1981; *Beachcomber*, November 1969.
24. Vashon Chamber of Commerce, *Vashon Island Story*; *News-Record*, May 1952.
25. Vashon Chamber of Commerce, *Vashon Island Story* and Vashon Chamber of Commerce, *To Build a Better Community*; *News-Record*, May 1952.
26. *News-Record*, November 1953; March 1954; October 1955; Irish, personal communication; *Seattle Times*, August 11, 1968.
27. *Seattle Times*, March 1, 1966; *Beachcomber*, April 1965; November 1965; *Seattle Times*, November 3, 1965; June 23, 1966.
28. *Beachcomber*, March 1966; April 1967; September 1967.

CHAPTER 8

1. Todras-Whitehill, "Vashon Island."

2. *News Tribune*, December 17, 2000.

3. *New York Times*, February 3, 2006.

4. Dietrich, "Creating Ecotopia."

5. Brookings Institution, *Dealing with Neighborhood Change*.

6. Haulman, "K2"; Larson and Haulman, Vashon Census Project.

7. *Seattle Times*, January 21, 1984; Lawrie, personal communication.

8. Department of Ecology, State of Washington, "Introduction to the Shoreline Management Act"; King County, "Critical Areas, Stormwater, and Clearing and Grading Ordinances (CAO)."

9. *New York Times*, February 3, 2006.

10. *Seattle Post-Intelligencer*, July 12, 2001; *New York Times*, February 3, 2006; Larson and Haulman, Vashon Census Project.

11. *Seattle Times*, October 28, 1984; Christie, "Vashon 101"; Alice Larson, personal communication; *Beachcomber*, June 2008.

12. *Beachcomber*, February 2013.

13. Ibid., August 2009; *Sunset Magazine*, 2012.

14. Woodroffe, "Vashon Island's Agricultural Roots"; Kurtwood Farms website; Vashon Island Growers Association website.

15. *San Francisco Chronicle*, December 5, 2014.

16. Vashon Island Marijuana Entrepreneurs Alliance website; *Beachcomber*, February 2014; March 2014; December 2014.

17. *Beachcomber*, August 1984; *Seattle Times*, November 3, 1984; Haulman, "Vashon-Maury Island Ferry Revolution"; League of Women Voters of Washington, "Washington State Ferries"; Chasan, "Keeping King County's Tiny Navy Afloat."

18. *Beachcomber*, April 1981; May 1981; August 1981; *Seattle Post-Intelligencer*, January 8, 1986; *Seattle Times*, June 15, 1988; *Seattle Post-Intelligencer*, January 8, 1986; *Seattle Times*, December 19, 1984; Chasan, "Should King County."

19. *Seattle Post-Intelligencer*, October 1, 1981; *Seattle Times*, November 3, 1984.

20. Haulman, "Vashon-Maury Island Ferry Revolution."

21. League of Women Voters of Washington, "Washington State Ferries"; *Beachcomber*, February 2009; December 2006; January 2008; January 2012; October 2012; November 2012; November 2013.

22. *Seattle Post-Intelligencer*, January 29, 2003; *Beachcomber*, September 2005; *News Tribune*, April 12, 2006; Chasan, "Keeping King County's Tiny Navy Afloat"; *Beachcomber*, March 2015.

23. *Beachcomber*, May 1976; December 2010; August 2010; January 2011; February 2011; March 2011; June 2011; April 2012; November 2012; December 2012.

24. Ibid., January 1994; May 1994; August 2005; March 2010.
25. *Seattle Times*, May 7, 1984; *Beachcomber*, May 1996; Christie, "Vashon 101."
26. *Beachcomber*, February 2006.
27. Ibid.
28. Christie, "Vashon 101."
29. Ibid.; Chasan, "How Maury Island's Mining Opponents."
30. Nelson et al., "PIO Win"; Moyer, "Timeline to Victory."
31. Chasan, "How Maury Island's Mining Opponents."
32. Ibid.; *Beachcomber*, January 2011; White, *It's Your Misfortune*, 633.
33. Bonkowski, personal communication.
34. Granny's Attic website.
35. Vashon Island Pet Protectors website; Baahaus Animal Rescue Group website.
36. *Beachcomber*, March 11, 1992; March 10, 2009; Vashon Food Bank website.
37. Vashon HouseHold website.
38. Voice of Vashon website.
39. Open Space for Arts & Community website.
40. Vashon Be Prepared website.
41. Island GreenTech website; DoVE Project website.
42. *Beachcomber*, May 1984; April 2007; August 2007; March 2009.
43. Ibid., December 1987.
44. Ibid., April 2004; December 2005; Rick Frye, personal communication; Larson, personal communication.
45. Chasan, "Great Vashon Library War"; *Beachcomber*, November 2008; December 2007.
46. *Beachcomber*, January 2009; April 2009; November 2008; June 2009; August 2010.
47. Ibid., November 2009; April 2011; October 2011; December 2011; October 2012; November 2012; December 2012; January 2013; February 2013; May 2013.
48. Ibid., January 2011; April 2008; November 2008; July 2011; August 2011; September 2011; May 2012; June 2012; July 2013; October 2013; July 2014; October 2014; December 2014; April 2015; May 2015.

Epilogue

1. Irish, personal communication.
2. Guterson, "Citizens of Paradise."

BIBLIOGRAPHY

Anderson, Benedict. *Imagined Communities: Reflections on the Origins and Spread of Nationalism*. N.p.: Verso, 1991.

Anderson, Ruth. Personal communication with the author, 2015.

Andrews, Jill A.B., and Kajira Wyn Berry, eds. *The Nature of an Island: Stories & Poems by Vashon-Maury Island Writers*. Vashon Island, WA: Sand Dollar Press, 2001.

Annual Report of the Commissioner of Indian Affairs. Washington, D.C.: Government Printing Office, 1852.

Bagley, Clarence B. *History of King County, Washington*. Seattle, WA: S.J. Clarke Publishing Company, 1929.

Ballard, Arthur C. "Mythology of Southern Puget Sound." *University of Washington Publications in Anthropology* 3, no. 2 (1929).

Blumenthal, Richard W. *The Early Exploration of Inland Washington Waters: Journals and Logs from Six Expeditions, 1786–1792*. Jefferson, NC: McFarland, 2004.

Bonkowski, Benno. Personal communication with the author, 2015.

Brookings Institution. *Dealing with Neighborhood Change: A Primer on Gentrification and Policy Choices*. Washington, D.C.: self-published, 2001.

Buerge, David. *Campsites and Mounds of Vashon-Maury Island*. N.p.: self-published, 1993. Available at King County Library, Vashon Branch.

Carey, Roland. *The Sound of the Steamers*. Seattle, WA: Alderbrook Publishing Company, 1965.

———. *Van Olinda's History of Vashon-Maury Island*. Seattle, WA: Alderbrook Publishing Company, 1985.

Carr, J.R., with Carr & Associates. *Vashon-Maury Island Water Resources Study*. King County Department of Planning and Community Development, Planning Division, 1983.

BIBLIOGRAPHY

Chasan, Dan. "The Great Vashon Library War." *Crosscut*, May 7, 2009.

———. "How Maury Island's Mining Opponents Finally Prevailed." *Crosscut*, December 31, 2010.

———. "Keeping King County's Tiny Navy Afloat." *Crosscut*, September 28, 2009.

———. "Should King County Be in the Ferry Business?" *Crosscut*, December 21, 2007.

———. *The Waterlink*. Seattle: University of Washington Press, 1981.

Chin, Art. *Golden Tassels: A History of the Chinese in Washington, 1857–1992*. Seattle, WA: self-published, 1992.

Chin, Art, and Daniel Chin. "The Legacy of Washington State Early Pioneers." *International Examiner* 14 (March 1988): 4.

Christie, Patrick. "Vashon 101." Course presented at Vashon College. Vashon, WA, 2007.

Cronon, William. "Why the Past Matters." *Wisconsin Magazine of History* (Autumn 2000).

Crowley, Walt. "Dahl and Crissman Report a June 21, 1947, Explosion of a Flying Saucer Over Maury Island on or After June 26, 1947." HistoryLink Essay 2068, January 1, 2000.

Densho Archive. Seattle, Washington.

Dietrich, William. "Creating Ecotopia." *Seattle Times*, April 20, 2003.

Eterovich, Adam. *Croatian Fishermen-Oystermen-Mariners-Shipbuilders-Fish Restaurants in America*. San Carlos CA: Ragusan Press, 2010.

Fields, Ronald. *Abby Williams Hill and the Lure of the West*. Tacoma: Washington State Historical Society, 1989.

Folz, Bernedine. "Storytelling." Friends of Mukai Presentation, 2013.

Frye, Rick. Personal communication with the author, 2015.

George T. Sinclair Journal, 1851–53. University of Virginia Libraries. Charlottesville, Virginia.

Gibbs, George. *Indian Tribes of the Washington Territory*. House Exec. Document 91, 33rd Congress, 2nd session, 1854. Reprint, Fairfield, WA: Ye Galleon Press, 1967.

Gornall, Tag. Personal communication with the author, 2015.

Gruenewald, Mary Matsuda. *Looking Like the Enemy: My Story of Imprisonment in Japanese American Internment Camps*. N.p.: NewSage Press. 2005.

———. "Storytelling." Friends of Mukai Presentation, 2013.

Gunther, Erna. *Ethnobotany of Western Washington: The Knowledge and Use of Indigenous Plants by Native Americans*. Seattle: University of Washington Press, 1973.

Guterson, David. "The Citizens of Paradise." *Harper's Magazine* (July 1996).

Hall, Richard, and Wilma David. "Battleship U.S.S. *Arizona* Rams and Sinks Purse Seiner Off Cape Flattery, Killing Two on July 26, 1934." HistoryLink Essay 5378, March 6, 2003. HistoryLink.org.

Harmon, Alexandra. *Indians in the Making: Ethnic Relations and Indian Identities around Puget Sound.* Berkeley: University of California Press, 1999.

Haskell, Patrick J. *The Wilkes Expedition in Puget Sound, 1841.* Olympia, WA: WICHE and State Capitol Museum, 1974.

Haulman, Bruce. "K2." "Time & Again Series." *Vashon-Maury Island Beachcomber,* July 8, 2009.

———. "The Other Maury Island Incident." "Time & Again Series." *Vashon-Maury Island Beachcomber,* April 2, 2014.

———. "Vashon-Maury Island Ferry Revolution." *Heritage Museum Newsletter* (Fall 2014).

Hilbert, Vi, Jay Miller and Zalmai Zahir, eds. *Puget Sound Geography: Original Manuscript from T.T. Waterman.* Federal Way, WA: Zahir Consulting Services, 2001.

Hilton, Als. "The Unvanquished." *New Yorker,* September 27, 1999.

Holm, Bill. *Northwest Coast Indian Art: An Analysis of Form.* Seattle: University of Washington Press, 1965.

Irish, Ann. Personal communication with the author, 2014.

James, Rosemary Bridges. *Hands Across Time.* Video, 1996. Available at King County Library, Vashon Branch.

Kappler, Charles J., comp. and ed. *Medicine Creek Treaty—Indian Affairs: Laws and Treaties.* Vol. 2, *Treaties.* Washington, D.C.: Government Printing Office, 1904.

King County Planning Commission. *Vashon Study.* King County, WA, 1949.

Kluger, Richard. *The Bitter Waters of Medicine Creek: A Tragic Clash Between White and Native America.* New York: Alfred A. Knopf, 2011.

Kruckeberg, Arthur R. *The Natural History of Puget Sound Country.* A Wyerhaeuser Environmental Book. Seattle: University of Washington Press, 1991.

Larson, Alice. Personal communication with the author, 2015.

Larson, Alice, and Bruce Haulman. The Vashon Census Project. Vashonhistory.com.

Lawrie, Michael. Personal communication with the author, 2015.

The League of Women Voters of Washington. *The Washington State Ferries.* Seattle: League of Women Voters of Washington Report, 2007.

Limerick, Patricia. *The Legacy of Conquest: The Unbroken Past of the American West.* New York: W.W. Norton & Company, 1987.

Lotus, Linda. Personal communication with the author, 2015.

Loutzenhiser, F.H., and J.R. Loutzenhiser, eds. *As Told by the Pioneers: Tales of Frontier Life as Told by Those Who Remember the Days of the Territory and Early Statehood of Washington.* Vol. 3. WPA Special Federal Project No. 5841. Olympia: Washington Pioneer Project, Secretary of State Office, 1938.

Lynn, Howard W. *Lieutenant Maury's Island and the Quartermaster's Harbor.* Vashon, WA: Beachcomber Press, 1975.

MacDonald, Betty. *Onions in the Stew.* New York: J.B. Lippincott Company, 1955.

Martin, Paul S., and Herbert Edgar Wright, Jr. *Pleistocene Extinctions: A Search for a Cause.* New Haven, CT: Yale University Press, 1967.

Matson, R.G., and Gary Coupland. *The Prehistory of the Northwest Coast.* San Diego, CA: Academic Press, 1995.

Matsuda, Miyoko. Personal communication with the author, 2015.

———. Yoneichi Matsuda Archive.

Matsuda, Yoneichi. Personal letter. Vashon Heritage Museum Archive.

McMurdo, Jenny. *A Brief History of Hogsback Farm.* Vashon, WA: Vashon Allied Arts, 2014.

Meade, Michael. Personal communication with the author, 2015.

Menzies, Archibald. *Menzies' Journal of Vancouver's Voyage: April to October 1792.* Archives of British Columbia, Memoir No. 5, 1923.

Morgan, Murray, and Rosa Morgan. *South on the Sound: An Illustrated History of Tacoma and Pierce County.* Woodland Hills, CA: Windsor Publications, 1984.

Moyer, Bill. "Timeline to Victory: How We Beat Goliath." *Vashon Loop,* December 2010.

Mullins, William H. *The Depression and the Urban West Coast, 1929–1933.* Bloomington: Indiana University Press, 1991.

Museum of History and Industry. Seattle, Washington.

National Fisherman. "History of Martinolich Boats" (May 1978).

Nelson, Sharon, Brenda Moore, Libby McLarty, J.W. Turner and Amy Carey. "PIO Win" editorial letter. *Beachcomber,* September 2009.

Nussbaum, Emily. "The Great Divide." *New Yorker,* April 7, 2014.

O'Brien, Suzanne Crawford. *Coming Full Circle.* Lincoln: University of Nebraska Press, 2013.

Payton, Charles. "The Spirit of Chautauqua." *Portage: The Magazine of the Historical Society of Seattle and King County* 3, no. 2 (Spring 1982): 22–23.

Pickens, Steven J. *Ferries of Puget Sound: Images of America.* Charleston, SC: Arcadia Publishing, 2006.

Proceedings: Operation Jigsaw. Vashon-Maury Island, 1963–64. Seattle, WA: King County, Community Development Study, 1964. Available at King County Library, Vashon Branch.

Ray, Peter. Personal communication with the author, 2015.

Rendall, W.T. (Bill). "Memories of Maury Island: Notations of Early Days Recorded by Bill Rendall, 1885–1935." King County Library, Vashon Branch, n.d.

Reynon, Brandon, Puyallup Tribe Cultural Regulatory Specialist. Personal communication with the author, 2012.

Rose, Gillian. *Feminism and Geography: The Limits of Geographical Knowledge.* N.p.: Wiley, 1993.

Schwantes, Carlos. *The Pacific Northwest: An Interpretive History.* Lincoln: University of Nebraska Press, 2000.

Shackleford, Elizabeth. "A History of the Puyallup Indian Reservation, Tacoma." Master's thesis, College of Puget Sound, 1918.

Sherman, Gene. Personal communication with the author, 2014.

Silverstein, Pam. "Remembering Augie." *Beachcomber,* December 2007.

Smith, Harlan Ingersoll. *Archaeology of the Gulf of Georgia and Puget Sound.* N.p.: G.E. Stechert & Company, 1907.

Smith, Marian W. "The Puyallup of Washington." In *Acculturation in Seven American Indian Tribes.* Edited by Ralph Linton. N.p.: Appleton-Century Company, 1940.

Spring, Tom. "The Matsuda Farm." Vashon-Maury Island Land Trust, 2014.

Stanley, Marjorie. "Search for Laughter: Compilation from *The Beachcomber.*" King County Library, Vashon Branch, 1967–68.

Stein, Julie K., and Laura S. Phillips, eds. *Vashon Island Archaeology: A View from Burton Acres Shell Midden.* Seattle, WA: Burke Museum, 2003.

Sunset Magazine. "The West's Top 20 Fantasy Towns" (September 2012).

Sunstrom, Carolyn J. "The Mukai Garden: An Issei Woman's Expression of Her Cultural Heritage and Immigration Experience." Master's thesis, University of Washington, 1996.

Suttles, Wayne. *Coast Salish Essays.* Seattle: University of Washington Press, 1987.

Takatsuka, Augie. Oral history interview by Jon Lee Joseph. King County Library, Vashon Branch, 1999.

Taylor, Herbert C. "Aboriginal Populations of the Lower Northwest Coast." *Pacific Northwest Quarterly* 54, no. 4 (October 1963): 160, 162–63.

———. *Aboriginal Populations of the Lower Northwest Coast in Roles of Certain Tribes in Oregon and Washington.* Fairfield, WA: Ye Galleon Press, 1969.

———. "Anthropological Investigation of the Medicine Creek Tribes Related to Tribal Identity and the Possession of Lands." In *Investigation and Archaeology of Puget Sound Indians, Coastal Salish and Western Washington.* Vol. 2. Edited by Riley Carroll. New York: Garland Pub. Inc., 1974.

"Those Dred Hippies of Vashon." Vashon Heritage Museum manuscript, n.d.

Thrush, Coll. *Native Seattle: Histories from the Crossing-Over Place.* Seattle: University of Washington Press, 2009.

Todras-Whitehill, Ethan. "Vashon Island, a Rural Throwback." *Seattle Times,* March 30, 2012.

Turner, Nancy J. *Food Plants of Coastal First Peoples.* Royal British Columbia Museum Handbook series. Vancouver: University of British Columba Press, 1995.

Tyler, David B. *The Wilkes Expedition: The First United States Exploring Expedition (1838–1842)*. Philadelphia, PA: American Philosophical Society, 1968.

United States Court of Claims. *The Duwamish, Lummi, Whidby Island, Skagit, Upper Skagit, Swinomish, Kikiallus, Snohomish, Snoqualmie, Stillaguamish, Suquamish, Samish, Puyallup, Squaxin, Skokomish, Upper Chehalis, Muckleshoot, Nooksack, Chinook and San Juan Islands tribes of Indians, claimants, v. the United States of America, defendant.* Consolidated petition. No. F-275, 1933. Special Collections, University of Washington Libraries. Seattle, Washington.

Vanderwal, Kathy Sue. "Compositional and Textural Variations in the Vashon Till and Underlying Drifts in the Northern and Central Puget Lowland, Washington." Master's thesis, University of Washington, 1985.

Van Olinda, Oliver S. "History of Vashon-Maury Islands." Series of articles in the *Vashon Island News-Record*, 1935.

———. *History of Vashon-Maury Islands.* Vashon, WA: Vashon Island News Record, 1935.

Vashon Chamber of Commerce. *To Build a Better Community*. Brochure, 1952.

———. *The Vashon Island Story.* Brochure, 1952.

Vashon College. 6th Catalogue, 1898. Burton, Washington.

Waterman, Thomas Talbot. "Puget Sound Geography." Manuscript, 1864. Smithsonian Institution, National Anthropological Archives. Washington, D.C., circa 1920.

White, Richard. *It's Your Misfortune and None of My Own.* Norman: University of Oklahoma Press, 1991.

———. *Land Use, Environment, and Social Change.* Seattle: University of Washington Press, 1980.

Woodroffe, Pamela J. *Vashon Island's Agricultural Roots: Tales of the Tilth as Told by Island Farmers.* Bloomington, IN: iUniverse, 2002.

Zahir, Zalmai. Personal communication with the author, 2012.

Newspapers

Independent Enterprise, Payette, Idaho.

Modern Farmer. Hudson, New York.

News Tribune. Tacoma, Washington.

New York Herald Tribune. New York City, New York.

San Francisco Chronicle. San Francisco, California.

Seattle Daily News. Seattle, Washington.

Seattle Post-Intelligencer. Seattle, Washington.

Seattle Times. Seattle, Washington.

Spokane Review. Spokane, Washington.

The Sun. November 2011.

Tacoma Herald. Tacoma, Washington.
Vashon Island News-Record. Vashon, Washington.
Vashon Loop. Vashon, Washington.
Vashon-Maury Island Beachcomber. Vashon, Washington.
Western Farmer-Stockman. Vancouver, Washington.

WEBSITES

Aviation Safety. www.aviation-safety.net.

Baahaus Animal Rescue Group. www.baahaus.org.

Department of Ecology, State of Washington. "Introduction to the Shoreline Management Act." www.ecy.wa.gov/programs/sea/sma/st_guide/intro.html.

The DoVE Project. vashondoveproject.org.

Granny's Attic. www.grannysattic.org.

Island GreenTech. www.islandgreentech.org.

King County. "Critical Areas, Stormwater, and Clearing and Grading Ordinances (CAO)." www.kingcounty.gov/property/permits/codes/CAO.aspx.

Kurtwood Farms. www.kurtwoodfarms.com.

Mosaic Voices. www.mosaicvoices.org.

Open Space for Arts & Community. openspacevashon.com.

The Polyclinic. www.polyclinic.com.

Vashon Allied Arts. www.vashonalliedarts.com.

Vashon Be Prepared. vashonbeprepared.org.

Vashon Food Bank. www.vashonfoodbank.org.

Vashon HouseHold. vashonhousehold.org.

Vashon Island Growers Association. www.vigavashon.org.

Vashon Island Marijuana Entrepreneurs Alliance. www.vimea.org.

Vashon Island Pet Protectors. www.vipp.org.

Vashon-Maury Island Health Collaborative. www.vmihc.wordpress.com.

Vashon-Maury Island Heritage Association. www.vashonheritage.org.

Vashon Parks. vashonparks.org.

Vashon Radio. www.vashonradio.com.

Voice of Vashon. voiceofvashon.org.

INDEX

ABOUT THE AUTHOR

Bruce and Pamela Haulman live on Vashon in Ellisport above KVI Beach. Their home, Vashon Heaven, is named in honor of Pam's Auntie Ethel, who always referred to the island as "Vashon Heaven." Bruce is the director of the Vashon History Project (vashonhistory.com) and on the boards of the

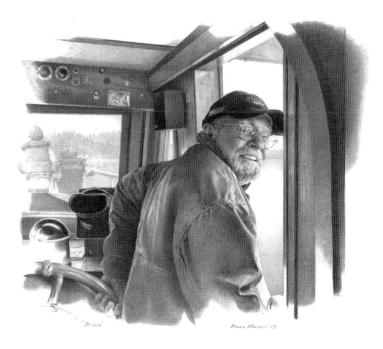

"Bruce" Bruce Morser '13

ABOUT THE AUTHOR

Vashon-Maury Island Heritage Association (vashonheritage.org), the Friends of Mukai (friendsofmukai.org) and Voice of Vashon (voiceofvashon.org). This is the second in a trilogy about Vashon history. The first, *Vashon Island: Images of America* (2011), told the history of Vashon through photographs. This book looks at the broad sweep of forces and events that shaped Vashon. The final book in the trilogy will explore the exceptional individuals and personalities whose stories capture the full sweep of the human experience on Vashon. He writes the "Time & Again" series, with photographer Terry Donnelly, for the *Vashon-Maury Island Beachcomber*. He also directs the Green River College Australia–New Zealand Study Abroad Program. In his spare time, you can find Bruce aboard his trawler, *Vashona*, or carving masks inspired by his love of the Northwest Coast.